Selling
Good Design

Promoting the Early Modern Interior

Marilyn F. Friedman

For Tom

ACKNOWLEDGEMENTS

My interest in Macy's, nurtured in the last few years, began much earlier. When I was growing up, my late father, Fred Friedman, stopped at Macy's several times a week on his way home from work to pick up our dinner from Macy's meat department, then run by my cousin Harold Perlmutter. My late mother, Rae Friedman, was an early holder of a Macy's credit card and a wonderful woman of impeccable taste.

My most heartfelt appreciation goes to those who preserved the history of the department store exhibitions: the unknown employees of Macy's, who saved all of the news reports about the expositions; Dorothy Shaver, who kept a scrapbook of the Lord & Taylor Exposition that her sister Elsie later donated to the National Museum of American History; Sigurd Fischer, who preserved all of the negatives of his photographs of early twentieth century interiors, which his daughter donated to the Library of Congress; and the Metropolitan Museum of Art, which carefully preserves records of its history. Numerous individuals assisted me in gaining access to these treasure troves, including Arthur Reiner, former President of Macy's, Bob Rutan, Production Manager at Macy's East, Inc., Barbara File at the Metropolitan Museum of Art, Ford Peatross at the Library of Congress, and Mimi Minnick at the National Museum of American History.

Among the many individuals who assisted me in this endeavor were Sean Ashby, Dirk Bakker, Gail Bardhan, Sue M. Brown, Ashley Callahan, Julia Collins, Susan Dolan, Tim Driscoll. Annette Fern, Anne Gros, Kurt Helfrich, Susan Kindberg, Kay Peterson, Tamara Préaud, and Judy Walsh. The New York Public Library gave me sanctuary. John Bender, Evelyn Junge, Mark Levine, and Robert Vanni all eased my transition from law to publishing with patience and good counsel.

A number of individuals in the decorative arts field shared with me their ideas, knowledge, and collections, including John Bloom, Barbara Deisroth, Adriana Friedman, Marcella Giamundo, Mark McDonald, Alan Moss, and John C. Waddell. Jewel Stern not only led me to a cache of original photographs, but provided encouragement and sage advice. Also, many people helped me with this work during my studies at the Cooper-Hewitt National Design Museum, in particular, Stephen Van Dyk, Elizabeth Broman, Dr. Barry Harwood, Gail Davidson, Dr. Maria Ann Conelli, Janna Eggebeen, Dr. Sarah Lawrence, Christina Corsiglia, Susan Hermanos, and Patricia Abramson.

Stephen Case provided not only superb editorial support, but also a level of enthusiasm for the project that kept me constantly wanting to learn more.

All of my friends deserve credit for the completion of this book, as they kept sending me back to the computer with words of encouragement during those inevitable periods of writer's block. The most important people in my life, my husband, Tom Block, and my children, Jon and Ali, supported my mid-life correction and motivated me to complete this project despite their almost complete lack of interest in the subject matter. That is true love.

First published in the United States of America in 2003 by
Rizzoli International Publications, Inc.
300 Park Avenue South
New York, NY 10010
www.rizzoliusa.com

ISBN 0-8478-2585-X (hardcover)
ISBN 0-8478-2545-0 (paperback)

Library of Congress Control Number: 2003093017

Design by Duuplex

Printed and bound in China

Contents

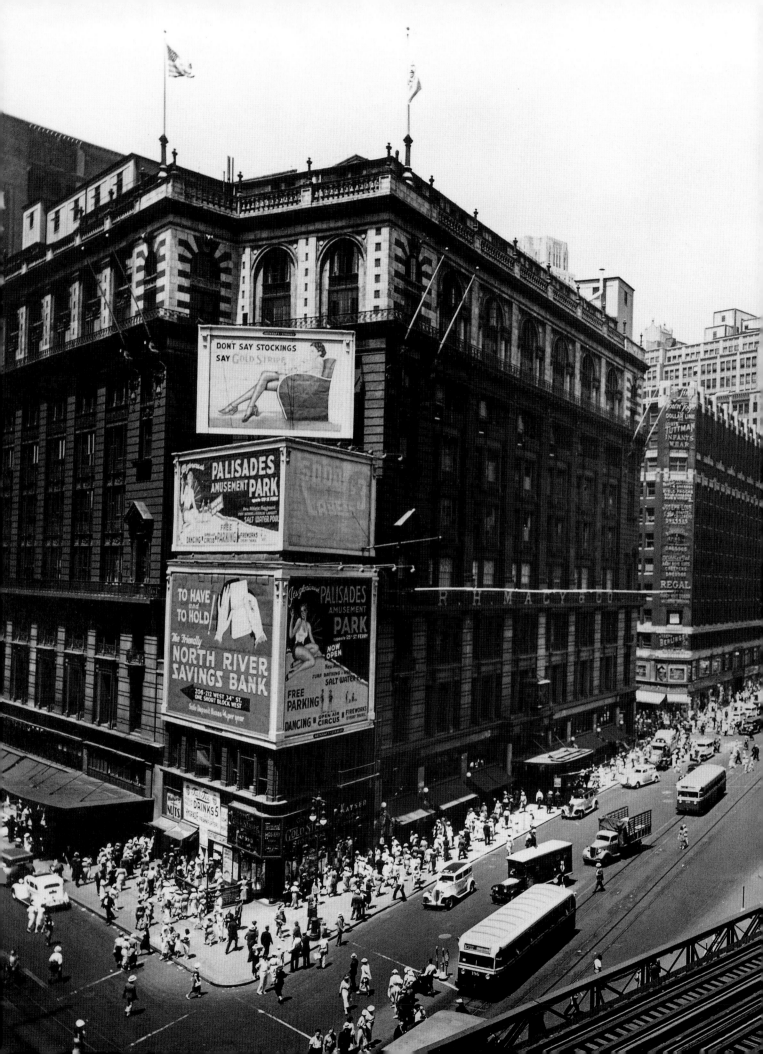

Introduction

In its July 1928 issue, the American design maga-
zine *Arts & Decoration* announced a home study
course entitled "The Modern Movement in Interior
Decoration" (fig. I.1). The course, consisting of six
lessons prepared by Paul T. Frankl, was intended to
enlighten the reader about modern design, which
had "penetrated into almost every hamlet in
America."[1] On August 11, 1928, *Women's Wear Daily*
inaugurated a column entitled "Home Furnishings
= Modern Art." In September 1928, *House &
Garden* promised its readers that the magazine
would help them keep their heads above water in
the "tidal wave of Modernism."[2]

While the press may have been indulging in a
bit of hyperbole regarding the impact of mod-
ernism in America in 1928, the advertisements
nevertheless demonstrate that the movement was
perceived as an important force in design. This per-
ception is especially noteworthy in light of the fact
that just four years earlier the United States had
declined the invitation of the French government
to participate in the *Exposition Internationale des Arts
Décoratifs et Industriels Modernes* held in Paris in 1925.

At the time of the Paris Exposition, American manu-
facturers were neither interested in nor capable of
participating in a world's fair that was limited to
"artistic and original objects" that were "well adapted
to the different uses and conditions of modern life."[3]

In New York, by 1928, public interest in mod-
ern design had been fostered by exhibitions that
were held by the Metropolitan Museum of Art,
department stores, and designers' groups, some-
times working in concert.[4] The department store
exhibitions assume particular importance in the
history of modern design in the United States
because they introduced a broad spectrum of the
New York public to a wide variety of modern
design and gave commercial credibility to the mod-
ern movement.

The series of major exhibitions began with the
Exposition of Art in Trade mounted by R. H. Macy &
Co., in May of 1927 (fig. I.2). The substantial press
coverage given the exposition was due in part to
the merchandising savvy of Macy's management,
and in part to the validation given the exposition
by the Metropolitan Museum of Art. Robert W. de

The Modern Movement
in
Interior Decoration

IN SIX EASILY MASTERED LESSONS

These six lessons will give you a complete mastery of every phase of this modern movement so that you will be qualified to distinguish between what is truly modern and what is mere sensationalism; how to apply this knowledge in the decoration of your own home or in a professional capacity as decorator of private residences, business offices and, in fact, wherever the occasion requires decoration in the modern manner.

Corner of Living Room of the Author

The Scope of the Lessons

Lesson 1—What is Modern?

Lesson 2—Fundamental Idea of Modern Decoration.

Lesson 3—Modern Styles as Expressed in Fabrics and Color Combination.

Lesson 4—Modern Furniture and Its Setting.

Lesson 5—The Spirit of Modern Art in Business— Window Display and Store Decorating.

Lesson 6—Combining the Modern with Other Styles.

This course presents the only comprehensive and authoritative home study course now available covering the subject of the Modern Movement as applied to interior decoration and related subjects

THE PERSONAL WORK OF *Paul T. Frankl*

The entire Course is the work of Paul T. Frankl one of the leaders of this movement in America, a practicing decorator of distinction and a designer in the modern spirit of the highest calibre.

An interesting booklet and full details of how you may take this fascinating home study course will be mailed on request

A special discount of 40% to those who enroll now

ARTS & DECORATION

578 Madison Ave., New York City

I.1 Advertisement. *Arts & Decoration* (July 1928), 91.

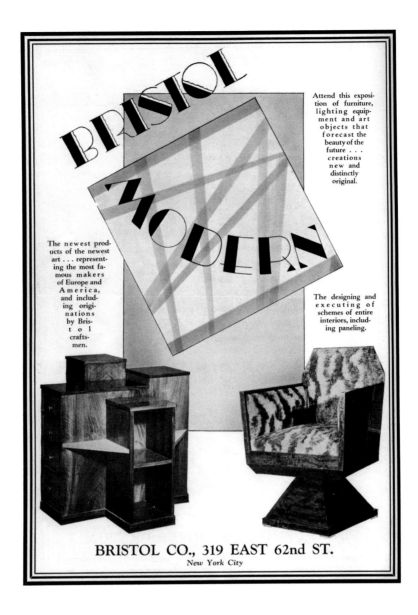

BRISTOL MODERN

Attend this exposition of furniture, lighting equipment and art objects that forecast the beauty of the future . . . creations new and distinctly original.

The newest products of the newest art . . . representing the most famous makers of Europe and America, and including originations by Bristol craftsmen.

The designing and executing of schemes of entire interiors, including paneling.

BRISTOL CO., 319 EAST 62nd ST.
New York City

I.3 Advertisement for Bristol Modern. *Good Furniture Magazine,* (July 1928), 92.

Forest, then president of the museum, served as chairman of the advisory committee for the exposition, which was an outgrowth of a collaboration between Macy's and the museum that began in 1913 in an effort to bring art into everyday life and improve the public taste. The exposition suited the purposes of both the proponents of modern design within the museum and the merchants seeking to expand Macy's markets, as it essentially served as a laboratory to introduce the public to modern design and gauge its response. Macy's gave the museum a mass audience, and the museum gave Macy's artistic credibility.

The 1927 Macy's Exposition was followed by exhibitions at The John Wanamaker Store, Abraham & Straus, Frederick Loeser & Co., Lord & Taylor, and B. Altman & Co. In March 1928, approximately 300,000 people viewed French modern art and design at Lord & Taylor. The following May, some 250,000 people visited Macy's *International Exposition of Art in Industry*, to see more than five thousand objects of modern design created by approximately three hundred exhibitors from six countries.

The department store exhibitions provide a snapshot of early modern design in New York. While there was a great deal of variety, the com-

I.4 Advertisement for Albert Grosfeld, Inc. *Good Furniture Magazine,* (July 1928), 89.

mon denominator was an attempt by artists and manufacturers to reflect the conditions and influences of contemporary life, including tight living spaces, absence of large household staffs, limited budgets, jazz rhythms, cubism in art, skyscraper architecture, and speed. For some, these conditions merely compelled simplicity in design; for others, they necessitated far bolder changes, including designs that embraced the machine ethic, new materials that would be inexpensive to use and maintain, multipurpose furniture and multifunction rooms, and patterns and colors that would reflect life in the twentieth century. In Europe, there were many and varied iterations of modern design. In France, the traditionalists and the rationalists adopted two totally different approaches, as did the futurists and the novecento designers in Italy. In Austria, Josef Hoffmann and the artists of the Wiener Werkstatte clung to high-quality workmanship, while in Germany, the artists of the Bauhaus championed industrialization, aligning themselves with Le Corbusier and his followers in a march toward "functional perfection and standardization."[5] American artists drew upon all of these design sources, and modified them to suit American needs and desires.[6]

In 1928, the terms *modern, modernistic,* and *art moderne,* which today conjure up images of different styles, encompassed all of the attempts made to reflect the twentieth century in design. The terms were used interchangeably, one critic or manufacturer favoring one term, another favoring a different one (fig. I.3, I.4).

What was then considered modern design was finally accepted by the New York art establishment in early 1929, when the Metropolitan Museum of Art welcomed the public to its eleventh American industrial arts exhibition.[7] This exhibition, which was intended to reflect current trends, featured new materials in model room settings designed by popular modern architects (fig. I.5, I.6). In this instance, the art establishment was trailing public

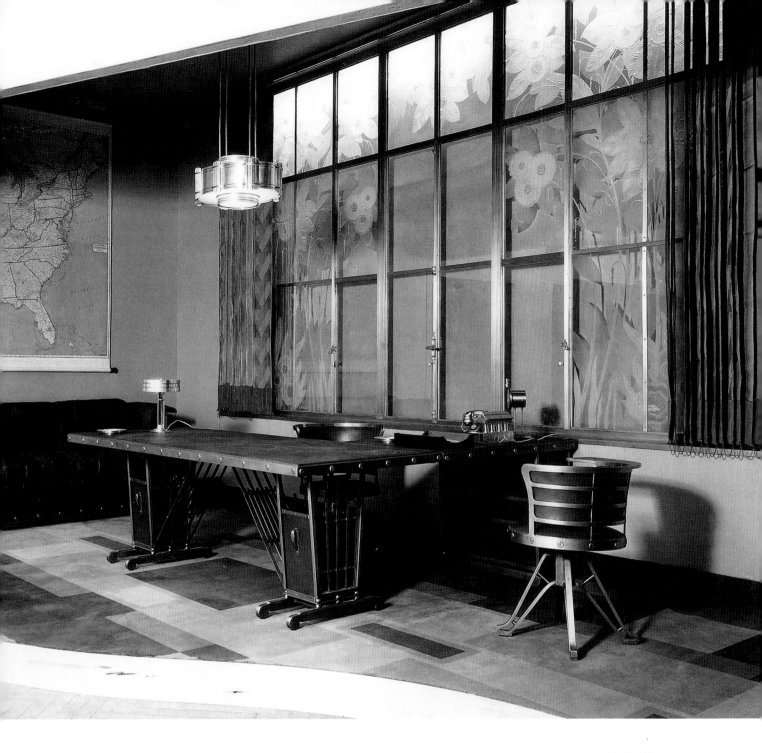

I.5 View of Business Executive's Office designed by Raymond Hood for *The Architect and the Industrial Arts; An Exhibition of Contemporary American Design* at the Metropolitan Museum of Art, 1929. The Metropolitan Museum of Art.

acceptance of modern design, which had been fostered by the department store exhibitions. (fig. I.7)

Given the involvement of the museum in a number of the department store exhibitions, and the generally positive press coverage, the public naturally assumed that modern design, which a few years before had been termed "bizarre" by many commentators, was now to be accepted as being synonymous with good taste, and that no home was complete without some modern element. Without the imprimatur of the museum, it is possible that the exhibitors might not have been as willing to participate, that the press might not have been as positive, and that, as a consequence, the department stores might not have influenced the public in the way they did. Similarly, without the drawing power of the department stores, the museum's efforts to improve design might have been less effective. The department stores and the museum seemed to understand that if they cooperated with each other they could impact the course of design history. The story of these department store exhibitions, and the relationship between the department stores and the museum, could serve as a template for contemporary efforts to improve design.

I.6 View of Bedroom designed by John Wellborn Root for *The Architect and the Industrial Arts; An Exhibition of Contemporary American Design* at the Metropolitan Museum of Art, 1929. The Metropolitan Museum of Art.

METROPOLITAN MOVIES
Trade Mark Reg. U. S. Pat. Off.

"Gee, Bess, you know I'm simply crazy about this new modern furniture. I'm going to get married before it goes out of style"

I.7 Cartoon. *New York World*, 5 June 1928.

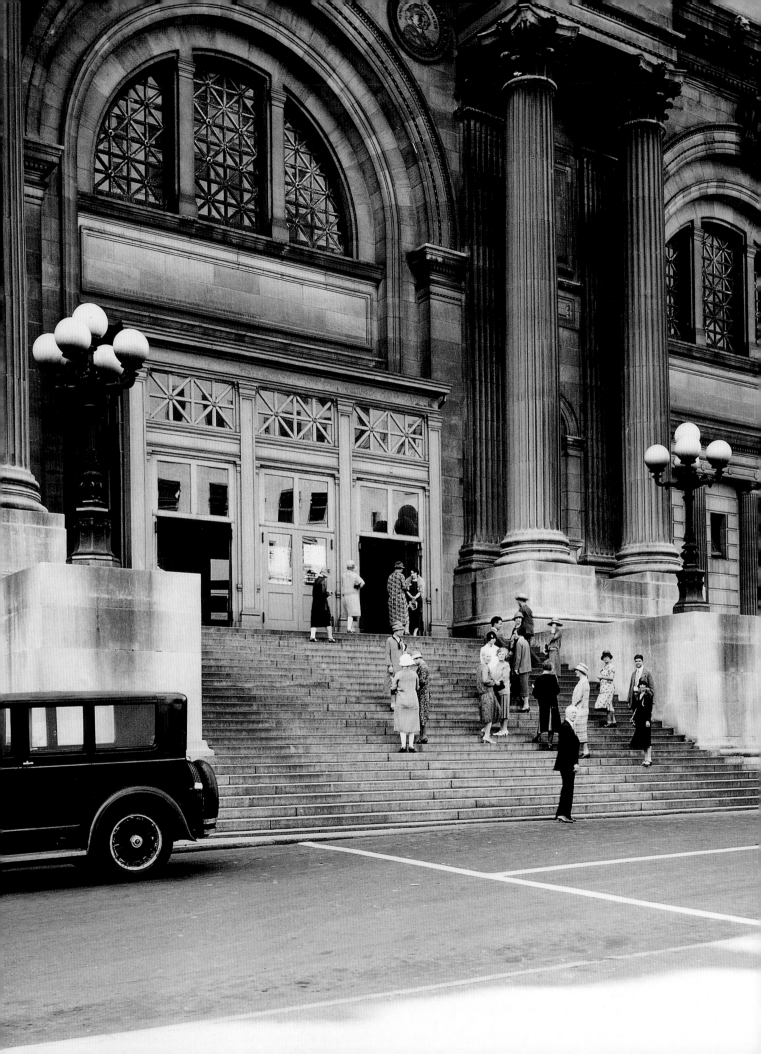

Commerce and Culture Join Forces

One autumn day in 1913, Donald Porteus, Manager of the Bureau of Home Furnishing and Interior Decoration at Macy's, walked up to the information desk at the Metropolitan Museum of Art and asked J. W. Robinson, who was on duty, about the possibility of the museum presenting lectures on period furniture to Macy's employees.

The astute Miss Robinson penned a note to her boss, Henry W. Kent, secretary of the museum, informing him of Porteus' inquiry and explaining that Macy's clerks wanted such a course because they wanted to know more than their customers.[1] Shortly after Kent received the note, he invited Porteus to come to the museum to discuss the possibility of a series of lectures.

Porteus presented an opportunity for the museum to assist department store salespeople and buyers in convincing the public to buy better design.[2] The museum's educational efforts began on a Saturday evening in January 1914, when Charles R. Richards, then director of the Cooper Union, lectured, primarily to department store buyers and salespeople, on French furniture of the seventeenth and eighteenth centuries.[3] During the next three years, the museum instituted several series of lectures on such topics as interior decoration from the eleventh century to modern times, the reproduction of historic furniture, national costumes, lace, jewelry, silversmithing, Italian furniture, pottery, and printed fabrics. It is an indication of the stature of the lecturers, and the importance accorded the lectures by museum officials, that two jewelry lectures were given by Charles Robert Ashbee, the British silversmith who founded the Guild of Handicraft.[4]

By 1917, the lecture series had become so popular that the museum hired Grace Cornell, a professor at Teachers College, to conduct four seminars on Saturday evenings "to show how to recognize good color, good line, and the other qualities that give value in art."[5] Cornell added a series of ten Sunday-afternoon seminars for approximately fifteen buyers, salespeople, and designers from a number of department stores. This course required the students to register for the series, attend regularly, and participate in the classes.

During the autumn of 1918, the museum added a series of Friday-morning lectures. This Friday series, which was to become a regular part of the museum's educational efforts, was significant because the participants were given time off from work to attend. In a 1926 review of the educational work of the museum, Richard Bach, associate in industrial arts at the museum, praised the merchants for their decision to grant their employees this benefit. In the same review, Percy Straus, then vice president of Macy's, opined that in holding classes for buyers, the Museum had done its duty to improve the public taste, and that it was "now up to the merchants to express full appreciation of this service by taking advantage of it increasingly."[6]

From 1918 onward, the museum held both Friday-morning and Sunday-afternoon classes. By 1922, more than one hundred "practical workers" were participating in the Sunday study-hours, forcing the museum to allocate more space to the program. Salespeople from Macy's, Lord & Taylor, James McCreery & Co, Bonwit Teller & Co., and Best & Co. attended the Friday-morning series. The December 1922 *Bulletin* of the museum announced that in response to requests by Abraham & Straus of Brooklyn and Macy's, the museum would schedule four special series for their executives, buyers, and assistant buyers, but that the museum had to turn down other requests for special courses because Grace Cornell's time was fully committed.[7]

Macy's executives welcomed the Museum's lecture series as an adjunct to Macy's own efforts to improve the design of the products it carried. Ralph M. Hower, who wrote an exhaustive history of Macy's early years, concluded that Macy's owed much of its success to the way in which it met the public demand for more artistic goods that developed after World War I.[8]

In 1917, the same year the museum hired Cornell to improve outreach to salespeople and buyers, it hired Bach to devote himself "to the needs of manufacturers, dealers, designers, artisans, and manual craftsmen in objects of industrial art, and [make] it his business to render accessible to them the resources of the collections." The museum also charged Bach with mounting public exhibitions of objects that derived from museum study.[9]

In a discussion of the early history of the muse-

um's exhibitions of industrial art, Christine Laidlaw credits Robert de Forest and Henry Kent with fostering the museum's interest in industrial art.[10] They saw the museum's collections as fertile ground for designers, and de Forest, in particular, had a passionate belief that art should pervade every object in the home, and that good art need not cost any more than bad art.[11]

In furtherance of the goal of improving design, the museum established study rooms in which designers had access to objects that were not on display, and in 1917 it mounted its first exhibition to demonstrate "the application of arts to manufactures and practical life," entitled *The Designer and the Museum*.[12] The guidelines for the first exhibition specified that the objects, which could be reproductions or adaptations, had to have been made in America that year and inspired by an object in the Metropolitan's collection.[13] The third exhibition, mounted in 1919, discouraged reproductions (fig 1.2).[14] The next several exhibitions-in 1920, 1920-1921, 1922, and 1923-reflected this new policy, and gradually increased the focus on objects that could be produced in some quantity.[15] The fifth annual exhibition in 1920-1921 was the first in which the term "American industrial art" was used in the title.

For the eighth exhibition, held in 1924, the museum did not require that objects be based on or inspired by museum collections. Instead, they had to be of the highest standards of design, designed and made in the United States during the previous year, examples of "quantity design," representative of the regular work of the exhibitor for some part of the period covered by the exhibition, and exhibited by the manufacturer or firm responsible for the design.[16] Items of "quantity design" were defined as pieces made from the same design, or identical pieces made from the same models, molds or drawings.

The exhibition catalog expressed the museum's view that "the hope of industrial art design lies in America, that our manufacturers and designers have not only the technical but also the artistic ability to produce objects of applied art of high type, especially on the basis of 'quantity production,' which is the only basis calculated to meet the requirements of current life."[17] In the catalog, Bach explained that the requirements for the exhibitions were changed

because the earlier exhibitions had demonstrated the value of the collections to designers and manufacturers, and it was time to modify the admission requirements so that the exhibitions would create "an annual record of the status of design in America."[18] The change in admission requirements for the more than eight hundred objects on display in the eighth exhibition seems to have represented a shift from a museum-centric view of the design process to one that recognized that "good design" need not be based on historical models.

Bach's comments about the tenth annual exhibition, held from December 4, 1926, through January 5, 1927, hint at a certain frustration with the recently revised purpose of the exhibitions (fig. 1.3). He saw the market as slowing progress toward good design, because "in the field of manufacture…convention will always rule. Large bodies move slowly, large investments and accepted equipment are not lightly turned to untried ways, however plausible or alluring."[19]

Elsewhere in the museum, the public was able to see contemporary European design. On February 22, 1926, the museum opened *A Selected Collection of Objects from the International Exposition of Modern Decorative & Industrial Art*, an exhibition of four hundred objects selected from the 1925 Paris Exposition by Charles Richards for the American Association of Museums (figs. 1.4 and 1.5). The collection, which toured eight American cities, including Cleveland, Ohio, brought together European furniture, metalwork, ceramics, textiles, and other works of decorative art loaned by the artists or manufacturers, all in the "modern style."[20]

At the same time, the Metropolitan Museum dedicated one of its galleries for the display of its permanent collection of modern decorative arts. The exhibition of the Museum's collection, which included works by Louis Süe and André Mare, Jacques-Émile Ruhlmann, Armand Rateau, and Jean Puiforcat, was intended, in part, to demonstrate that the museum had been collecting works by the masters of modern design for some time.[21]

Bach cannot have been immune to the excitement generated by the European modern design being shown at the museum. In an article written in 1927, he again expressed his frustration with the state of American industrial arts, railing against the

1.4 View of objects displayed at the Cleveland Museum of Art as part of *A Selected Collection of Objects from the International Exposition of Modern Decorative and Industrial Art*, exhibited in Galleries IX and X, April 2-20, 1926. (c) The Cleveland Museum of Art. The display in the center features a suite of furniture by Armand Rateau.

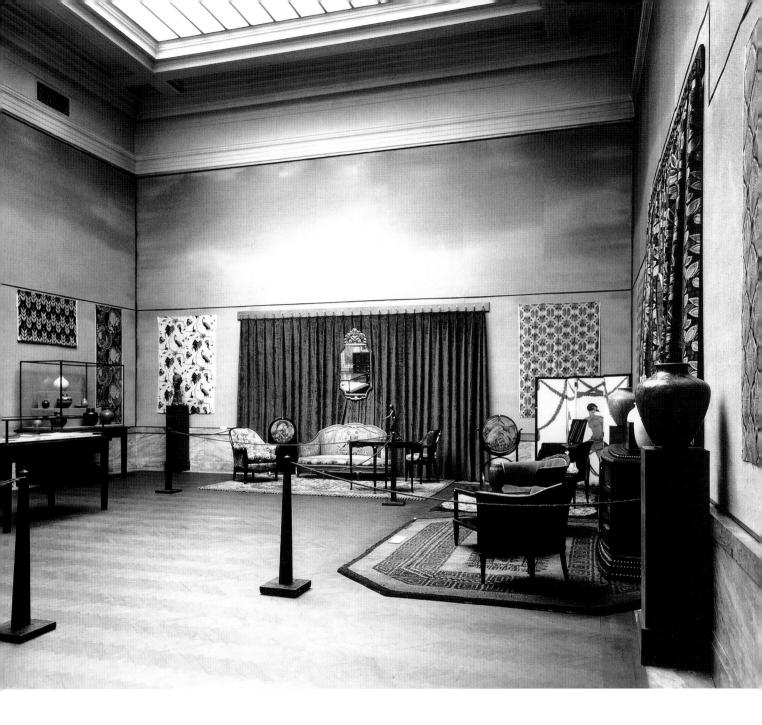

1.5 View of objects displayed at the Cleveland Museum of Art as part of *A Selected Collection of Objects from the International Exposition of Modern Decorative and Industrial Art*, exhibited in Galleries IX and X, April 2-20, 1926. (c) The Cleveland Museum of Art. The display in the center features a suite of furniture by Süe et Mare.

"conspiracy against public taste" that had caused the industrial arts to become "a lame muscle in an otherwise healthy working arm." Blaming the manufacturers, dealers, schools of design, and the purchasing public for the sorry state of the industrial arts, he prescribed a course of cooperation among all the parties to treat the malady. He exhorted each manufacturer to support schools of design and "grant his designers time on pay to study their current problems in terms of the best sources in nature and in museums and libraries." He asked dealers to take action to improve design, such as offering some well-designed items, even if they did not produce a profit. While Bach did not denigrate the role of schools in educating the public on matters of taste, he believed that the "shorter route" to improved taste was "through the manufacturer and dealer, relayed to the ultimate consumer in concrete form in the objects of industrial art which he buys and uses."[22] Bach desperately wanted to do something to increase the pace of progress in American industrial design.

The frustration expressed by Bach was also felt by Macy's executives, who were not satisfied with their efforts to induce manufacturers to improve their designs. In March 1927, this frustration, together with Macy's long-standing relationship with the Metropolitan Museum, led Edwin R. Dibrell, Macy's director of publicity, to propose to Henry Kent that the Museum mount an exhibition of "art in trade" at Macy's, which was "prepared to offer all its facilities in cooperation." The exhibition would "demonstrate the influence of a museum in promoting good taste in merchandise" to "a circulation which is not available to the Museum because of its location." Dibrell suggested an exhibition of glass, furniture, fabrics, toilet articles, jewelry, rugs, tableware, silver, apparel, and accessories, all in an environment "planned by a designer of high rank who would be able to achieve a unified scheme into which each of the exhibits would fit as an organic part." Macy's promised not to commercialize the exhibit, and offered to "exploit the exhibition fully," in order to promote higher standards of good taste. Macy's efforts would include arranging addresses by numerous design luminaries and mounting a major publicity campaign.[23]

On March 10, 1927, Henry Kent communicat-ed to Dibrell the museum's interest in the proposed exhibition, which had already been approved by Macy's management.[24] Kent offered the museum's cooperation in an exhibition to be held at Macy's, and under Macy's name, particularly with respect to the character of the exhibits and the lectures to the public. The museum would not, however, take any role in assembling the exhibits, approaching the manufacturers, or installing the exhibits.[25]

Robert de Forest agreed to accept the chairmanship of the advisory committee in April, based in part on Dibrell's assurances that there would probably be only one meeting and that the committee would have a limited role in the exposition.[26] Macy's management promised the Museum that the exposition would serve dual purposes: "First, to demonstrate the influence of accepted standards of the past upon modern design and color; second, to stimulate a greater public appreciation of the importance of good design and style when applied to objects of every day use."[27] The first purpose demonstrated Macy's desire to show its respect for the museum and its collections; the two purposes taken together would seem to reflect a growing sense in both the merchant and artistic communities that modern design could also be good design.

Macy's hired Lee Simonson, a prominent New York stage designer, to be art director and designer of the exposition. To organize the exposition, Macy's tapped Virginia Hamill, a New York stylist who had headed Lord & Taylor's first antique department.[28] Hamill's emphasis in the Macy's Exposition would be "placed on creative design, eliminating mere reproductions and facsimiles of historic period design," to demonstrate that "modern art as applied to industry, in the finest examples, is not seeking after the bizarre or extreme."[29] There appears to have been a certain preoccupation with assuring the public that the exhibits were not "bizarre." Macy's executives may have been concerned that if the public, which had not been exposed to modern design to a significant degree, perceived the exhibits as inappropriate to their current mode and manner of living, they would stay away. Macy's added credibility to the exposition by assembling an advisory committee of individuals well respected in the design field. The store also secured endorsements from various public figures,

YOU ARE CORDIALLY INVITED TO ATTEND AN

The
ADVISORY COMMITTEE

Exposition of Art
in Trade
AT MACY'S

from MAY 2 to MAY 7, 1927

The PROGRAM

EVERY day America grows more wisely critical of the things it buys. There is not only strong feeling for design and color, but irresistible enthusiasm for real beauty in objects of everyday use.

Macy's, in contact with the millions, is keenly sensitive to this demand. To mark the upward progress of public taste, Macy's opens this Exposition of Art in Trade.

In a dramatic setting, contrived in the modern spirit, we have given an entire floor of our new West Building to show actual exhibits of modern products, each chosen to illustrate the new alliance between industry and art.

A famous craftsman shows grillwork, a metal-worker shows lamps inspired by primitive torches, a great weaver adapts brave modern motives to glowing silks; the plain utility of household glass and pottery is here transfigured by color and design; examples of fine printing and bookbinding mark the influence of art on the printed word; so, too, in silver, rugs, in furniture and jewelry, you will see here the inspiration, the adaptation, and the final product.

The Metropolitan Museum of Art, in accordance with its policy of extending help and advice to all American industry in the cause of the furtherance of good taste and art in modern life, has been most generous with suggestions and advice in the preparation of this exposition.

Interesting and authoritative guests will speak daily in the special auditorium of the Exposition. Their addresses will be broadcast from Station WJZ every day at the hours listed in the program.

Most convenient entrance to Exhibit, 151 West 34th Street
Take special Exhibit elevators to Fourth Floor

EXPOSITION ON THE FOURTH FLOOR—WEST BUILDING

1.6 Advertisement. *New York Herald Tribune*, 1 May 1927.

including Herbert Hoover and New York City Mayor James J. Walker.

Using information supplied by Macy's, the major New York newspapers wrote articles about the Macy's Exposition the weekend before it opened.[30] On April 27, *Women's Wear Daily* reported that Macy's had mounted the show in order to "dramatize the varied influences of the fine arts upon our daily lives," and to "portray the application of modern, classic and primitive art to objects of everyday use, the modern note predominating."[31] On May 1, the *Brooklyn Daily Eagle* noted that one of the purposes of the exposition, which would "show a definite creative spirit," was to "point out the inestimable value of museum collections toward furthering creative expression in the decorative and industrial arts."[32] Macy's had apparently made it clear to the reporters that it would neither sell merchandise at the exposition nor exploit the exposition through the sale of any kind of merchandise, so the press accorded the exposition the respect that would be due a museum show.[33]

Macy's also advertised the Macy's Exposition heavily in the press. As an advertisement from the *New York Herald Tribune* makes clear, the commercial establishment (Macy's) was relying heavily on its relationship with the cultural establishment (the museum), to attract the public and to convince both the visitors and the critics that they were seeing something of great importance (fig. 1.6).

2

The 1927 Macy's *Exposition of Art in Trade*

Fueled by Macy's publicity campaign, the *Exposition of Art in Trade* officially opened at 11:30 A.M. on Monday, May 2, 1927, to great public interest. Macy's had printed 30,000 copies of a *Catalog of the Exposition of Art in Trade at Macy's*, which referenced the Metropolitan Museum of Art on the cover page. The catalog listed the more than one hundred exhibitors, as well as the members of the advisory committee and the speakers for the program of lectures to be given daily and broadcast on "The Metropolitan Museum of Art Show" on radio station WJZ.

In a 25,000-square-foot auditorium seating six hundred, constructed especially for the Macy's Exposition, Percy Straus greeted the many invited guests. In his remarks, Straus credited the museum with "exerting a powerful influence on the development of an art which shall be typically modern and American." Straus thanked the museum for help in arranging the exposition, and attributed much of the success of Macy's "outstanding departments," such as the furniture department, to the assistance given the store by the museum over many years.

Finally, he noted that the American public was developing an artistic consciousness, which, he argued, challenged American retailers and manufacturers to improve their wares.[1]

Robert de Forest responded to Straus's kind words by praising the department stores in general, and Macy's in particular, for their role in fostering the development of art. He expressed his belief that department stores could exert a wider influence than art museums because salespeople could influence consumers to purchase affordable artistic objects.[2]

Emerging from these reports and statements is confirmation that the partners in the 1927 exposition had different goals. The museum wanted to demonstrate, to a broader public than it was able to attract, the importance and feasibility of good design. Macy's wished to increase sales. They were not at cross purposes, however, because good design was increasingly being associated with modernism, and modernism would sell, if it was perceived as being in vogue, because most New Yorkers did not have it in their homes. Neither the museum nor

2.1 View of backgrounds of the 1927 Macy's Exposition. *Journal of the American Institute of Architects* 15, No. 7 (July 1927), 233.

Macy's wanted to alienate the public with "bizarre" items, so it is not surprising that the objects displayed represented the more conservative end of modernism.

In designing the exposition setting, Lee Simonson tried to demonstrate that art could and should be simplified, in order to be produced in sufficient quantity to enable many people to purchase it at reasonable prices.[3] In accordance with this theme, Simonson designed plain backgrounds, but added interest by incorporating angles into the plan and by using materials of different colors and textures (fig. 2.1).

For the facades, Simonson chose some natural building materials, including unfinished American redwood, and some manufactured products, such as

cork substitute, rubber finished to imitate marble, imitation stone, and a combination of paint and plaster known commercially as Craftex. He used the synthetic materials because they yielded a broad range of colors and surfaces and reflected his belief that society should utilize designs that a machine could produce. In Simonson's view, the surface and color interest of the synthetic materials would replace the handmade ornamentation that had become increasingly expensive.

Because Simonson believed that an exhibition visitor literally had to be cornered in order to focus on the objects displayed, he incorporated angles of 45 and 60 degrees to establish "pockets" in which visitors would have to focus on a small number of the many objects on display (fig. 2.1). He cited his

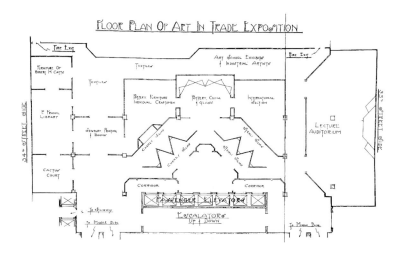

FLOOR PLAN OF ART IN TRADE EXPOSITION

2.2 Plan of the 1927 Macy's Exposition. Courtesy of Macy's East, Inc.

2.3 View of the central court of the 1927 Macy's Exposition. "Art in Trade Exhibit Suggest Novel Shop Interiors," *Women's Wear Magazine* (20 June, 1927), p. 40.

design for the Macy's Exposition as an example of how an architectural treatment could force the visitor to "listen to the still small voice of his personality and the reaction of his own taste"[4] (fig. 2.2).

Writing for the *Brooklyn Daily Eagle*, Helen Appleton Read asserted that the setting of the exhibition added to its importance. She contrasted the Macy's settings with the settings designed for the Metropolitan Museum's exhibitions of industrial art, which she characterized as "dull and lifeless, this largely due to the cold, cheerless hall where the exhibitions were held and which allowed for no beauty or originality of display."[5]

The 6,000 opening-day visitors exited the Macy's elevators into a court that featured a fountain of hand-beaten copper, a wrought-iron grille,

and two portals by Oscar Bach, with iron motifs representing woodland scenes[6] (fig. 2.3).

One portal led to an exhibition of silks produced by the Stehli Silks Corporation; the other opened onto an exhibition of silks produced by Cheney Brothers. The Stehli silks included "Moth Balls and Sugar" (fig. 2.4), and Cigarettes and Matches" (fig. 2.5), both developed from Edward Steichen's photographs of unusual combinations of common objects, The designs emphasized Steichen's use of contrasts between strong light and deep shadow to create a three-dimensional effect.

Stehli also displayed designs that reflected the frenetic pace of twentieth-century life, including "The Stadium," by Rene Clarke (fig. 2.6), and "Accessories," by Helen Dryden (pl. 1).[7]

2.5 Stehli Silks Corporation. "Cigarettes and Matches." The Metropolitan Museum of Art, Gift of Stehli Silks Corporation, 1927. (27.149.2)

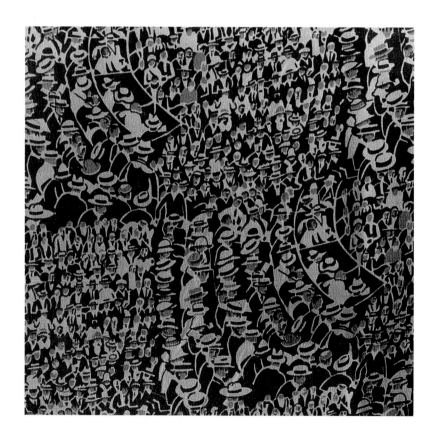

2.6 Stehli Silks Corporation. "The Stadium." The Metropolitan Museum of Art. Gift of Stehli Silks Corporation, 1927 (27.249.13)

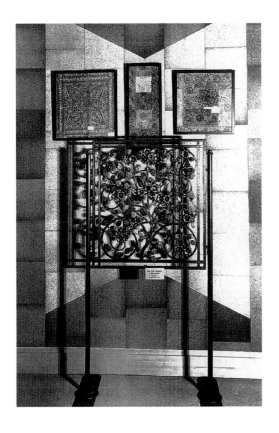

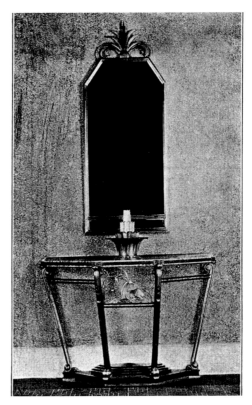

The Cheney silks were arranged to show the source of design as well as the finished work, thus emphasizing the importance of museum collections in the creation of industrial art. *Women's Wear Daily*, which described the exposition as "a modern art museum [that] has been reproduced on the fourth floor of R. H. Macy & Co., Inc.," praised the textile designs, and commented that the exhibition depicted "the influence of modern art tendencies on merchandise as they affect modern life."[8] The Cheney exhibit included a stained-glass window, a painting by Raoul Dufy, and two fire screens by Edgar Brandt, one of which is shown in figure 2.7.[9]

Many of the textile designs were inspired by everyday objects, abstracted and fragmented in a reflection of the cubist movement that was already on the wane in Europe. These designs were to some degree a harbinger of the exhibits that would follow; in general, the objects displayed in the New York department stores were derived from European designs developed years earlier. The wrought-iron console and mirror by Kantack & Co. that stood in the textile gallery (fig. 2.8) might well

have been included in the 1925 Paris Exposition, which is not surprising, as Walter Kantack had been a member of the delegation appointed by Herbert Hoover to visit that exposition after the United States decided not to participate.[10] Similarly, the console by Jules Bouy strongly resembled pieces that Edgar Brandt and Raymond Subes had been designing for years (fig. 2.9).

Europe and America were represented in the galleries that held European and American silver, pottery, china, and glass. *Women's Wear Daily* cited the glass of Maurice Marinot for its combination of strength and fragility. *The Upholsterer and Interior Decorator* applauded the "superb examples of silver" offered by International Silver.[11] The graphic arts were also represented by books, book plates, bindings, posters, trademarks, and "an extraordinary binding by Pierre Legrain of Oscar Wilde's 'Two Tales.'"[12] Corning Glass Works, Orrefors, Cowan Pottery Studio, Hunt Diederich, and Henry Varnum Poor were among the exhibitors in these galleries, from which visitors walked into a modern library by Paul T. Frankl (fig. 2.10).

The Frankl room was described by *Good Furniture Magazine* as follows:

> The most impressive of [the model interiors] was perhaps the modernistic library of Paul Theodore Frankl, who demonstrated here most effectively, his ideas of the so-called 'skyscraper' furniture of today, of which he is a most enthusiastic sponsor. Here, against a background of California redwood was grouped a most extraordinary arrangement of library fittings, with huge, towering bookcases reaching ceiling-ward in a series of set-back terraces, a desk set sidewise against the wall, its upper part against a mounting series of compartments, and a large and most modern library table. In contrast to the skycraping lines of the bookcases and desks, the chairs were strikingly low, and covered with brilliant shades of Morocco leather in bright reds and blues. In this room, as in the entire exposition, the lighting effects were most original, making use of indirect methods, the light units being shaded with a series of planes and angles in various materials.[13]

There were other furniture groups in the exposition, but Frankl's suite garnered most of the attention. The critics may have found some of the other furniture, like the bedroom suite by Jules Bouy pictured in figure 2.11, less striking than Frankl's.

Also, some of the furniture, like a large oval table by John Helmsky, Inc., had been seen before and so may not have been deemed worthy of comment. The Helmsky table had been featured in the Metropolitan Museum's tenth annual industrial arts exhibition (fig. 1.3).

The excitement generated by the exposition was manifest in the attendance. In order to accommodate the crowds and allow its employees to view the exposition, Macy's kept the exhibit open on Thursday and Friday until 10 P.M.[14] Merchants from other cities also came to visit, and indicated an interest in carrying out similar exhibitions in their stores. Macy's was praised for allowing the public to be "in convenient and friendly touch with artistic objects of intimate concern" but with "no circulars, no salesmen, no suggestion of advertising."[15] In essence, the exposition combined the best of both the museum world and the world of commerce: visitors could view objects of quality in a setting that neither intimidated them, as a museum might, nor imposed on them, as a store otherwise might. By the time the exposition closed, approximately 50,000 people had seen it. The *New York World* reported that as they were closing the exposition, management indicated that more shows might follow, in order to keep the public "informed of current progress by designers in linking art with everyday household life."[16]

The attendance was probably boosted substantially by the continuing news coverage of the lecture series. On the afternoon of the opening, Bruce Barton, an author and artist, described the emergence of a focus on craftsmanship and beauty as an outgrowth of a reaction against the Puritan tradition in American art that had repressed beauty as a manifestation of frivolity.[17] Barton was followed by Richard Bach, who likened the modern store to a museum, and told the public that "there is just as much art in your rug or your doorknob as in any oil painting in the Met."[18]

Throughout the week, prominent New Yorkers held forth on the state of the decorative arts. Neysa McMein, an artist, commented on an improvement in public taste and discussed the use of her art work for women's apparel designs.[19] Mrs. George Palen Snow, fashion editor of *Vogue*, predicted that those who visited the exposition would develop a taste for the finer things in life. Alon Bement stated that "the nation was on the verge of a renaissance in art and industry was responsible for the situation as the patron saint of art."[20] Paul Frankl, contemplating the seemingly inherent contradiction between the complexity of modern life and the move toward simplicity in modern design, explained that "we do not desire to have the complexity evident; we like to conceal the force with which we conquer nature and reduce labor."[21]

In general, the contemporary accounts of the exposition focused more on the fact that it was held in a department store, and the implications of that fact, than on the contents of the show. Occasionally, a critic would single out work to be praised. Repard Leirum of *The New Yorker* commented on the "simplicity and fine workmanship" of the mirror and console by Kantack & Co., a walnut table and chair designed by Alice Bernstein, and a mantelpiece of iron, Monel metal, copper, aluminum, and brass by Winold Reiss.[22] *The Furnishing Trades' Organizer* noted the textiles, including "Helen Dryden's satiric inventory of modern requisites

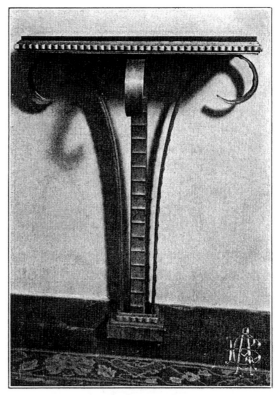

Console by Jules Bouy.

2.9 Console by Jules Bouy. *Upholsterer and Interior Decorator* (15 May 1928),115.

from high hats to taxi-cabs and cocktail shakers, in 'Accessories.'"[23] Most critics, however, focused on the importance of the ideas behind the exposition-that good taste was affordable to all, it should infuse every item in every home, and it was inextricably linked to modern design. The 1927 Exposition demonstrated that a department store exhibit could aid in making these ideas a reality, because it could generate both great interest and excitement in a broad spectrum of the public, and positive press coverage for modern design. According to the *New York World*, the "previous shows of the industrial art order had demonstrated little as to the attitude toward a movement whose merit no one disputed but whose popularity while the museums alone conducted it was of tediously slow growth." In the view of the *World* commentators, "this first venture in a big store, where the show could be seen conveniently and without the effort or formality of a museum visit, proved a winner from the start."[24]

Disparaging the role of the Metropolitan

Museum exhibitions in influencing public taste, Helen Appleton Read asserted that in the United States the department store acted as a "living museum of the industrial and decorative arts, in which the ideas of artist-designers incorporated in furniture, textiles, ceramics, etc., are through mass production, made available to the masses." Read saw the exposition as winning the public over to modern design, thus aiding the effort to force manufacturers to be more creative. She noted with favor the textile designs that were based on artifacts of modern culture, as well as the designs inspired by machinery and man-made objects, all of which she saw as an indication of a growing creativity in the decorative arts.[25]

Read's enthusiasm was echoed by Henry McBride of the *New York Sun*, who saw the exposition as helpful in fostering a continuing improvement in public taste because it was aimed at both the masses and the experts. McBride had some hope for the masses because "the first mad plunge of the working classes into silk pajamas" was over,

2.10 View of Paul Frankl library from the 1927 Macy's Exposition. *Good Furniture Magazine* (June 1927), 326.

and the public had become more selective in its buying habits.[26] Mc Bride made a pitch to manufacturers to hire the best artist-designers in order to provide the best quality in mass-produced goods.

For Margaret Bruening of the *New York Evening Post*, the exposition exemplified a new democracy, providing the public with equal opportunity to possess and enjoy the articles of mass production. The same people who "would not dream of visiting anything so formidable as a museum exhibition of industrial art penetrate boldly in such a display in a department store." Bruening did not expect the process of improving the public taste to be swift, but she saw in the textile displays encouraging signs of creativity.[27]

The commentary on the objects in the exposition indicates the level of confusion surrounding the term "modern" in 1927. While the *Brooklyn Daily Eagle* praised the "modern" design in the show, *Women's Wear Daily* focused on the "simplicity" of the merchandise shown, asserting that "nothing 'modern' or cubistic" was shown.[28] The *Brooklyn Daily Eagle* was impressed by the selection of objects: "The potential buyer comes to understand that the modern note is not something ultra or bizarre. . . but something which has grown out of modern living conditions in exactly the same way in which

modern dress has been evolved."[29]

The 1927 Macy's Exposition was important in several respects. First, as Macy's management had hoped, it convinced at least some manufacturers that modern design would sell. Paul Hyde Donner of Stehli Silks Corporation wrote to Herbert Straus to let him know that the exposition had increased the interest of Stehli's customers in the textiles exhibited, and to express a hope that Macy's would hold more such expositions in the future.[30] Ralph Abercrombie of Cheney Brothers promptly requested a place on the invitation list for the following year.[31] Second, the exposition caught the attention of the critics, and virtually assured press coverage of subsequent modern design shows. Third, it demonstrated to the public that modern design could take many forms, at least some of which might appeal to their tastes and fit into their homes. Finally, it sent a signal to other department stores in New York and elsewhere that modern design, however it might evolve, merited both expenditure of funds and allocation of space; even before the exposition closed, Macy's had sold Lee Simonson's setting to Gimbel Brothers of Philadelphia for an anticipated autumn exposition.[32]

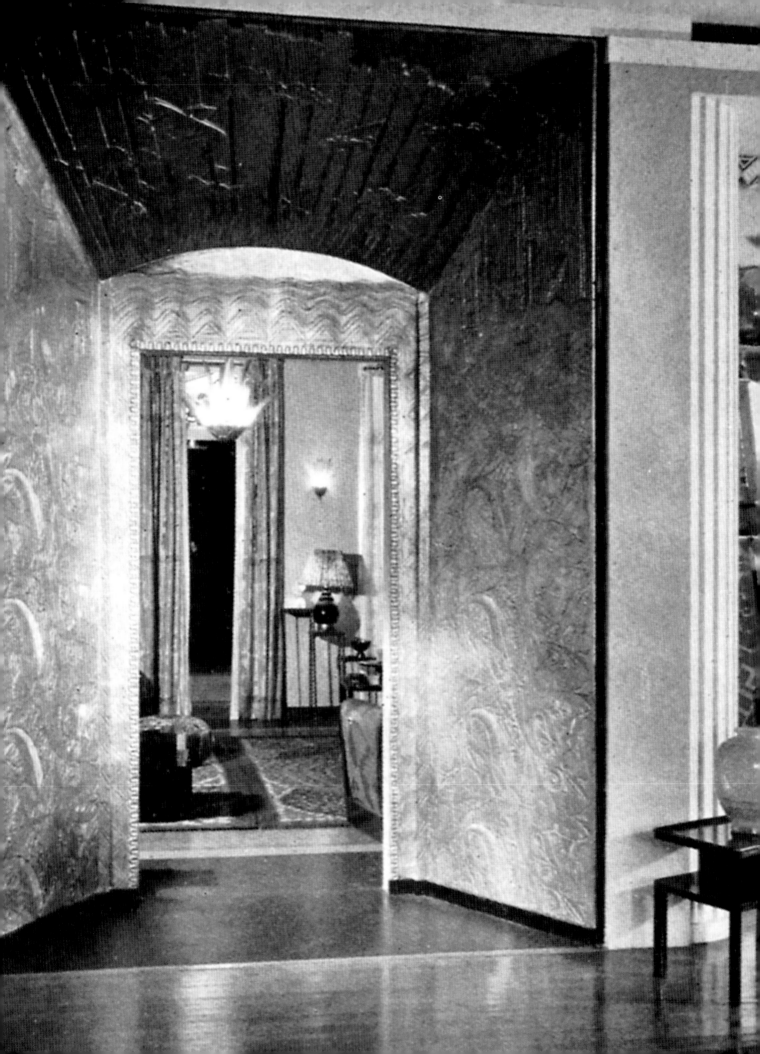

Model Rooms At John Wanamaker and Macy's

"What would it be like to live with this strange, new modern furniture?" [1]

While the next blockbuster exhibition would not take place until the spring of 1928, two exhibitions that opened in late 1927 merit attention, because they demonstrate a continuing focus on modern design, and they illustrate the way in which modern design was developing in New York.

In a discreet advertisement placed in the *New York Sun* on December 10, 1927, The John Wanamaker Store in New York invited the public to visit the "rooms of Venturus," Wanamaker's entry into the world of modern design. (fig. 3.1)

Wanamaker's had no museum partnership in this endeavor, but a number of features of the advertisement indicate that the store was trying to gain artistic credibility for Venturus, including the reference to the inclusion of work by Jean Puiforcat in a museum collection, the statement that Primavera, the design gallery of the Paris department store Le Printemps, was loved by visitors (translation: people of sophisticated tastes),

3.1 Advertisement. *New York Sun*, 10 December 1927, p. 12.

Opposite: 3.2 View of Doorway into Venturus. "Modern Art in a Department Store," *Good Furniture Magazine* (January 1928), 32.

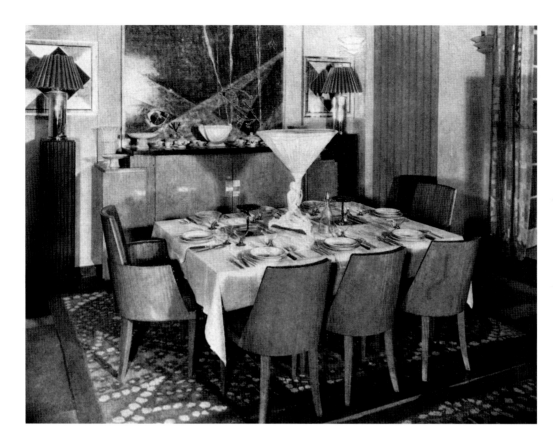

3.3 View of Venturus. "Modern Art in a Department Store," *Good Furniture Magazine* (January 1928), 35.

and the listing of designers and manufacturers that were either well known to the public or well respected by the critics. Wanamaker's chose many such exhibitors, including Lalique, Rodier, Edgar Brandt, Jean Luce, Dominique, Süe et Mare, Hunt Diederich and Henry Varnum Poor.

Like Macy's, Wanamaker's did not show cutting-edge modern design; a number of the items on display had been shown at the 1925 Paris Exposition. The store was rewarded for this conservatism by positive press. *The Decorative Furnisher* praised the practicality of the furnishings, noting that the "the odd, the bizarre, and the stunt piece…have been passed by." Walter Rendell Storey, writing for the *New York Times*, praised the coherence of the design. *Good Furniture Magazine* reported that, apart from some negativity regarding the angularity of some of the furniture, the public reaction was positive, visitors commenting favorably on the sensible designs, the color schemes, and the lighting.[2]

In announcing the opening of Venturus, Wanamaker's explained that its purpose in exhibit-ing the work of major French and American design-ers and manufacturers was to demonstrate how New Yorkers could throw off the shackles of inherit-ed design and "live on frank terms with sun, air, light, cleanliness, and modern conduct" in the pur-suit of health and happiness.[3] Assembled by Paul Chalfin, an architect, the exhibition comprised one large multipurpose room, with additional areas for the display of decorative objects. The room was designed to give an immediate impression of sun, light, and air; from the entranceway itself the visitor could see a series of French doors that were intend-ed to mimic those in a penthouse (fig. 3.2).

The gilded doorway, deeply recessed, was carved with images that characterized the trajectory of decorative art as viewed from the perspective of a twentieth-century artist; fruits and flowers at the base gave way to skyscrapers and airplanes above. The door opened into the large room, rectangular in shape, which was divided into several areas, uni-fied by three carpets in the same colorful abstract floral pattern.

3.4 View of the living area at Venturus. *Good Furniture Magazine* (January 1928), 33.

One end of the room constituted the dining area, with a lemon wood dining ensemble by Primavera (fig. 3.3), similar to one that had been displayed at the 1925 Paris Exposition (pl. 2). In keeping with the contemporary approach to design, geometric forms and intense graining replaced applied ornament as decoration for this furniture. Rodier table linens, in a woven textile with stripes of silver, gold, and beige, formed a backdrop for plain flatware by Puiforcat that had "blunt, uncompromising, geometric outlines."[4]

Across the room, in the living area, a pair of gold, black, and silver doors by Léon-Albert and Maurice-Raymond Jallot echoed the undersea theme of the artwork in the dining area. (fig. 3.4). The doors, which had been exhibited at the 1925 Paris Exposition, provided a dramatic backdrop to the furniture that occupied the living area, including a black-and-white lacquer sofa and a variety of chairs in tan, red, blue, and green leather.

Accompanying the seating furniture in the living area were various tables and bookshelves that drew comment from the critics. Storey singled out the low table of Makassar wood, topped with porpoise skin, shown in figure 3.4, which had slides on two sides that nearly doubled the surface space of the table when extended. He liked the bookshelves, some tall and narrow, some with double-height shelves, which could meet a variety of decorating needs.

The long entrance wall, connecting the dining area and the living area, was enlivened by Primavera wall hangings in a palette of creams and browns (figs. 3.4 and 3.5). To the right of the wall hanging shown in figure 3.5, sat a small table of a type that attracted a great deal of press attention, with supports of tubular steel and removable tops of glass or lacquer. These tables, some of which are also seen in figure 3.6, were appealing in a number of ways. First, they were lightweight, so they could be moved easily for cleaning and used in various places in the room. Second, they were less obtrusive than tables made out of wood. Finally, they were designed to be useful for multiple purposes.

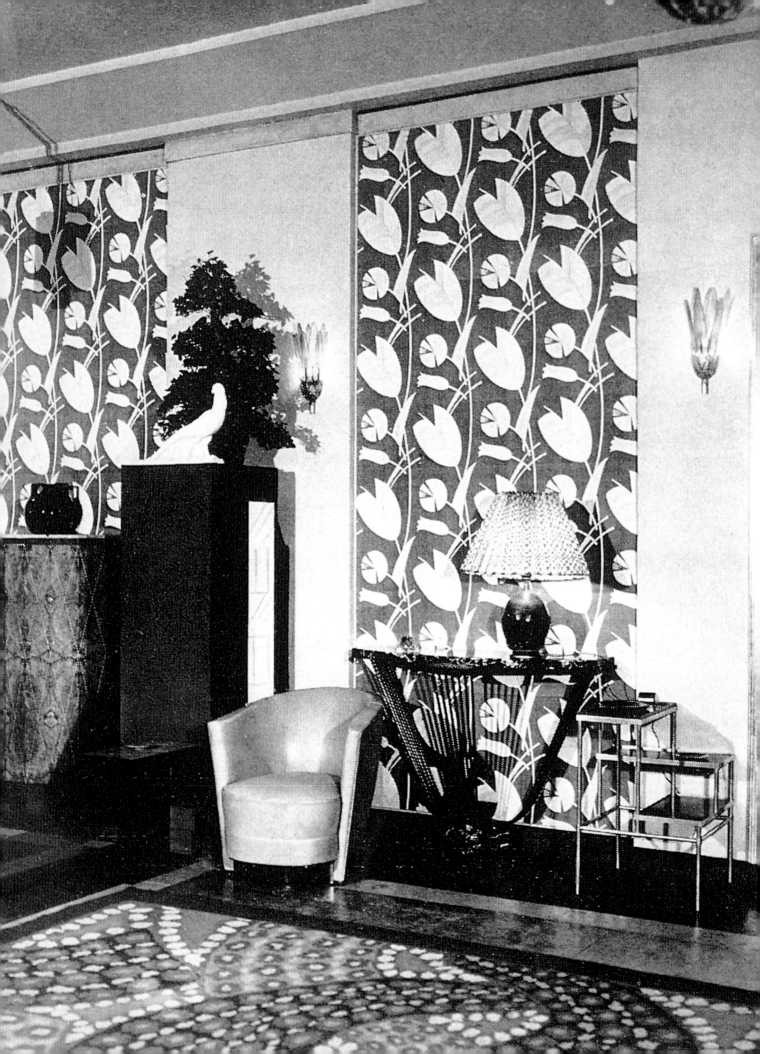

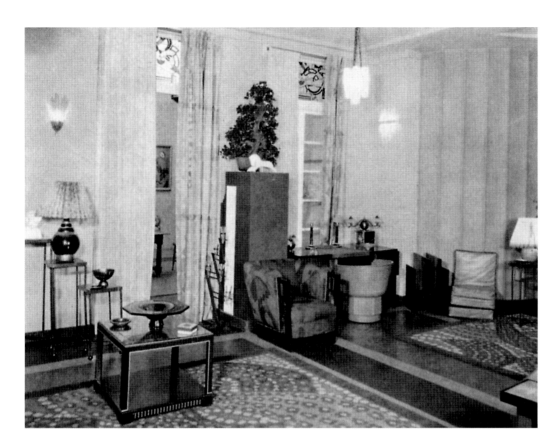

3.6 View of Venturus. "Modern Art in a Department Store," *Good Furniture Magazine* (January 1928), 32.

Small tables of varying heights permitted the placement of objects at appropriate levels, so that a lamp could be placed on a taller table, while a book or a coffee cup could be placed on a shorter one. One table was actually designed with a split circular top so as to accommodate these varied uses in one piece of furniture. The lamps that sat on these tables were not traditional table lamps. Made of polished steel, they were topped with shades of glass or polished nickel with colored lacquer inside.

The other long wall of the large room, across from the entrance, formed a backdrop for a variety of furniture (fig. 3.6). The wall itself was interrupted by three tall French doors, with transoms designed by the American artist Robert Locher, who utilized ground glass, white glass, and enamel paint in fabricating the abstract designs. On each door was a set of damask draperies by Rodier, in a geometrical pattern in peach tones, and a set of liners in natural voile.

The furniture along this wall included the ubiquitous small tables and lamps, a pedestal that held a sculpture and a large plant, and a library suite, encompassing a desk, desk chair, and club chair. Storey singled out the desk for comment, impressed by the fact that the six-foot-long top was supported not by traditional legs but by thin boards at each end, an effect made possible by the development of lamination techniques.

The lighting in the room must have intensified the gleam of the steel lamps, the metal tables, and the polished wood. It was indirect, the bulbs hidden behind frosted or opaque glass. Consisting of overlapping planes, cylinders, and disks, the ceiling and wall fixtures harmonized with the somewhat stark geometric forms of the furniture.

All of these forms reflected the images that New Yorkers viewed every day. Storey deemed it appropriate that the simple furniture and furnishings at Venturus had been inspired by city images, including the steel infrastructure of skyscrapers in process, the concrete masses of the finished buildings, and the play of light on this "towering architecture."[5]

Opposite: 3.5 View of Venturus. *House & Garden* (April 1928), 94. The Condé Nast Publications, Inc.

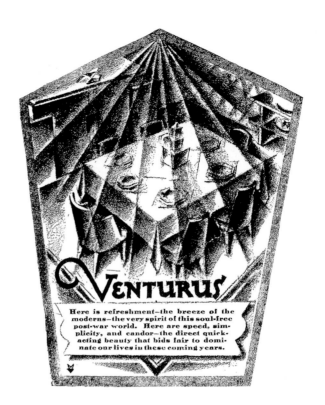

3.7 Advertisement, *New York Evening Post* (11 February 1928), n.p. Courtesy of *New York Post*.

The public reaction to the Venturus exhibition was mixed. Of the objects on display, all of which were for sale, only the smaller pieces and accessories sold well. Lalique glass was very popular, as was the setting on the dining table. According to *Crockery and Glass Journal*, Wanamaker's had determined that the most "modernistic" items were being purchased by "artistic people."[6]

An advertisement placed in the *New York Evening Post* on February 11, 1928, showcases Venturus (fig. 3.7), but traditional furniture is shown in other portions of the advertisement, demonstrating that Wanamaker's, like all of the department stores, was hedging its bets, offering both the new and the old in furniture design.

Wanamaker's management must have considered Venturus a success, however, because by December 1928, Wanamaker's had tripled the size of the area allocated to modern design, adding objects by Viennese and German designers to those of the French and American designers represented in 1927. *Women's Wear Daily* reported in December 1928 that much of the modern furniture never reached the display floor, as it was "sold to private

clients from the reserve stocks."[7]

Around the time Wanamaker's introduced Venturus, Macy's mounted a small exhibition that broke new ground by presenting an entire house given over to modern design. This approach enabled the visitor to view the new mode in a unified, coherent whole, rather than as an anomaly among more traditional furnishings (fig. 3.8).

Macy's offered for sale not only the furniture and furnishings in the exhibition, which were made in France to designs approved by Macy's, but also American-made reproductions, similar to the originals but available at much lower prices. The prices of both the originals and the reproductions were posted outside the rooms, and several critics commented on the affordability of the reproductions.

In the living room (figs. 3.9 and 3.10), the original French furniture was priced at $2,138, the reproductions at $1,311.[8] Rich looking, wine-colored palisander was the primary wood, used for the desk, coffee table, side table, various bookcases, and the frame for the long, curved sofa. The wood was enlivened not by applied ornament, but by short vertical inlaid strips of ivory, that created a

MACY introduces modernistic furniture for the american home

You are invited to visit the
Furniture Department
during these next few weeks to
view the stimulating things which
have been done here with modern furni-
ture in modern settings. Three complete rooms,
living room, bed room and dining room,
that are livable, beautiful, and thorough-
ly in the spirit of contemporary art.

MACY'S — BROADWAY AND THIRTY FOURTH STREET, NEW YORK CITY

3.8 Advertisement, *New York Herald Tribune* (4 December 1927), 19.

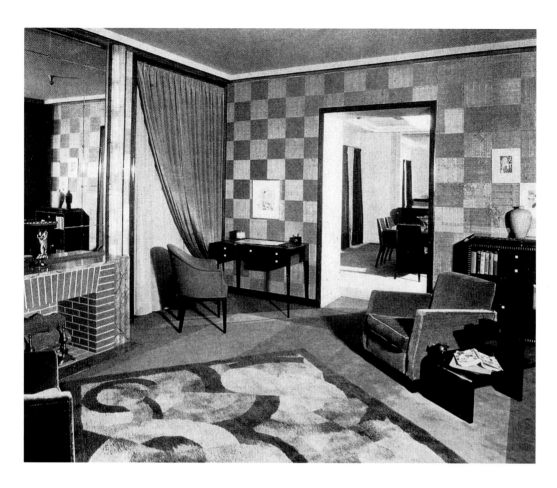

3.9 View of the living room at Macy's. *The Decorative Furnisher* (January 1928), 106.

dentil effect. Ivory was also used for knobs on the drawers of the desk and on the long, low bookcase. The living room furniture embodied some of the elements that were beginning to emerge as characteristic of an American adaptation of European modern design. The furniture minimized care requirements. Dust could not accumulate under furniture that rested on solid bases rather than legs. Nor could it hide in applied ornament, banished in favor of inlay. The top of the bookcase to the right in figure 3.9 had no overhang to harbor those nasty dust particles; a shallow curved molding receded from the body of the piece to the top. A number of critics commented that features like these were necessitated by a postwar diminution in household help.

All of the furniture in the living room was low to the floor, designed to create a sense of space in the small, low-ceilinged apartments of New York City. Even the fireplace mantel was lower than usual, leaving room above for a mirror that

stretched to the ceiling, accentuating the height of the room. The vertical tubular lights and the floor-to-ceiling draperies added to the illusion of spaciousness, as did the relatively small chairs and tables. While these Macy's rooms might seem quite large to a twenty-first-century urban dweller, it is apparent from the press commentary that apartment living had focused attention on ways to make small spaces appear to be larger than they were.

A third goal of the designers appears to have been the creation of a haven from the bustle of the city outside. *Women's Wear Daily* commented on the calming effect of the "soft beiges and rich deep browns."[9] The draperies were a medium-brown heavy silk, with liners in beige georgette. The sofa and the chairs were all upholstered in shades of brown and beige.

This calming color palette might have been boring, were it not for the strategic use of texture and pattern. The varied textures included the silk

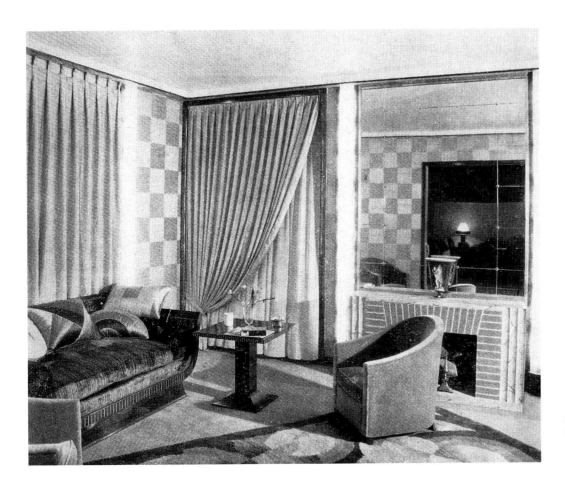

3.10 View of the living
room at Macy's. *The
Decorative Furnisher*
(January 1928), 106.

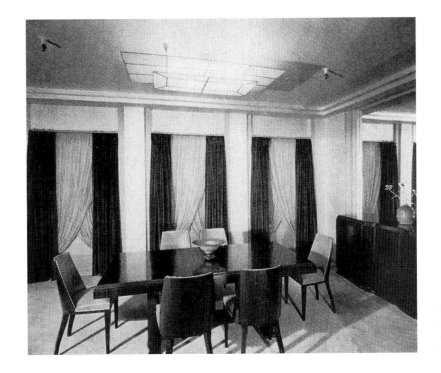

3.11 View of the dining
room at Macy's. *The
Decorative Furnisher*,
(January 1928), 107.

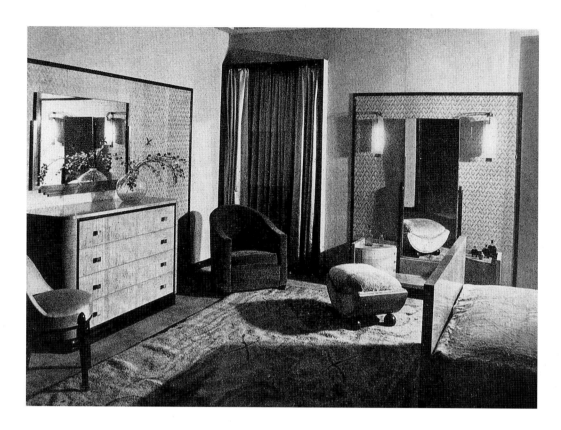

3.12 View of the bedroom at Macy's, *The Decorative Furnisher,* (January 1928), 107.

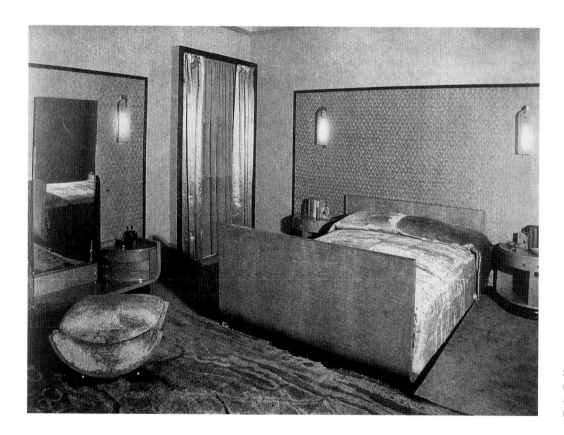

3.13 View of the bedroom at Macy's. *Good Furniture Magazine* (January 1928), 31.

of the draperies, velvet on the sofa, broadcloth on the desk chair, and mohair on the square-back chair. The walls were papered to simulate birch bark, laid in a block pattern with alternating grain. Another pattern appeared on the floor; set diagonally on a beige carpet, an area rug in shades of brown and green was reminiscent of a Sonia Delaunay painting. Incorporating both curvilinear and rectilinear elements, the rug appears to have been the feature that tied the various elements of the room together and gave it life.

The dining room at Macy's was formal (fig. 3.11). The palisander dining room set, very similar in design to the set at Wanamaker's, derived its interest from form rather than ornament. The room had a neutral palette, with silver-gray walls, a gray carpet, and brown velvet draperies with gray liners, but there was a focal point: the chairs were upholstered in a bright red leather. A mirror over the buffet stretched to the ceiling, creating a sense of space. The price of the twelve pieces of French furniture in the dining room was $2,449; the reproductions sold for $1,948.

In the bedroom, the dark palisander gave way to highly polished light maple, and the room was further enlivened by "natural" sunlight from tall windows and lights that filtered through columns of frosted glass (figs. 3.12 and 3.13). Panels of pale pink hand woven fabric, enclosed by flat moldings of amber maple, were inserted into the ivory walls. The "futuristic" carpet comprised subtle tones of pink, green, beige, and ivory.[10] Ivory satin draperies were hung over liners consisting of four tiers of pink silk liners, each tier slightly deeper in color than the one above.

There were some similarities between the bedroom and the other two rooms. To create the illusion of spaciousness, the furniture was built low. Vertical elements, like the partially framed mirrors, tall windows, and lighting fixtures, added to this illusion. To ensure that the woman of the house would not have to spend too much time cleaning, the case furniture was set onto the floor, and the plain surfaces derived interest from inlaid strips of amber wood, amber bases, and silver metal drawer pulls rather than applied ornament. The furniture bases were slightly indented to minimize scuffing. To meet the practical needs of the occupants, the chest contained drawers of varying sizes to accommodate various articles of clothing, and the top drawer of the dresser was fitted with compartments for the myriad items of a woman's toilet. To lend excitement to the somewhat restrained forms, the designers again used texture and pattern. Woven fabric was used for the wall panels. A new textile termed "fur plush" covered both the dressing table bench and the bed. Silver lacquer tubing held the mirrors in place.[11]

In the coverage of the exhibition, one begins to see the qualities that most impressed the press. *Women's Wear Daily* praised the livability of the rooms, and the absence of the bizarre and extreme designs that had characterized "much of that which has been shown recently and identified with modern art." *House Beautiful* lauded the adaptability of modern design to apartments and small houses, citing as characteristics of the style the unornamented surfaces, use of pattern and texture, and subtle color palette. *Good Furniture* cited the "hard-headed practicality" that pervaded the exhibit-the comfortable chairs, the sturdy tables, the space-saving dressers and drawers.[12]

This focus on livability and practicality appears to have been a success. *Good Furniture* reported that thousands of visitors had viewed the rooms, and that furniture sales had exceeded expectations. It is not clear whether this report was based on independent analysis or a Macy's press release, but the influential magazine was informing the public, as well as those department stores and manufacturers not yet committed to modern design, that it was a "trend of public taste," and that it would bring profit to those astute enough to join the bandwagon. It would seem that the department stores, at least, heeded the advice. The year 1928 brought five major exhibitions of modern design.

A&S presents for american homes

modern art

made in america

Exhibitions at Abraham & Straus and Frederick Loeser & Co.

In February 1928, while Macy's and Lord & Taylor were amassing large quantities of European modern design for their coming expositions, two Brooklyn department stores looked to American sources to acquaint their customers with the new style, and to demonstrate its livability. Abraham & Straus, owned by another branch of the family that ran Macy's, chose Paul T. Frankl to design a home consisting of five rooms (fig. 4.2). Frederick Loeser & Co. asked William Lescaze to produce two rooms (fig. 4.3). More modest in scale than the exhibitions of their Manhattan counterparts, these two efforts nevertheless enabled the department stores to better understand which aspects of modern design would appeal to New Yorkers.

By 1928, Paul Frankl, who had arrived from Vienna in 1914, was firmly entrenched in New York as a designer in the modern manner, considered by at least one critic to be "one of its few high priests in America."[1] His effort for A&S, *The Livable House Transformed*, was intended by store management to gauge the interest of the public in modern design, which may account for the fact that it

4.3 Frederick T. Loeser & Co., ca. early twentieth century. The Brooklyn Historical Society.

encompassed a variety of furniture forms and color schemes (fig. 4.1).

The large living room, with a sunroom at one end, embodied Frankl's belief that furniture and decoration should reflect the contemporary American spirit (figs. 4.4 and 4.5). It was dominated by one of his signature "Skyscraper" bookcases. Soaring almost to the ceiling, the bookcase mimicked the skyscrapers of New York, which conserved space by building up instead of out. The frame of the bookcase was outlined in black trim on gray lacquer, in furtherance of a Frankl principle that, in "an age of expression rather than concealment," structure should be emphasized. Frankl laid out his principles of design in a series of articles in *Arts & Decoration* in 1928. He preached "(1) simplicity; (2) plain surfaces; (3) unbroken lines; (4) accentuation of structural necessity; (5) dramatization of the intrinsic beauty of materials; (6) the elimination of copying of meaningless and distracting motives of the past."[2]

Other features of the living room fulfilled these principles. The lighting fixtures flanking the fireplace consisted of tall cylinders of ground glass,

girded with steel rings, encasing numerous electric bulbs. The lights on the bookcase wall glowed behind simple circles of glass, superimposed on one another. The lighting fixtures did not imitate the candleholders of the past; they took their inspiration from the geometric shapes of the architecture outside.

The seating furniture reflected Frankl's belief that "the very essence of modernity lies in comfort and livability."[3] The easy chairs, with low, deep seats and loose cushions, were designed with the informal lifestyle of the 1920s in mind.[4] Small tables were fitted with shelves and compartments for handy storage.

Like the Macy's rooms described in chapter 3, the living room at A&S derived its interest from texture and color. The plain surfaces of the tables were lacquered to a high polish, while the unornamented chairs were upholstered in red Morocco leather. Squares of wood veneer covered the walls, and a mirror topped the coffee table. The gray and silver fireplace was set off by a dark carpet, variously described as dark brown, taupe, and grayish black, and by a ceiling painted in deep salmon.

4.4 View of the living room at Abraham & Straus. *Good Furniture Magazine* (April 1928), 174.

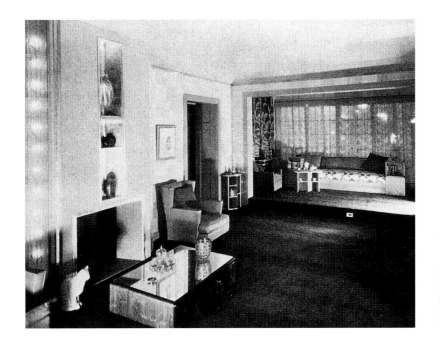

4.5 View of the living room and sunroom at Abraham & Straus. *Good Furniture Magazine* (April 1928), 174.

Above the fireplace, ceramic pieces and Lalique glass gleamed from dramatically backlit niches built into the wall.

Two rooms provided venues for dining-a more formal dining room and a rather whimsical dinette (figs. 4.6 and 4.7). In the dining room, the pedestal table and chairs, devoid of applied ornament, derived their interest from form and texture. The lacquered walnut base of the table contrasted with the lighter top, composed of inlaid rectangles of natural maple. The chairs, also of lacquered walnut, displayed the unbroken lines favored by Frankl, and featured cream-colored calfskin upholstery. The sideboard shown in Figure 4.6 was formed of two pedestal cabinets connected by glass shelves, the uppermost of which was mirrored, to reflect both the objects placed on the sideboard and the silver-framed circular mirror hanging above it. Another cabinet used contrasting woods to outline its structure, in a manner similar to that utilized in the sky-scraper bookcase.

Good Furniture's Nellie Sanford reported that some early visitors to the exhibition thought the dining room was too light in color, formality perhaps being considered synonymous with the dark woods used in the Macy's dining room. The walls in the room were also light, consisting of horizontal stripes of varying shades of yellow in an ombré effect. The only darker element of the room was the window drapery, "of dull blue brocade, in a futuristic pattern."[5]

The dinette, on the other hand, appears to have been a riot of color, with patterned draperies, pillows, and wall hangings. The chestnut chairs, in which Frankl's principle of comfort does not appear to have been implemented, were a study in geometry, with squares and isoceles triangles dominating. The sideboard seems to reflect Frankl's earlier work, grounded in Central European design of the previous decade.[6]

The bedroom and the boudoir, like the dining room and the dinette, appear to have been

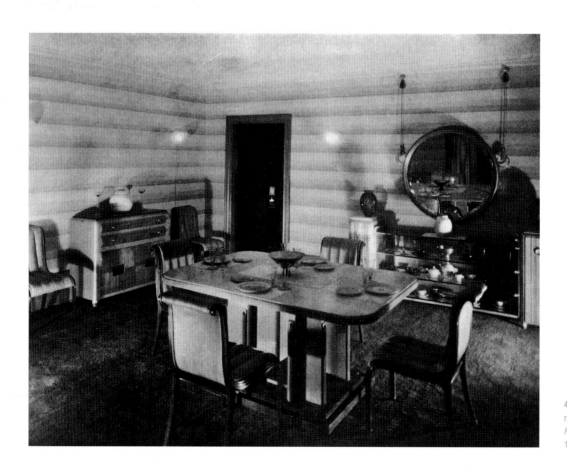

4.6 View of the dining room at A&S. *Good Furniture Magazine,* (April 1928), 175.

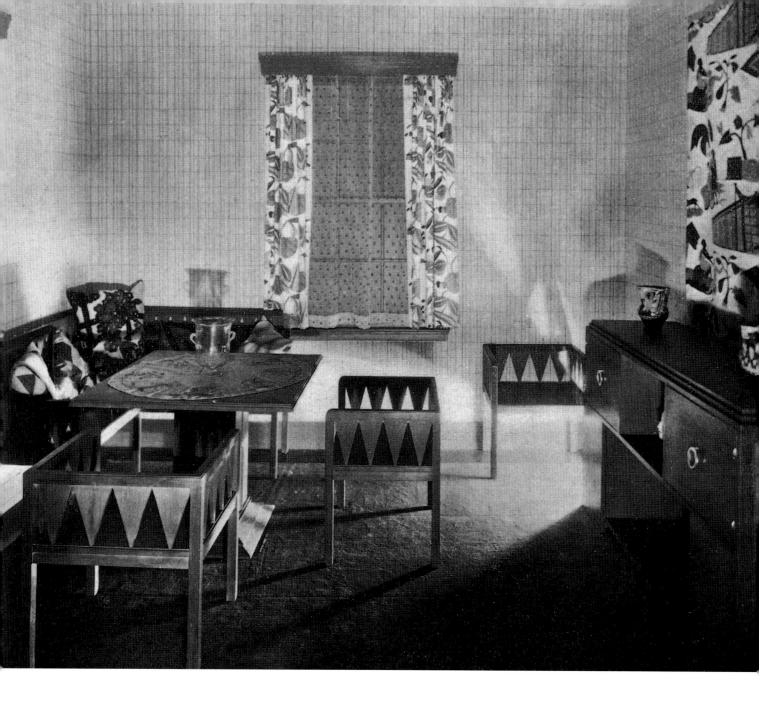

4.7 View of the dinette at A&S. *Upholsterer and Interior Decorator* (15 March 1928), 111.

Exhibitions at Abraham & Straus and Frederick Loeser & Co.

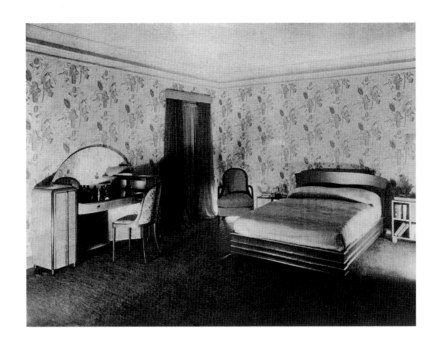

4.8 View of the bedroom at A&S. *Good Furniture Magazine*, (April 1928), 176.

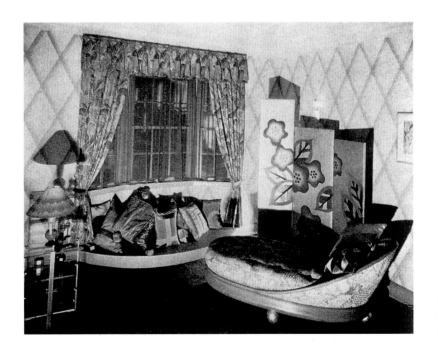

4.9 View of the boudoir at A&S. *Good Furniture Magazine*, (April 1928), 176.

designed to give visitors a taste of the various iterations of modern design, with the restrained pattern and rectilinear lines in the bedroom giving way to exuberant motifs and curvilinear forms in the boudoir (figs. 4.8 and 4.9).

In the bedroom, the predominant element was the bed. A bedcover in gold, cream, and silver complemented the bed platform of silver and lacquered wood in "a peculiar shade between mahogany and eggplant."[7] This color combination was echoed in a man's cabinet, a chest of drawers, and the woodwork. A green carpet covered the floor, and green was the prevailing color of the wallpaper, which was covered with sprays of flowers and leaves. Purple chiffon draperies, placed over sheer green liners, completed the design.

Walter Rendell Storey found the boudoir to be the most modernistic room in the exhibition, with its screen of "strange, large flowers," and a small chair upholstered in snakeskin.[8] If the profusion of patterns in the room failed to awaken the spirit, the color scheme of orchid, rose and silver would certainly have done so.

The critical reaction to the exhibition was positive. Storey praised the simplicity of the furniture and the treatment of surfaces that reflected light and color. Margaret Bruening appreciated the restfulness engendered by the light colors and the unbroken lines of the furniture, while Helen Appleton Read proclaimed the exhibition to be the embodiment of "the very principles upon which we are rebuilding our society—hygiene, light, cheerfulness and the elimination of unnecessary labor."[9]

The public reaction does not seem to have been as positive as that of the press. The exhibition, which remained on display through August 1928, drew thousands of visitors, but not so many buyers. In an interview given in March 1928, the merchandise manager of the A&S furniture departments asserted that many pieces had been sold from the exhibition, but he acknowledged that the prices might be too high to attract a broad spectrum of the public.[10] The pieces sold may have been primarily the accessories, which were mostly French, including Baccarat animal sculptures and Jean Dunand's lacquered vases. In August 1928, A & S dismantled *The Livable House Transformed* and placed the furniture on sale at about one-third the

marked prices. As an example, the four-piece bedroom suite was reduced in price from $2,275 to $875. One might conclude from the drastic price reductions, coupled with the replacement of the modern rooms by eighteenth-century interiors, that the exercise had been a failure. In an interview given to *Women's Wear Daily*, however, a spokesman for the store explained that the exhibit had served its purpose, in that it had demonstrated that the public had an appetite for modern design (though only at price points that approximated those at which other furniture was being sold). He affirmed the store's commitment to modern design, promising to expand the modern lines, and to offer them at prices "within the means of the average purse."[11]

In early 1928, Frederick Loeser & Co., another Brooklyn department store, launched what it termed a permanent exhibition of modern design, showcasing two rooms designed by William Lescaze. Born in Switzerland, Lescaze emigrated to New York in 1920, but later traveled frequently between Europe and the United States. As a result of his visits to Germany and France from 1923 through 1927, he incorporated into his work many elements of European modern design, as seen in the Loeser rooms.

Two rooms, a living room and a smoking room, were linked by dropped ceilings and a dark carpet that extended from one into the other. Both rooms were sparsely furnished, but the forms and colors were so "exhilarating" that the influential critic Adolph Glassgold proclaimed the interiors to be "eminently suited for New York living conditions since they are at once restful, uncluttered with distracting detail, fitted with an eye for the limited proportions of the modern apartment, and refreshing in color."[12]

In the living room, the walls, painted oyster white, light gray, and silver, and the furniture, upholstered in gray tweed on black-and-gray wood bases, provided the restful aspect. The exhilaration must have come from the screen, painted silver with red, black, and blue accents, the silver draperies with rose-colored liners, the Archipenko sculptures, and the indirect lighting (fig. 4.10). Glassgold appreciated the way in which the angular shapes of the fireplace, walls, and ceilings were repeated in the furniture, shelving, and display

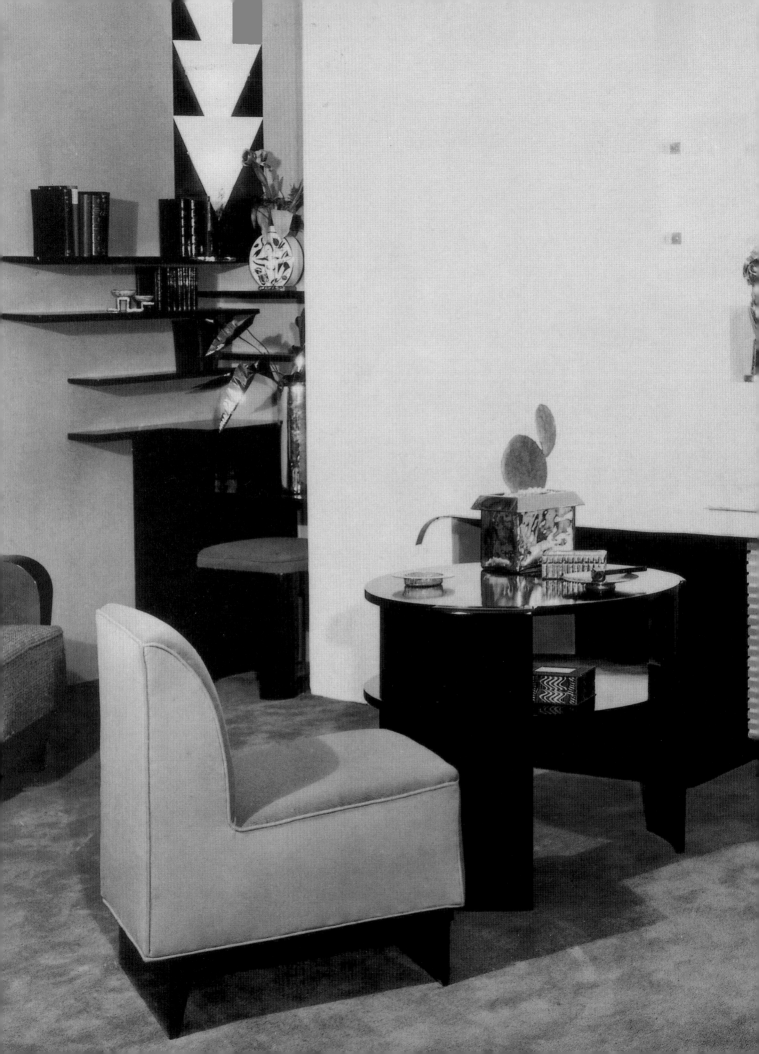

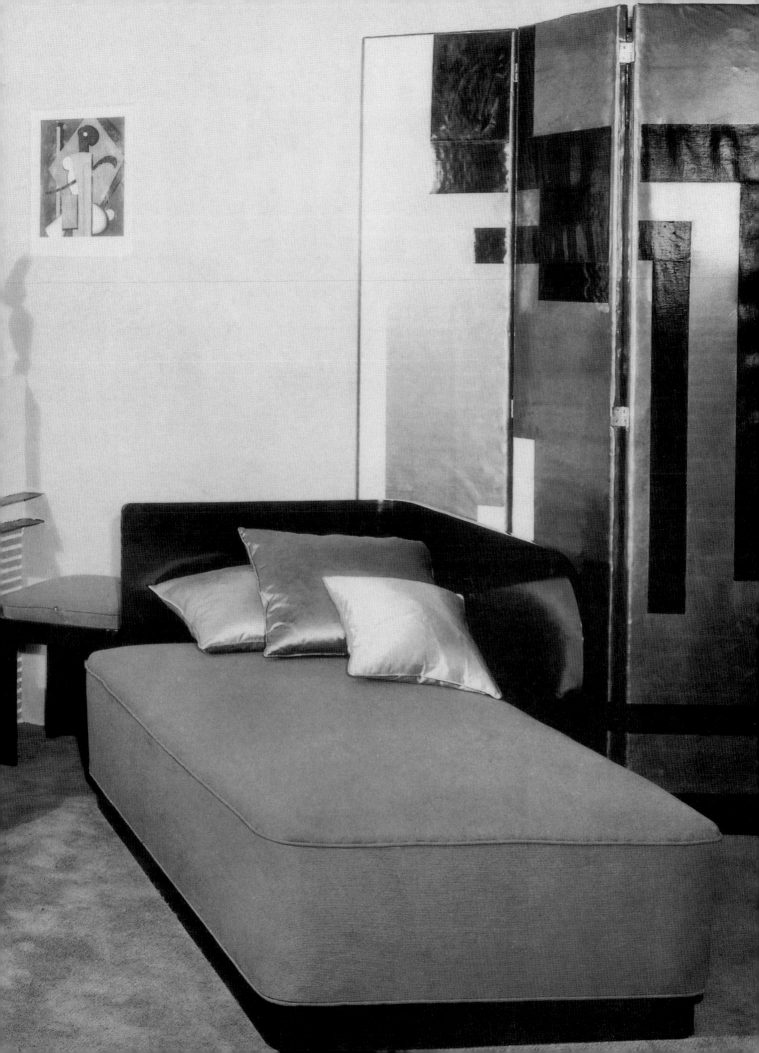

4.11 View of a corner of the living room at Loeser's. *Arts & Decoration* (September 1928), 64.

objects, creating a unified interior. The starkly geometric shapes and vibrant colors, hallmarks of the rationalists in France and the De Stijl movement in Holland, had not yet been shown in the other department exhibitions, probably out of fear that they might be considered bizarre or extreme. What also distinguished the Loeser's installation was the introduction of a group of furniture utilizing tubular steel (fig. 4.11). These three pieces, like the tables at Wanamaker's, gave New Yorkers a small taste of the functionalist design that had influenced Lescaze on his trips to Stuttgart in 1926 and France in 1927, where he visited Le Corbusier.[13] None of the major department store exhibitions would include this iteration of modernism.

The cozy smoking room, featuring two large, comfortable, upholstered easy chairs with wood accents, also had the silvery accents that led

Lorraine Welling Lanmon to term the exhibit an example of "metallic modernism"[14] (fig. 4.12). In considering Lescaze's work during the late 1920s, Lindsay Stamm Shapiro concludes that one could view it as "either a compromise with established taste or as a manifestation of an uncertain moment in the complex evolution of a modernist architect."[15]

Wherever Lescaze may have been in his own development, his rooms for Loeser's afforded Brooklynites the opportunity to examine a spectrum of European modernism, as viewed by one architect. In the following expositions, they would once again have to cross the Brooklyn Bridge. At Lord & Taylor, Macy's, and B. Altman & Co., they could view the designs of the European masters from whom both Frankl and Lescaze were deriving inspiration.

4.12 View of the smoking room at Loeser's. Photograph by Ralph Steiner. *Architecture* (August 1928), 90.

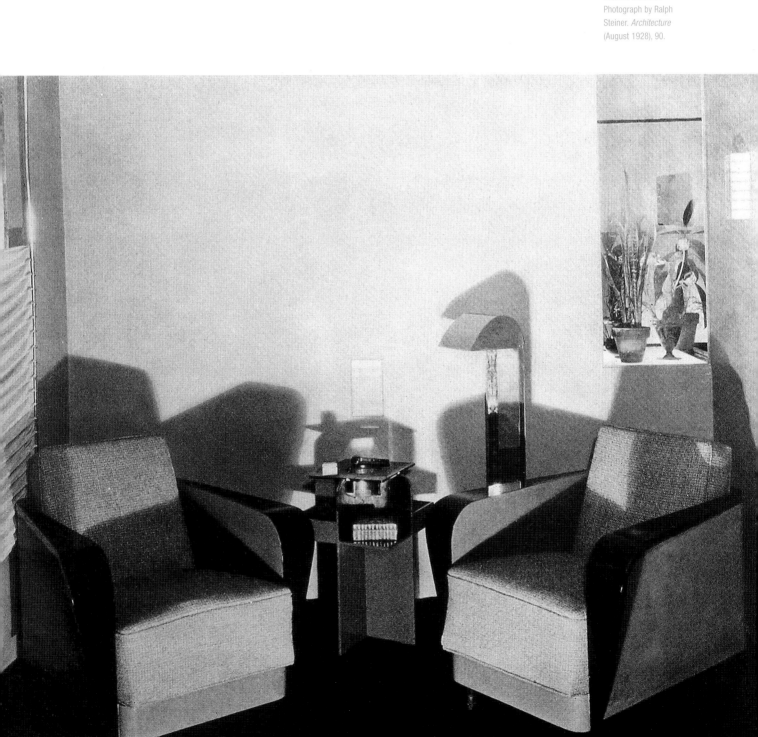

textiles · rugs · ceramics · paintings
metal work · glass · furniture

lord & taylor

an-nounce

in collaboration with

- RUHLMANN
- SUE ET MARE
- PIERRE CHAREAU
- FRANCIS JOURDAIN
- JEAN DUNAND
- VERA CHOUKHAEFF
- D. I. M.
- RODIER
- BIANCHINI FERIER
- MME. HÉLÈNE HENRY
- MME. CUTTOLI of MYRBOR
- LUCIEN VOGEL

exposition of MODERN french decorative ART

AS A FURTHER STEP IN SPONSORING THIS NEW ART OF THE 20th CENTURY—LORD AND TAYLOR HAVE CREATED A PERMANENT DEPARTMENT OF MODERN DECORATION AND ARE EXHIBITING FIVE ROOMS DECORATED BY THEIR STAFF.

3036 "Lord & Taylor announce" 8 5-16 x 11 1-4 in. Final proof, 1-31-28

Lord & Taylor Presents *An Exposition of Modern French Decorative Art*

"We believe that this modern movement is but the beginning of an expression of the time in which we live—the twentieth century."[1]

While Virginia Hamill was combing Europe for the best examples of modern design, to be shown at Macy's 1928 *International Exposition of Art in Industry*, Dorothy Shaver, the director of Fashion and Decoration at Lord & Taylor, was collecting materials for *An Exposition of Modern French Decorative Art*, set to open at the store in February 1928. (figs 5.1 and 5.2) Based on both practical and esthetic considerations, Shaver had decided to focus only on French design. During her six month sojourn in Europe, she had concluded that the store could not do justice to all of the countries producing modern design, and that in France the interpretation of the modern movement was "stronger and more complete, with a fuller range of creative activity than elsewhere." She described her selections as follows:

We have tried in assembling this collection to avoid the bizarre, eschewed fads and extravagances and have endeavored to focus upon the serious efforts of the two important schools in France today—that of the rationalists as evidenced by the work of Pierre Chareau and Francis Jourdain, and that of the traditionalists, as expressed by Ruhlmann and Süe et Mare.[2]

Shaver chose tested designers and designs; many objects seen at Lord & Taylor had been shown at the 1925 Paris Exposition and the French design exhibitions that followed.

Like Macy's, Lord & Taylor sought to elevate its effort above the mere commercial. It assembled an advisory committee that included respected artists, designers, writers, and businessmen, as well as representatives of the Metropolitan Museum of Art (fig. 5.3). It also drew a group of "Patrons and Patronesses" that included the names Harriman, Vanderbilt, Morgan, Roosevelt, and Guggenheim. Paul Claudel, the French ambassador to the United States, opened the exposition at a private reception held the evening of February 28, 1928, to which more than a thousand guests had been invited.

Opposite: 5.1 Press Release for *An Exposition of Modern French Decorative Art.* Dorothy Shaver Papers CA. 1922-1959, Archives Center. National Museum of American History, Smithsonian Institution [hereinafter, "Shaver Papers"].

5.2 Dorothy Shaver in her modern office at Lord & Taylor, circa 1928. Shaver Papers.

Lord & Taylor also looked to a well-known designer, in this case the architect Ely Jacques Kahn, to create a suitable backdrop for the exposition. The store scheduled a series of lectures and produced a thirty-two-page catalog that listed the exhibits and gave background information about the artists and designers (pl. 3).

In his introduction to the exposition catalog, Samuel Reyburn, chairman of Lord & Taylor, explained that the purpose of the exposition was to gauge whether the American public had sufficient interest in "Modern Art" to "justify activity on the part of American artists, manufacturers and merchants in the production and presentation of such merchandise as a business venture." A true businessman, Reyburn was not willing to commit the resources of the store to an untested movement. He viewed the exposition as an educational effort, with commercialization to follow, if it could be shown to be warranted. Shaver, on the other hand, was convinced that the modern movement was the wave of the future; her goal was to demonstrate to artists and manufacturers that the public would buy modern design, and to "encourage them to

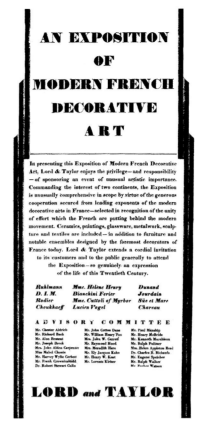

5.3 Advertisement for *An Exposition of Modern French Decorative Art. New York Herald Tribune,* 29 February 1928, p. 7.

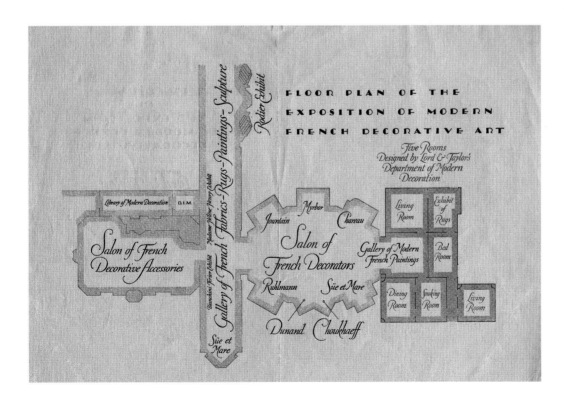

5.4 Floor plan of *An Exposition of Modern French Decorative Art.* Shaver Papers.

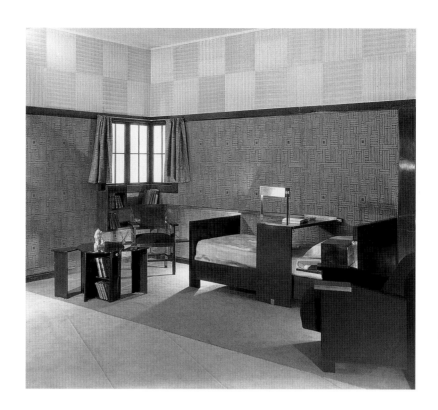

5.5 View of Jourdain's "Man's Bedroom" at Lord & Taylor. Photograph by Sigurd Fischer. Library of Congress, LC-255-N5.

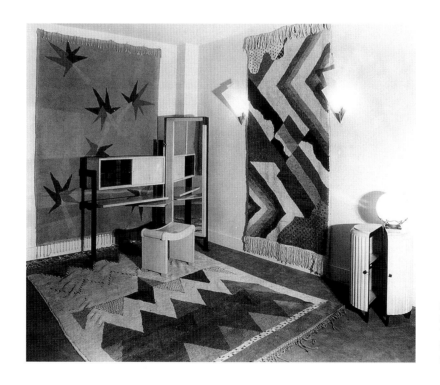

5.6 View of the Myrbor-Chareau alcove at Lord & Taylor. Photograph by Sigurd Fischer. Library of Congress 255-N3

make their own contribution" to the movement by cooperating "in the production of beautiful objects for general consumption."[3]

Included in the Lord & Taylor Exposition were many exhibitors that would also present displays a few months later at Macy's, including Jean Dunand, René Joubert and Philippe Petit, Compagnie des Cristalleries de Baccarat, Jean Luce, Daum Frëres, and Christofle. Lord & Taylor, however, was the only department store in which the public could see the work of Pierre Chareau and Francis Jourdain, or paintings by such artists as Picasso, Léger, Braque, and Raoul Dufy. Not only did Lord & Taylor present "ensembles" by French designers, it offered galleries filled with fine art, glass, silver, textiles, and rugs from France, and a separate series of five "American" rooms, designed by the store's newly organized Department of Modern Decoration, three of which featured furniture designed by Lord & Taylor staff and made in New York. (fig. 5.4). The exhibition, however, did not include any work by Le Corbusier or Robert Mallet-Stevens; Dorothy Shaver may have concluded that the American public was not yet ready for their versions of modernism.

Most of the alcoves containing the work of the French designers were arranged around the periphery of the "Salon of French Decorators." Entering the reception area of this salon from the gallery, visitors could stroll to the right, viewing the work of the more traditional designers, or to the left, perusing rationalist design.

In the first alcove to the left, Francis Jourdain, then president of the Chambre Syndicate des Artistes Décorateurs Modernes in France, presented a "Man's Bedroom" that also served as a study (fig. 5.5). This was a sober, masculine room. The broad expanses of walnut, the brown upholstery, and the beige bedcover were enlivened only by the brown-and-beige geometric pattern of the wall covering and window curtains.

The bed, made of polished walnut, featured a number of novel elements. A small, square cabinet, fastened to the headboard by hinges, had a door that dropped down to form a shelf. When not in use, the cabinet swung out of the way. A walnut table on wheels, with built-in lighting, slid along a metal railing on the wall behind the bed. When pushed to

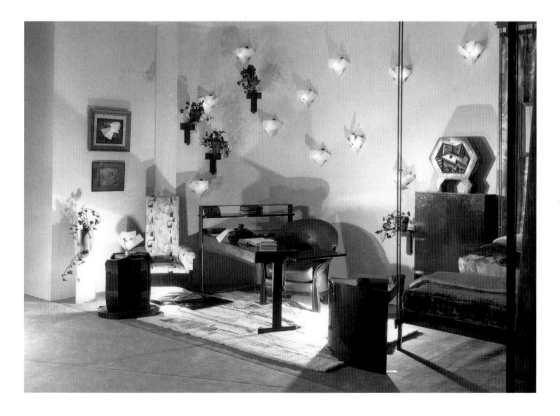

5.7 View of Chareau Study at Lord & Taylor. Photograph by Sigurd Fischer. Library of Congress 255-N3.

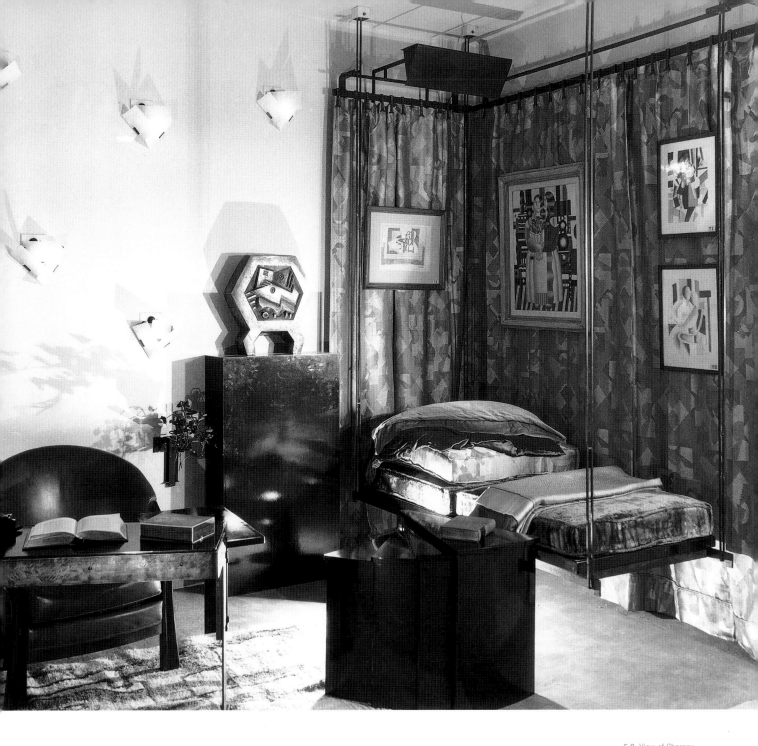

5.8 View of Chareau
Study at Lord & Taylor.
Photograph by Sigurd
Fischer. Library of
Congress 255-N4.

the chair at the window wall, the table functioned as a desk; when placed in the position shown in figure 5.5, it was perfect for breakfast in bed.

A small table, which also functioned as a bookcase, featured two "wings" that increased the surface area when they pivoted outward. The chair in the window corner incorporated two fold-down shelves that could be used for drinking glasses or books. The armchair to the right in figure 5.5 could be adjusted for sitting or reclining. Hanging walnut shelves behind each chair afforded open storage space. An armoire had two vertical compartments: one with a rod for hanging garments, the other with shelving. In effect, Jourdain had designed a small studio apartment, presaging the versatility that would be required for urban interior design during the remainder of the twentieth century. The *American Architect* praised the "utility camouflaged by beauty" that characterized Jourdain's work.[4]

The next two alcoves featured the work of Pierre Chareau, who believed that in order to adapt traditional designs to a new era the decorator had to borrow from them "the inner balance of their conception, its vital logic, its perfect concordance to the use for which it is destined, as well as to the environment from whence it has sprung."[5] In the alcove adjoining the Jourdain bedroom, Chareau's furniture shared the spotlight with a

variety of rugs from the French manufacturer Myrbor (fig. 5.6). These were only a few of the more than two dozen hand-tufted rugs exhibited by Myrbor, most of which were designed by Jean Lurçat, with a few by Fernand Léger. Chareau's furniture in this alcove included his trademark stool, a small commode with shelves for storage, and a dressing table and mirror of sycamore and wrought iron, which looked to Maxine McBride of the *New York Sun* like "moving day after the movers have gone home."[6]

Like his compatriot Francis Jourdain, Chareau created a multipurpose room. His study, in the next alcove, could function as such, or as a bedroom or a sitting room (figs. 5.7 and 5.8). Its most striking feature was the daybed, suspended from the ceiling on double rods from a frame made of wrought iron, which could be adjusted to sleeping or seating height. Silk drapery covered the walls behind the bed and provided a backdrop for a painting and two watercolors by Léger on one wall, and a Picasso drawing on the other.

Complementing the bed was a desk that heralded the direction of the modern movement, with its "essential parts . . . reduced to their simplest forms."[7] A solid piece of wood, forming the top of the desk, rested on three wrought iron supports that were approximately four inches wide and an inch thick. In keeping with the trend toward fur-

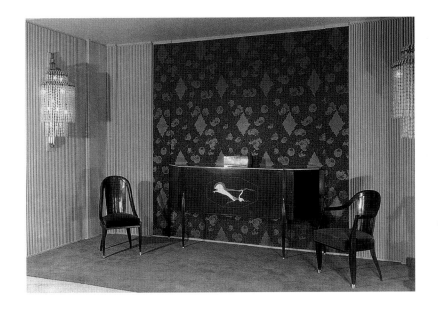

5.9 View of Ruhlmann Elements of a Dining Room at Lord & Taylor. Photograph by Sigurd Fischer. Library of Congress 255-N1.

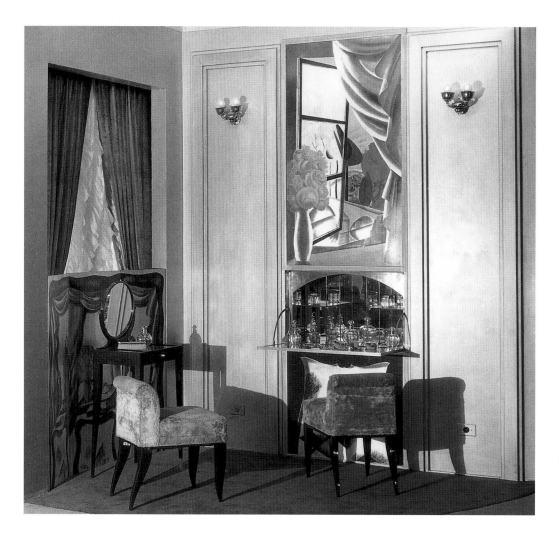

5.10 View of Choukhaeff Boudoir at Lord & Taylor. Photograph by Sigurd Fischer. Library of Congress 255-N6.

nishings closer to the ground, the desktop was lower than the norm, and coordinated with the height of the desk chair, which was really an armchair, trimmed in walnut and covered in deep blue leather. At one end of the desk, two supports extended above the top and were connected by horizontal strips of wrought iron that formed a bookshelf. At the other end, a swinging shelf could be adjusted for various uses, such as typing or stenography, and hidden beneath the desktop when it was not in use. The fan-shaped, hinged set of tables, which could be opened or closed as necessary, and the small stand with rotating shelves were further examples of Chareau's ability to create versatile furnishings for the modern home.

As in the Jourdain room, the color scheme was brown and beige. The artwork lent interest, as did various textures. The mattress was covered in tan velour. The high-back chair was upholstered in a modern Rodier linen and velour design, which complemented the cubist art that hung on the walls and the bronze bas-relief by Jacques Lipshitz. Four wrought-iron wall brackets held pots filled with ivy. A series of wall-mounted light fixtures consisted of three rectangular pieces of alabaster, "cunningly arranged so that, while furnishing sufficient light, they protect the eye from so much as a glimmer of sharpness."[8]

Across the reception area of the "Salon of French Decorators," visitors encountered the more traditional French modernists. Jacques-Émile Ruhlmann furnished an alcove with his extraordinary "Chariot" sideboard in Makassar ebony with ivory inlay, flanked by a side chair and an armchair,

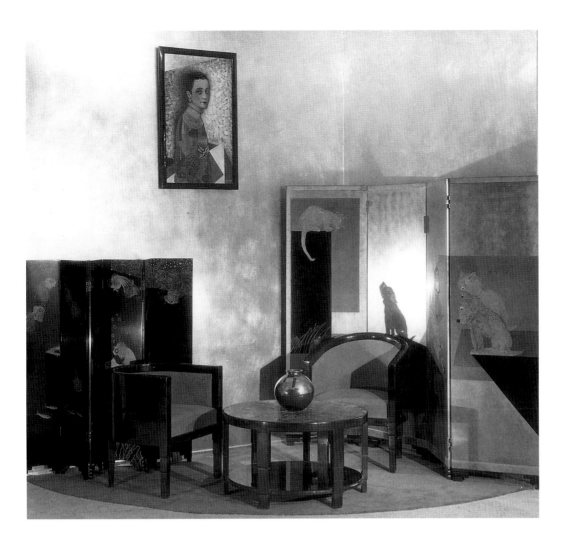

5.11 View of Dunand's alcove at Lord & Taylor. Photograph by Sigurd Fischer. Library of Congress 255-N2.

both made of lignum vitae wood and upholstered in gray wool mohair (fig. 5.9; pl. 4). The vertical lines of the crystal-and-silver wall sconces were echoed in the fluted walls. The purple-and-silver wall hanging set off the small silver chest from Christofle that shone on the sideboard.

Ruhlmann provided furniture for other areas at the exposition, including the boudoir (fig. 5.10) designed by Vera Choukhaeff, a painter who was born in Russia but moved to Paris in 1921 and subsequently became an interior designer. In this alcove, the Ruhlmann dressing table and two boudoir chairs, both in burled amboyna, were outshone by the fanciful screen and painting by Choukhaeff, in shades of brown, tan, and blue. As in the Jourdain and Chareau ensembles, brown shades in both the upholstery and the draperies

provided an unobtrusive backdrop, in this instance for silver walls and the array of crystal and silver toilet articles that gleamed in the cleverly designed mirrored toilet cabinet.

Lodged between the Ruhlmann and Choukhaeff alcoves was an ensemble by Jean Dunand (fig. 5.11). The lacquer work of Dunand, particularly the eggshell lacquer effect used in the portrait of Madame Agnes hanging prominently in the alcove, drew a great deal of press attention. *Women's Wear Daily* praised the deep orange tortoiseshell lacquer chairs as a "splendid" example of Dunand's work, and commented favorably on the small table[9] (pl. 5). The four-fold gold and black lacquer screen entitled "Cat and Dog," the six-fold black lacquer screen entitled "Fish," and the lacquer vase shown in the alcove are just a few examples of

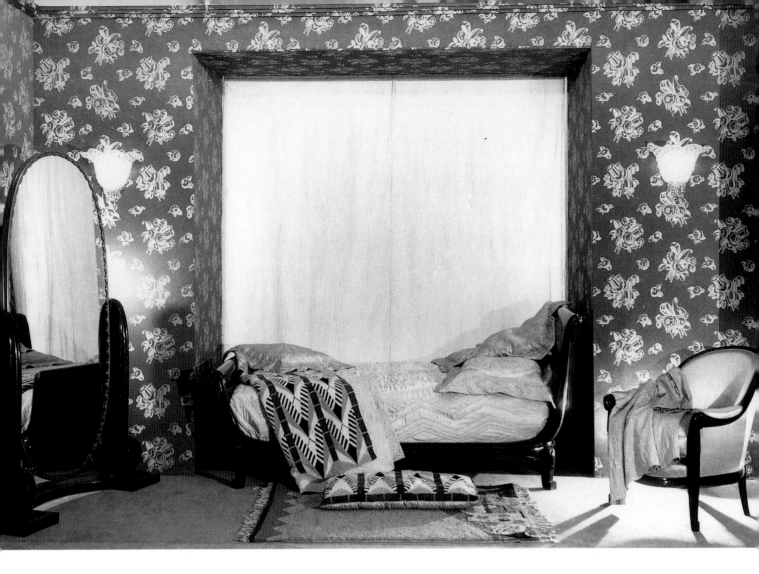

5.12 Süe et Mare "Woman's Bedroom" at Lord & Taylor. Photograph by Sigurd Fischer. Library of Congress 255-N7.

the more than two dozen pieces that Dunand contributed to the exposition.

The last alcove in this row was the "Woman's Bedroom" designed by Louis Süe and André Mare, in partnership as the Compagnie des Arts Francais (fig. 5.12). Striving "for warmth and harmony, supple lines and reposeful forms in order that the home be restful," Süe et Mare, with the able assistance of Jeanne Lanvin, created a luxurious retreat that drew heavily on traditional French design.[10] This was a room about color and texture. The Makassar ebony armchair was covered in pink satin. The bedcovers, in rose quilted satin with silver embroidery, were designed by Lanvin, as were pink-lined silver lamé pillowcases and the coordinating rose-and-silver nightdress draped casually across the chair. The foot cushion and bed rug, also designed by Lanvin, were made of sheepskin, cut to various lengths in a geometric pattern, dyed pink

and black, and lined in pink. Crystal sconces in a flower basket design held the electric lights, reflected in the oval cheval mirror encased in a gilded frame on an ebony base. Blue-and-white silk damask covered the walls, and pink net curtains shaded the windows.

The critics strove mightily to find modern elements in the Süe et Mare installation. *American Architect*, while agreeing that the furniture had strong classical influences, nonetheless saw a modern conception in its "sweeping lines and strength of construction."[11] With the exception of the patterned rugs, however, the furniture and furnishings, expensively produced, and with a single purpose, can barely be considered to have been designed in the modern spirit.

Süe et Mare's other contribution to the exposition, a "Corner of a Living Room," was more akin to the other exhibits. Located at one end of the

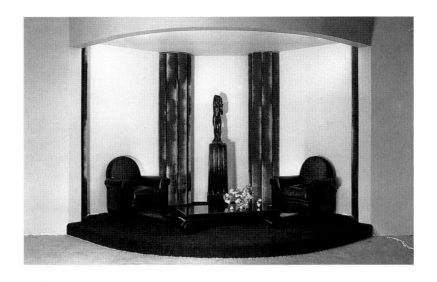

5.13 Süe et Mare's "Corner of a Living Room." Photograph by Sigurd Fischer. Library of Congress 255-N8.

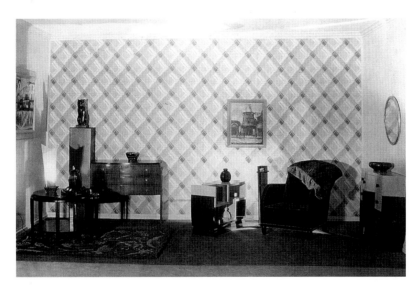

5.14 View of Joubert et Petit's "Smoking Room" at Lord & Taylor. Shaver Papers.

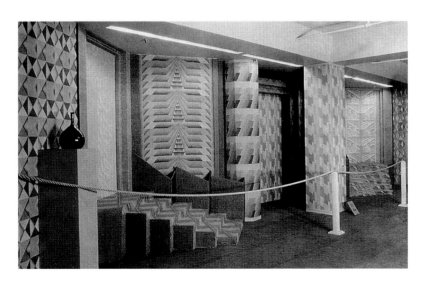

5.15 View of Rodier fabrics at Lord & Taylor. Shaver Papers.

long gallery, the ensemble consisted of two mahogany armchairs upholstered in green leather, a red lacquer coffee table, and a tall mahogany pedestal holding *Le Jeune Bacchus*, a sculpture by Auguste Guénot, which was flanked by putty-colored velour draperies. The furniture was low to the floor, in the modern manner, and embodied the modern approach of using texture to afford interest.

The last ensemble in the French section was the "Smoking Room" designed by René Joubert and Philippe Petit, in partnership as Décoration Intérieure Moderne, or D.I.M. (fig. 5.14). This room, located across the gallery from the majority of the French exhibits, lacks the cohesion of many of the other rooms and appears to have been an agglomeration of various pieces designed by D.I.M. during the previous several years.[12] Green-and-gray plaid wall hangings added a dash of color to the otherwise somber room.

A long gallery showcased a variety of French fabrics, as well as art and decorative objects. The House of Rodier furnished textiles in artificial silk

and cotton that the catalog termed "an interesting adaptation of the cubistic and machine-inspired motives favored for drapery and upholstery fabrics in combination with the straight lines and unornamented shapes of modern furniture"[13] (fig. 5.15).

Opposite the "Salon of French Decorators," across the gallery, was the "Salon of French Decorative Accessories," which held individual pieces by some of the decorators participating in the exposition, as well as vitrines filled with some of the finest silver, crystal, and ceramics that France could provide (fig. 5.16).

In the vitrine shown to the right in figure 5.16, Christofle silver and pewter predominated, with tea sets, vases, boxes, ashtrays, and other objects (pl. 6,7,8). To the left in figure 5.16 are several vitrines with glass produced by a number of French masters, including Maurice Marinot, François Decorchmont, and Jean Luce.

The most popular of the French glass was that produced by René Lalique, presented in another vitrine with work by Daum Frères. Lalique pre-

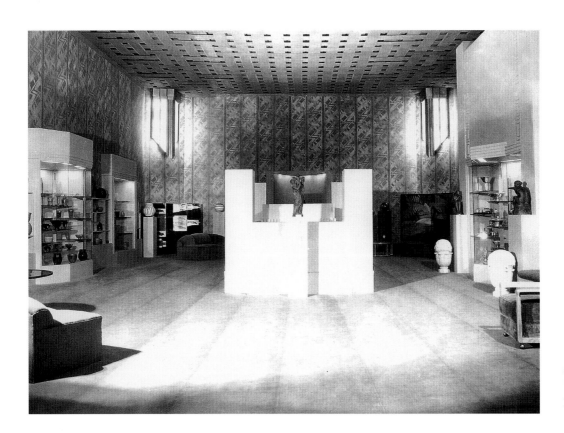

5.16 View of "Salon of French Decorative Accessories" at Lord & Taylor. Shaver Papers.

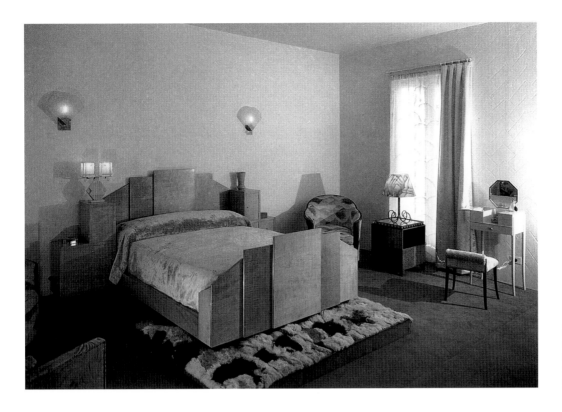

5.17 View of the bedroom at Lord & Taylor. Photograph by Sigurd Fischer. Library of Congress 255-N15

sented a large variety of objects, from small pieces, such as cigarette holders in the "Lierre" design and glass seals, to large ones, such as glass vases in the "Tourbillon" and "Rampillon" designs. In April 1928, *Crockery and Glass Journal* reported that all of Lalique's glass had been sold, and that Lord & Taylor was placing large replacement orders.[14]

The five "American Rooms" designed by Lord & Taylor staff were well received in the press and by the public. *Good Furniture*'s Nellie Sanford considered them to be "really livable," with "solid, honest furniture, plain, as befits the times, practical in its many conveniences, and with its ornamentation restricted to the polished beauty of various woods, occasionally inlaid with ivory, ebony, silver or pewter."[15]

In its May 1928 issue, *House & Garden* included some of the "American Rooms" in its "Little Portfolio of Modernist Rooms." The magazine wrote approvingly of the "cool colors and furniture designed for comfort" in the bedroom shown in figure 5.17. The walls, satin draperies, and voile curtains with crescents and stars, all in pale colors, formed a simple backdrop to both the bed, made

of "silvery gray wood inlaid with pewter,"[16] and the starkly patterned fur rug, which seemed to at least one critic to be ubiquitous in the modern bedroom.[17] Large cabinets attached to each side of the headboard served several purposes. One could rest a reading lamp or flowers on top of the cabinets and store books and other items inside. The practicality of this arrangement was somewhat diminished by the placement of the bed on a platform, which seems so narrow as to present a danger to an occupant bounding off the bed in the middle of the night.

In the dining room, the yellow walls provided a simple backdrop for the striking table, chairs, and buffet of silver lacquered wood, designed by Lord & Taylor staff and manufactured in New York (fig. 5.18). The black mirrored tabletop reflected a white pottery centerpiece by Süe et Mare. The fluted edging of the silver buffet and table is reminiscent of the work of Ruhlmann and demonstrates the influence of European designers on their American counterparts.[18]

Through the doors of the dining room was the "Smoking Room," which, according to the catalog,

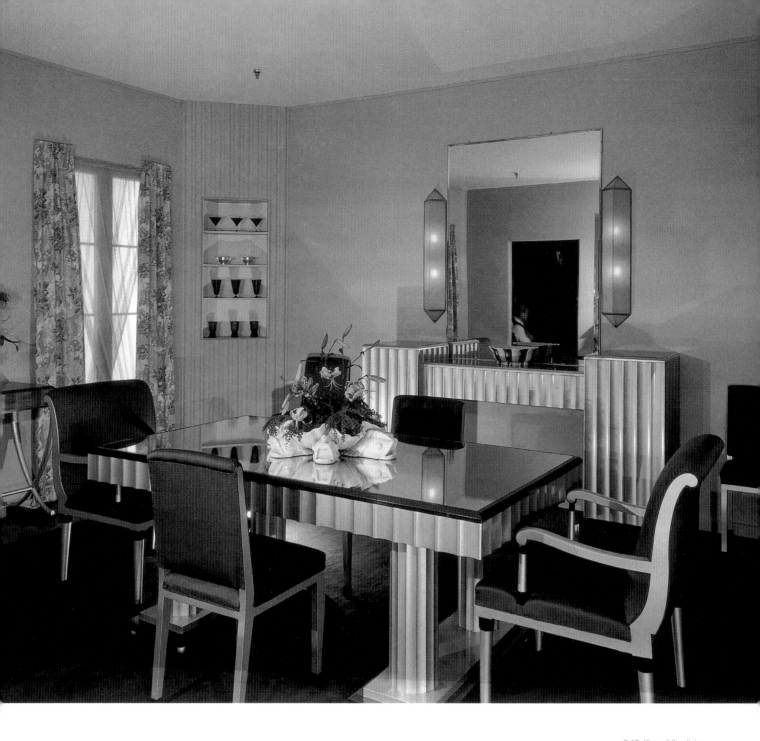

5.18 View of the dining room at Lord & Taylor. Photograph by Sigurd Fischer. Library of Congress 255-N17.

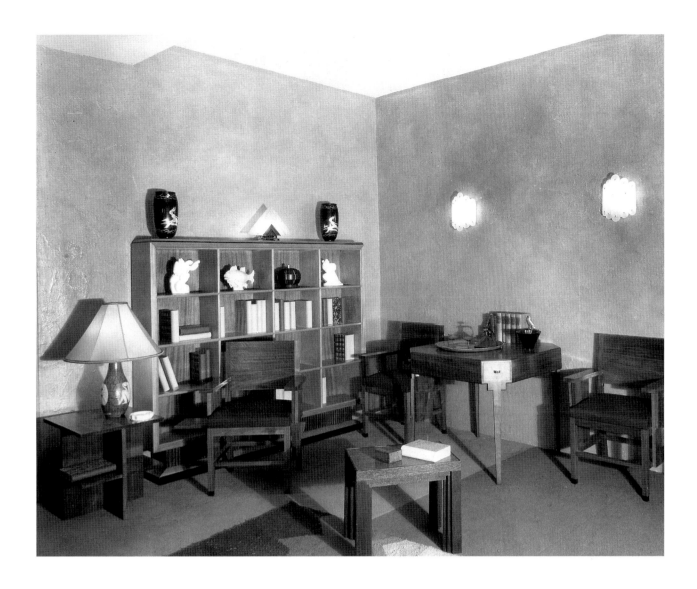

also displayed furniture designed and made in New York (fig. 5.19). Sanford praised the octagonal table, with drawers built into each corner, the small tables with storage space underneath, and the "plain, substantial chairs, roomy, sturdy and of proper height," with pull-down shelves at their sides.[19] It is difficult to distinguish these chairs from the version in Jourdain's "Man's Bedroom," pictured in figure 5.5. There is some evidence that the French were unhappy about the blatant copying engaged in by American designers. In a letter dated May 9, 1928, Jacques Rapin and Count Maxence de Polignac advised the Société des Artistes Décorateurs that the Lord & Taylor Exposition was a huge success for French art but an unmitigated

catastrophe for French industry, because very good American copies of French goods were being sold at half the price of the French originals.[20]

The "Beige Living Room" provided another example of the American penchant for French design (figs. 5.20, 5.21, and 5.22). One can see in the American-made furniture hints of many French masters, including Ruhlmann (small tables), Joubert et Petit (cabinet), André Groult (daybed), and Chareau (various chairs). The room apparently got its name from the beige-and-brown upholstery, beige mantel, and beige papered walls. A fireplace rug featuring a geometric rendition of a male figure provided some color and pattern, as did the upholstery in abstract designs.

5.19 View of the "Smoking Room" at Lord and Taylor. Shaver Papers.

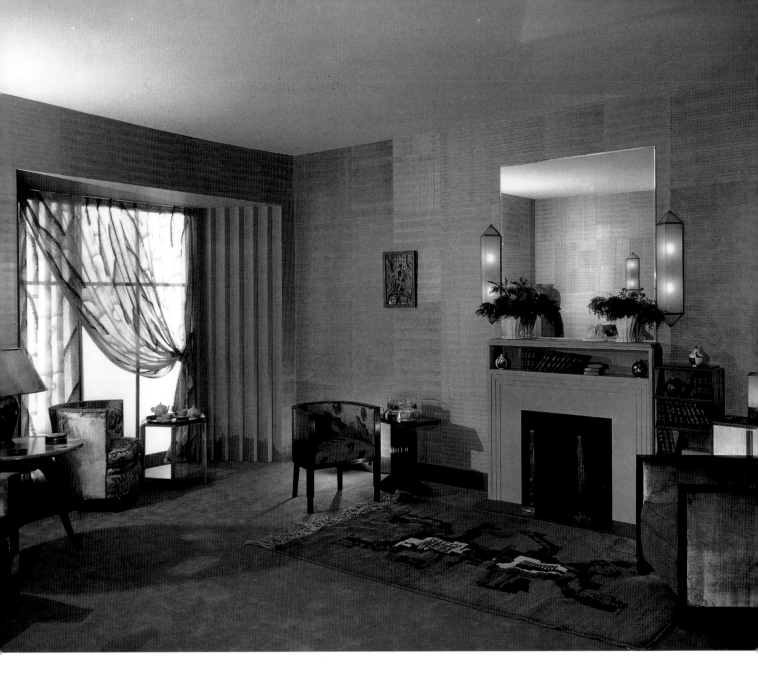

The other American living room, designed by Lord & Taylor's staff, incorporated some furniture and fixtures of American design and manufacture, and some pieces by the French participants in the exposition (figs. 5.23 and 5.24). It was more uplifting than the "Beige Living Room," with walls described by *House Beautiful* as "chartreuse, a most lively color with which the whole room glows."[21]

The public signaled its approval of the American rooms by purchasing the furniture shown at the exposition. One newspaper reported that Lord & Taylor had sold $50,000 worth of American-made modern furniture and that "practi-

cally every piece done by the American designers has received orders."[22]

Because it presented a wide spectrum of French modern art and design, the Lord & Taylor Exposition was an important addition to the department store shows. M. D. C. Crawford told his readers that "no one interested in satisfying the taste of a more distant tomorrow should miss the inspirational and educational value of this exposition."[23] By the time the exposition closed on April 1, more than 300,000 people had seen it.[24] Lord & Taylor had extended the run twice and kept it open during the evenings to accommodate the crowds.

5.20 View of the "Beige Living Room" at Lord & Taylor. Photograph by Sigurd Fischer. Library of Congress 255-N14.

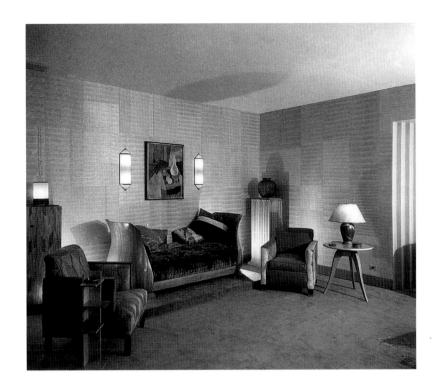

5.21 View of the "Beige
Living Room" at Lord &
Taylor. Photograph by
Sigurd Fischer. Library of
Congress 255-N13.

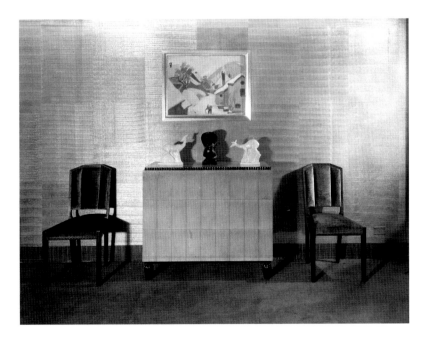

5.22 View of the "Beige
Living Room" at Lord &
Taylor. Shaver Papers.

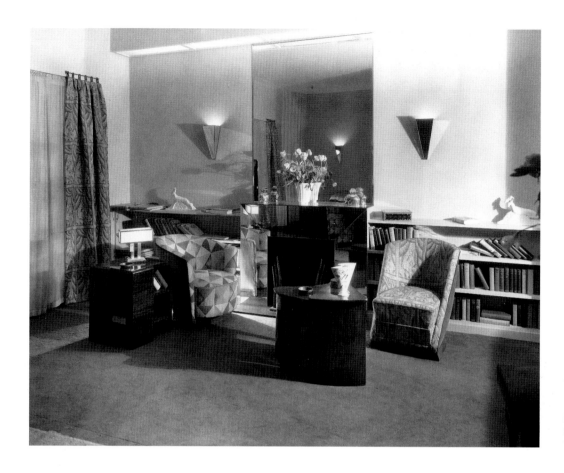

The Decorative Furnisher devoted four pages to photographs of the exposition and reported that "this modern French art has got to be considered whether we want to or not."[25] Peter Small, writing for *Creative Art*, disliked most of the exhibits, but thought that the exposition would "impress upon the rich of this country the necessity, the timeliness, the fashionableness of new furniture, new pictures," and "spur the American merchants to greater boldness in employing contemporary artists and offering new wares."[26]

One merchant, Samuel Reyburn, considered the reaction to the modern designs to have been almost universally positive; he concluded that Americans were "ready and willing to accept it." Dorothy Shaver announced the intention of the store to hold an exposition of American modern design as soon as American artists and designers were ready.[27] The store was, however, hedging its bets with respect to the direction of interior design in America. In March 1928, Lord & Taylor announced the creation of a department of modern decoration, but a Lord & Taylor advertisement in the August *House & Garden* pictured a Ruhlmann sofa with Louis XVI chairs, and touted the ability of the store's decorating department to combine the old and the new in decoration.

After the exposition closed, Shaver left the country to enjoy "a long rest abroad."[28] While she was sojourning in France, Virginia Hamill was putting the finishing touches on Macy's 1928 *International Exposition of Art in Industry*, which would give New Yorkers the opportunity to see the work of Scandinavian, Italian, German, Viennese and French designers, as well as the efforts of three Americans. The 1928 Macy's exposition drew even more press coverage than the Lord & Taylor exposition, insuring that modern design would be increasingly perceived by the public as an essential element in any home.

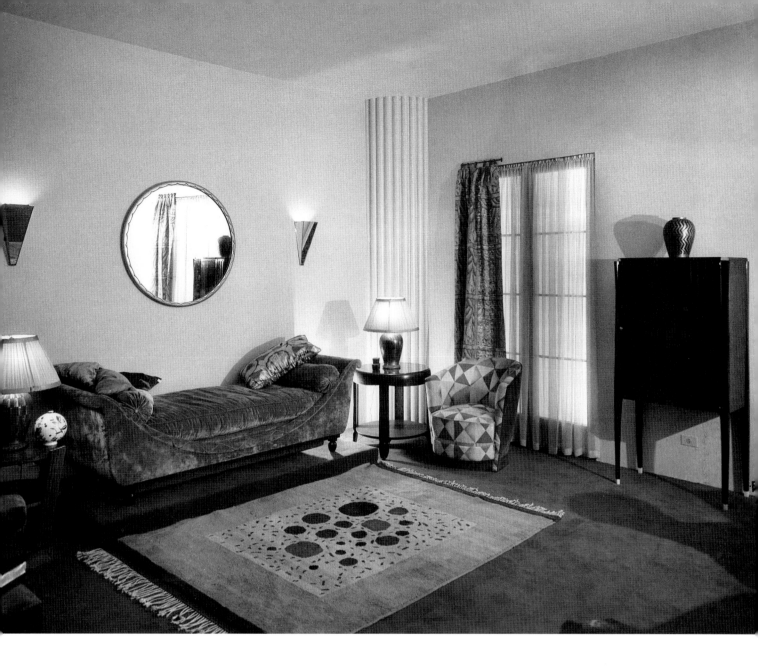

R.H. MACY & CO. INC. PRESENTS MAY 14 *through* MAY 26

An International Exposition

OF

Art

IN

Industry

The modern movement in industrial design is international. It belongs to all the world. France, Germany, Austria, Italy, Sweden and America—all are making valuable contributions · · · Macy's, recognizing this, has collected what it considers to be the finest examples in this movement. Among the exhibitors are many of the world's foremost designers of furniture, fabrics, metals, silverware, ceramics, glassware, jewelry, rugs and sculpture · · · · · Just as our great museums have always served as sources of inspiration for American craftsmen and artists, so, we hope, this Exposition will be an inspiration to all who are in any way interested in the contemporary movement in art · · · Advice and counsel from the Metropolitan Museum of Art and the cordial cooperation of distinguished societies and designers, both here and abroad, have made this Exposition possible.

A Sales Information Bureau has been installed, which will explain how orders may be placed for any of the articles exhibited.
ADDITIONAL ROOMS IN THE MODERN MANNER, 7TH FLOOR

THERE ARE A SERIES OF FASCINATING WINDOWS ON BROADWAY, WITH BACKGROUNDS REPRESENTING THE MODERN MOVEMENT. THE SCREENS WERE PAINTED BY ROBERT PALLESEN

Fourth Floor, New West Building · · Entrance 151 W. 34th St. · · · You Are Cordially Invited

6

The *International Exposition of Art in Industry* at R. H. Macy & Co., 1928

"By far the most important and far-reaching exhibition of modern furniture and decoration which America has seen."[1]

Despite the favorable response to the 1927 Macy's Exposition, management did not rush into planning another one. It was not until October 1927 that Macy's advisory council officially approved a proposal to hold another "art-in-trade Exposition." In December 1927, Jesse Straus sought members to serve on the advisory committee for the new show, to be held in the spring of 1928.[2] As in the 1927 exposition, the involvement of the advisory committee, whose members are listed in figure 6.1, gave a certain level of credibility to Macy's efforts.

In the correspondence regarding the advisory committee, Straus stated that the exposition would be similar in spirit to the 1927 show, "but with considerably more attention to the exhibits of the European countries."[3] In a December l6 letter to potential advisory council members, Straus noted that Macy's had retained Virginia Hamill to "conduct an extensive survey of European exhibit sources."[4] For the exposition, which was to be called *An International Exposition of Art in Industry*, Hamill made two trips to Europe, during which she visited ten countries. She assembled more than five thousand objects from approximately three hundred sources in six countries.[5]

Virginia Hamill selected objects for the exposition so that consumers could explore the "French genius for catering to the luxuries of life, German recognition of the artistic possibilities of the machine age, Italy's facility in projecting classicism into modern forms, Austria's imaginative treatment of the smaller decorative pieces, and Sweden's modernistic adaptation of its traditional national art in the media of glassware and metals."[6] In essence, by displaying "articles in every day use" from various countries, and gauging critical and public response, Macy's could both enable Americans to determine their personal preferences in modern design and provide guidance to manufacturers unwilling to take the financial risks of producing untested goods.[7]

Macy's management also wanted the exposition

Opposite: **6.1**
Advertisement. *New York Herald Tribune*, 13 May 1928, sec. 1, p. 19.

to demonstrate that public interest in modern design was growing rapidly, so that manufacturers would perceive an expanding market.[8] In the preliminary announcement of the exposition, Hamill stated that for the 1927 exposition Macy's had "had difficulty in finding sufficient material to stage a worthwhile exhibit of modern design in industry," but that in 1928 "our problem has been one of elimination and selection from a wealth of offerings."[9] She cited this difference as an indication of the rapid development of modern design, and its staying power.[10]

There had indeed been rapid development in modern design, as demonstrated at the 1928 *Salon des Artistes Décorateurs* in Paris, which opened at about the same time as the 1928 Macy's Exposition. Yvonne Brunhammer and Suzanne Tise describe this Salon as "a showcase for tubular steel furnishings."[11] Yet, for the 1928 exposition, Hamill selected the work of the more conservative designers, in France and elsewhere in Europe, eschewing the work of the German Bauhaus designers, the French rationalists, and the Italian futurists. Perhaps she surmised that Americans had to be shown a conservative iteration of modern design before they could accept the modernism of tubular steel and geometric form that was then finding an audience in Europe. Like the exhibits at Lord & Taylor, most of the European ensembles at Macy's, and many of the individual objects brought from Europe, were based on models that were one to three years old. The New York public, however, did not know this, and may have fairly assumed that, given the vast number of offerings, the modern movement had really exploded during the previous year. The critical acclaim for the exposition, and the many positive comments on the absence of "bizarre" pieces, would seem to support the decision to focus on the conservative designers.[12]

Macy's heralded the opening of the 1928 exposition with full-page advertisements in many major New York newspapers on Sunday, May 13 (fig. 6.1). Macy's produced a catalog that listed all of the exhibits, for which Macy's had authorized an expenditure of approximately $6,000 for fifty thousand copies, as compared with a cost of $1,100 for thirty thousand copies the previous year.[13] The catalog included statements by representatives of all of the participating countries, as well as a foreword by Robert de Forest.

The 1928 exposition opened at 10:30 Monday morning, May 14, with formal ceremonies in a newly built auditorium.[14] Percy Straus explained that the purpose of the exposition was to bring together the work of the outstanding designers of countries that had shown a trend toward innovation in design and the use of color. He acknowledged that Americans had been exposed, at various times, to the work of one or another of these countries, but that a comprehensive exposition, not theretofore attempted, would "serve the two-fold objective of interpreting the contemporary decorative arts of those countries in terms that will be understood in America and of being an inspiration to our artists and artisans." Straus explained that Macy's, like the department stores of Paris, was interested in fostering the application of art, as the "universal language," to commerce and industry, as the "all-pervading factors of modern life." This was an interest grounded in economic savvy, as Straus understood that New Yorkers sought beauty and comfort in their purchases, and that the department stores had to respond to the new desires of its customers. He urged Americans to take inspiration from the European designs on display, but then to give modern design "a new twist, to make it a part of our lives."[15]

The first speaker was de Forest, who stressed the importance of making art a part of one's life and the lives of one's children, crediting harmony in color and form with instilling in the occupants of the home a sense of satisfaction and enjoyment. De Forest characterized the department store as an ally of the museum in the effort to spread the "gospel of beauty," and asserted that department stores had an advantage over museums: "In a museum you can see, you can look, but, unless you violate all the rules of property, you cannot take." He went on to say that a department store, in which people could purchase what they saw, had the ability to put beautiful objects within the reach of everyone.[16] To de Forest, the efforts of the department store to combine beauty and utility in industrial design gave rise to a new form of art "more or less international in character, and yet retaining distinct racial individuality."[17]

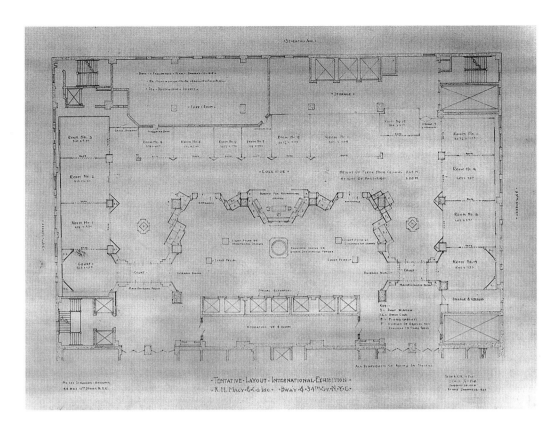

6.2 Preliminary plan of the 1928 Macy's Exposition, dated January 23, 1928, revised January 26, 1928. Lee Simonson Papers. The Harvard Theatre Collection, The Houghton Library.

Other speakers at the opening ceremonies focused on the relationship between art and international peace. The German ambassador, Baron Wilhelm von Prittwitz und Gaffron, expressed his hope that the exposition would bring Germany and the United States closer, and would contribute "to the formation of international good taste."[18] For Germany, shut out of the 1925 Paris Exposition and still suffering the economic impact of World War I, the Macy's show was an important platform to regain what it saw as its rightful place in the field of industrial design. The Austrian minister, Edgar Prochnik, asserted that in stripping Austria of its assets after World War I, the Peace Conference had forgotten "the old Austrian traditions of art and science."[19] Musing that Austrian designers appeared to have learned how to please American consumers, he expressed his hope that the exposition would engender greater understanding between Austria and the United States. Jules Henri, the secretary of the French Embassy, touted international trade as the best way to bring about peace and understanding among nations.

These speakers were expressing views that had long been the justifications for international expositions.[20] Henry Cole and Prince Albert of Great Britain, and their successors in exposition planning, believed that the mechanism of international expositions could improve public taste, engender healthy economic competition, and forestall conflict among nations. Macy's participants had these same goals. The Europeans took pride in their accomplishments in the design field and sought to improve the markets for their wares. The American designers and manufacturers, denied a showcase at the 1925 Paris Exposition, wanted to display their efforts to a broad public. The Metropolitan Museum of Art envisioned the Macy's Exposition as a way to improve public taste and move American design forward. The result was a vast assemblage of furniture, glass, textiles, metalware, and ceramics that exposed approximately 250,000 people to modern design in a two-week period.

Macy's estimated that about fifteen thousand people visited the exposition on the first day.[21] They exited the elevators into the "Court of

Honor," which displayed objects from the participating countries so visitors would immediately sense the international nature of the exposition. The objects on view, like the model rooms, were arranged by nationality to enable visitors to compare and contrast national styles. Four exits led visitors from the "Court of Honor" to an arcade, around which were arranged fifteen ensembles or model rooms, as well as decorative objects. The exposition covered approximately twenty thousand square feet, encompassing the entire west wing of the fourth floor of Macy's (fig. 6.2). Macy's had again hired Lee Simonson as the exposition architect. In 1928, Simonson saw it as his mandate to use materials and backgrounds that would "dramatize the story of modern art as it applies to everyday life."[22]

The centerpiece of the "Court of Honor"—literally and figuratively—was the "fountain" (fig. 6.3). It was not a real fountain; a sculpture sat on top. But for anyone who had visited or seen images of the 1925 Paris Exposition, the fountain, like the materials selected by Simonson, immediately

evoked a sense of modernity. The Macy's fountain was similar in form to the sculptural elements atop the columns of the "Porte d' Honneur" at the 1925 Paris Exposition (fig. 6.4). At Macy's, pansies filled benches flanking the fountain, giving the whole court "the illusion of a great salon."[23] Behind the fountain in the "Court of Honor" was a set of wrought-iron gates designed by Raymond Subes of France.

To display decorative objects in the "Court of Honor," Simonson designed sixteen shop windows and eighteen show cases, all constructed with angled walls in a manner that forced the visitor to focus on a few items at a time (fig. 6.5). Concluding that the high cost of finished wood made it inappropriate as a modern building material, Simonson used asbestos to create the background structures.[24] Asbestos treated to look like stone formed the base of the front of some of the display cases, giving them the appearance of outdoor shop windows. The transoms above these display cases were also made of asbestos, finished to look like green marble and embellished with metal

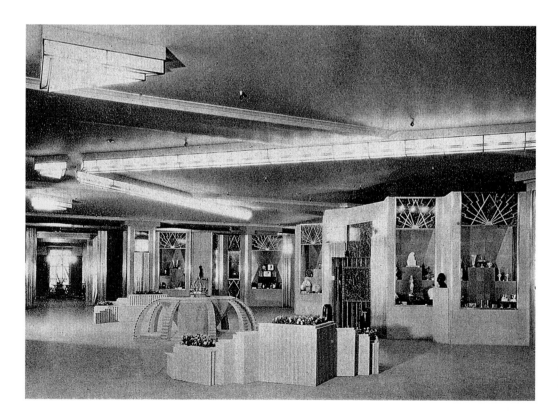

6.3 View of the "Court of Honor." *Good Furniture Magazine* (July 1928), 15.

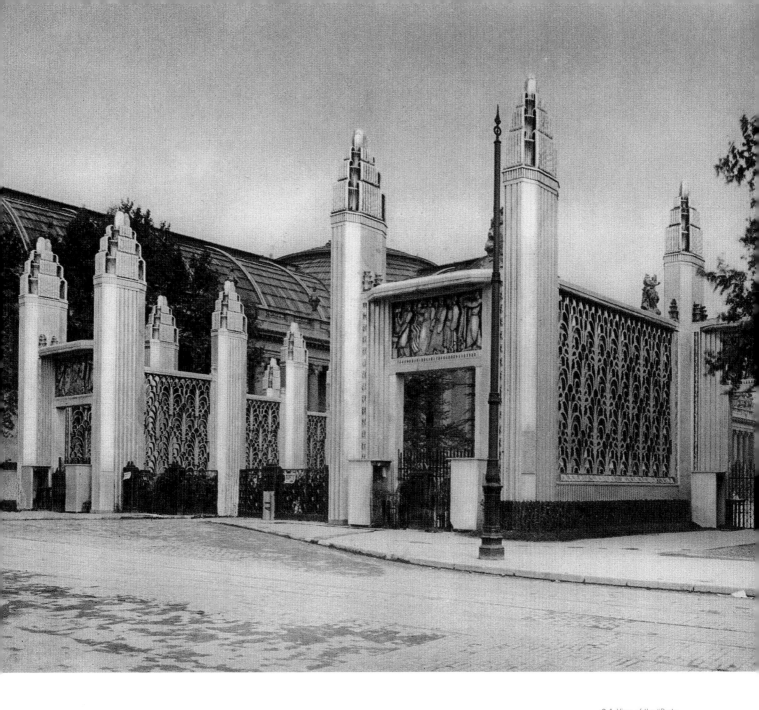

6.4 View of the "Porte d'Honneur" at the 1925 Paris Exposition. *Exposition des Arts Décoratifs Modernes* (Paris: Braun & Cie, 1925).

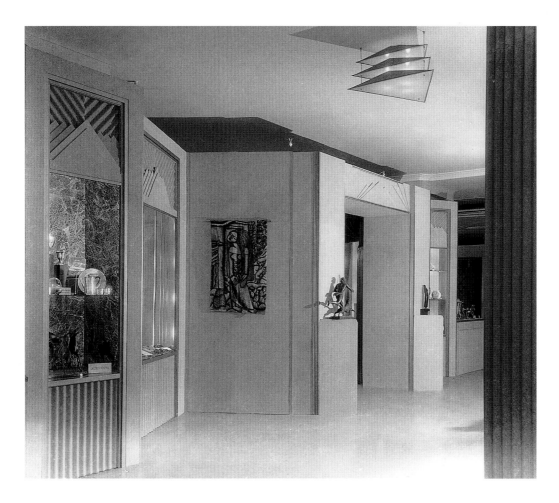

strips applied in a zigzag pattern. Cork lined the interiors of the display cases, to provide a neutral background for the objects. Other display cases featured corrugated stonelike bases and transoms, with interiors of marbleized asbestos. To give color to the stone-like asbestos, Simonson used strips of copper, zinc, and brass.[25]

Simonson used metal, cork, and asbestos in the exposition to demonstrate that raw materials could give vitality to modern decoration. He saw modern art as "capturing the discoveries of the scientist in his laboratory for the purpose of combining utility, beauty and economy to meet the needs of present day life."[26] The backgrounds were a harbinger of the future of modern design in the United States-they incorporated the materials and the shapes that would characterize the design of the 1930s.

As noted above, the objects on display were grouped by nationality. Holding a prominent place

in the "Court of Honor" was *Indian Runner*, by the American sculptor Paul Manship, shown in figure 6.5. In the foreground of figure 6.5 can be seen several pieces by Peter Müller-Monk, a silversmith who had emigrated from Germany to America only a few years earlier.

Cowan Pottery Studio sent many ceramics objects, including *Adam and Eve* by R. Guy Cowan, and *Introspection* and *Antinea* by A. Drexler Jacobson as seen in plates 9 and 10.

Reed & Barton furnished examples of its modern designs in silver and pewter. Figure 6.6 contains images of modern designs produced by Reed and Barton at the time of the exposition, as does plate 11.[27]

International Silver Company also exhibited tea sets, candlesticks, and other forms of hollowware, primarily in its "Evening Sea," "Northern Lights," "Ebb-tide," and "Tropical Sunrise" patterns. Several

Color Plates

1 Stehli Silks Corporation. "Accessories." Helen Dryden. The Metropolitan Museum of Art. Gift of Stehli Silks Corporation, 1927. (27.149.7). Photograph © 2000 The Metropolitan Museum of Art. Stehli donated a large collection of its modern designs to the museum following the 1927 Macy's Exposition.

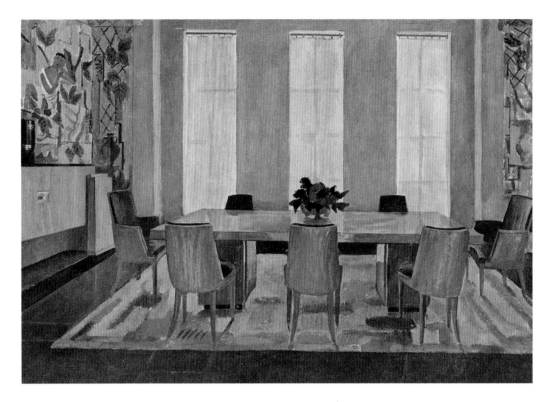

2 Salle a manger par M. Guillemard; Édité par l' Atelier "Primavera;" Aquarelle de Boris Grosser. Léon Deshairs. *Interieurs en Couleurs France.* (Paris: Éditions Albert Lévy 1926), pl. 28. This is a collection of fifty plates that constitute a rare record of the colors that characterized the exhibits at the 1925 Paris Exposition.

3 Cover, *An Exposition of Modern French Decorative Art* (Exh. cat., New York: Lord & Taylor, 1928). Shaver Papers.

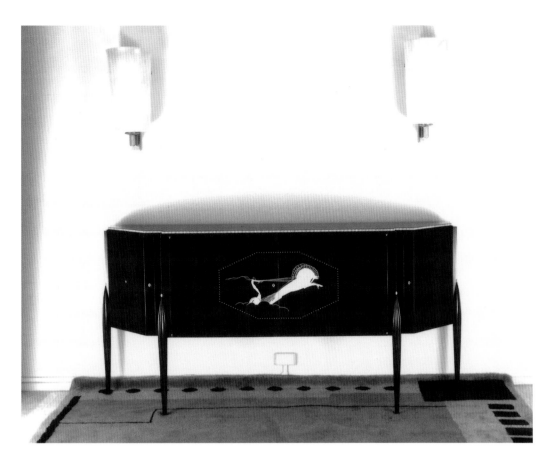

4 Sideboard, Jacques-Émile Ruhlmann, Makassar with ivory inlay, ca 1925. Courtesy of Delorenzo Gallery.

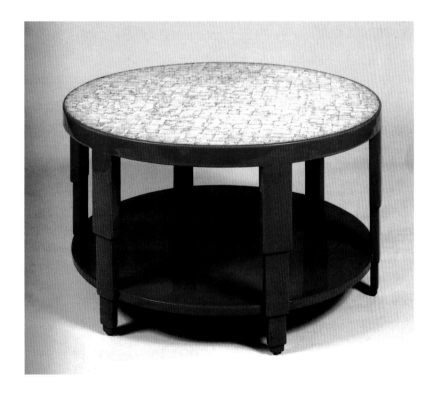

5 Table, lacquer and eggshell lacquer. Jean Dunand ca 1925 (sale cat. Sothebys, New York, 23 April 1988), Item 323. Courtesy of Sotheby's. Dunand was reported to have learned the eggshell lacquer technique in China. In this technique, ground eggshell is pressed into a base consisting of numerous coats of lacquer that have been melted to a consistency of soft rubber, and then additional coats of lacquer are applied to protect the design created by the application of the eggshell.

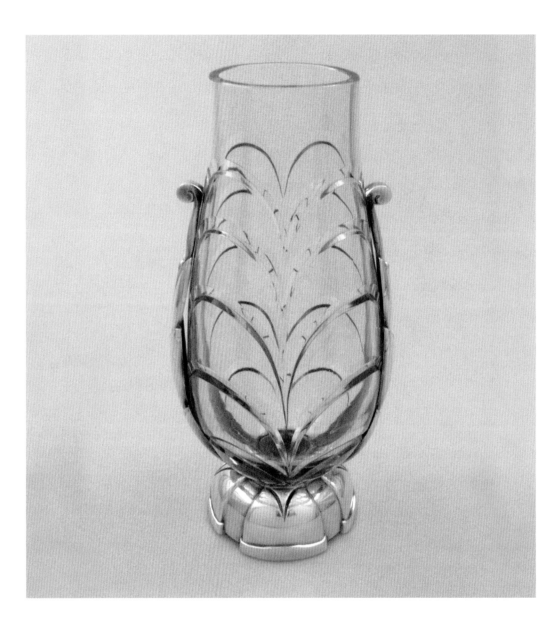

6 Christofle Vase Ecailles, silverplate and crystal. Georges Chevalier, ca 1925. Courtesy of Musée Bouilhet-Christofle. This vase was designed for the 1925 Paris Exposition.

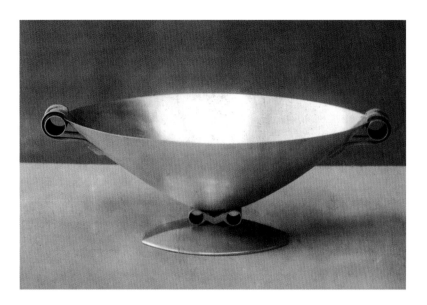

7 Christofle Coupe ovale
anses et pied tube,
Christian Fjerdingstad, ca
1925. Courtesy of Musée
Bouilhet-Christofle.

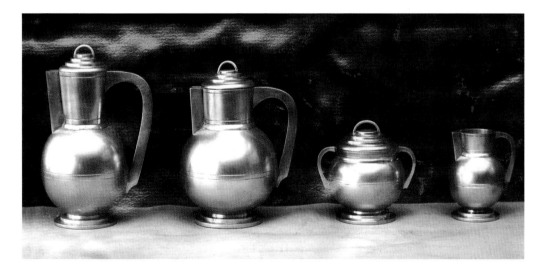

8 Christofle Service à thé
et à café, pewter. Christian
Fjerdingstad, ca 1926.
Courtesy of Musée
Bouilhet-Christofle.

Pls. 7 and 8 are part of a
line of pewter objects
named "Etains de
Carville," for which the
pieces were designed by
Christian Fjerdingstad.
Linguists will note that the
"Carville" is the rough
translation in French of
Fjerding (car) stad (ville).

9 Cowan Pottery, "Adam & Eve," R. Guy Cowan, ca 1928. Photograph by Mark Bassett; courtesy of Rocky River Public Library.

10 Cowan Pottery, Bird "Introspection," and Head of Girl "Antinea," A. Drexler Jacobson, ca 1928. Photograph courtesy of Rocky River Public Library.

11 Reed & Barton candle-
sticks, cigarette box, and
bowl, pewter, ca 1928.
Collection of Mark
McDonald; courtesy of
330. When polished, as
shown in Reed & Barton
advertisements, the
pewter was hardly distin-
guishable from silver, but
it was much less expen-
sive. During the first
decade of the twentieth
century Liberty of London
had championed the use
of polished pewter in its
"Tudric" line of arts and
crafts metalwork.

12 International Silver Co. bowl "Tropical Sunrise," sterling silver, ca 1928. Collection of the author.

13 International Silver Co. bowl "Northern Lights," sterling silver, ca 1928. Collection of John C. Waddell.

14 International Silver Co. bowl "Ebb Tide," sterling silver, ca 1928. Collection of the author.

All three designs appeared in the company's 1929 Sterling Hollow Ware catalog in dozens of forms, including bowls, dishes, candalabras, and salt and pepper shakers. The catalog declared these designs to be "in the spirit of today."

15 Christofle Vase
Ecailles, Dinanderie col-
lection, silverplate and
patina. Luc Lanel. ca
1928. Collection of John I.
Bloom.

DINANDERIES

ORFÈVRERIE
CHRISTOFLE

16 Cover, *Dinanderies*
(sale cat. Paris: Orfèverie
Christofle, 1931). Courtesy
of Musée Bouilhet-
Christofle. The catalog
contains dozens of vases,
platters, boxes, and lamps,
all in the dinanderie
technique.

17 Richard Ginori vase "Nautica," Gio Ponti, circa 1928. Photograph courtesy of Richard Ginori. At the 1928 Macy's Exposition, Richard Ginori presented nearly two dozen pieces of ceramics designed by Ponti, including pieces from his "Classic Conversation" series, which reflected Ponti's belief in the continuity between past and present.

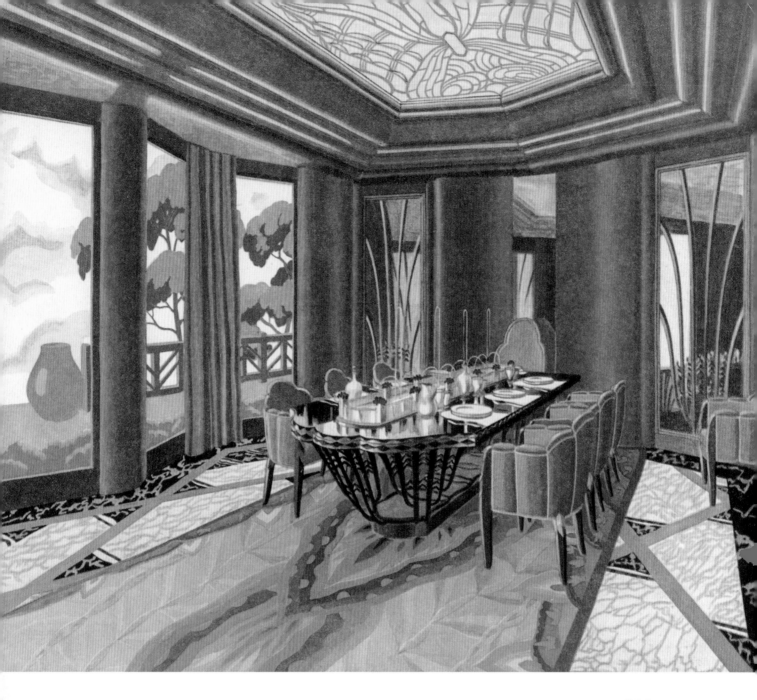

18 Salle a manger par
Maurice Dufrêne, collabo-
rateur-dessinateur:
Englinger; édité par la
"Maîtrise" des Galeries
Lafayette. Léon Deshairs.
*Interieurs en Couleurs
France.*

Opposite: 19 Maison
Commune, M. Dufrêne;
édité par La Maîtrise.
*Interieurs au Salon des
Artistes Decorateurs Paris
1928 Presentes par Rene
Prou* (Paris: Charles Moreau,
éditeur, ca 1928), pl. 31.

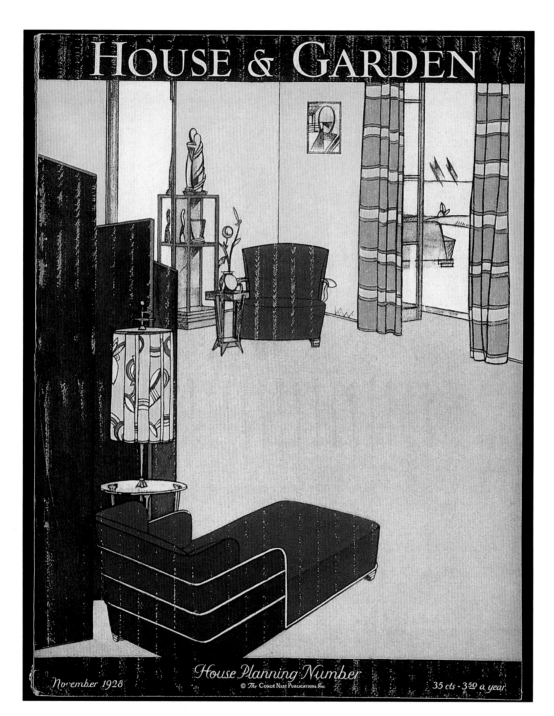

HOUSE & GARDEN

House Planning Number

November 1928
© The Condé Nast Publications Inc.

35 cts · 3.50 a year

20 Cover, *House & Garden* (November 1928). Courtesy of The Condé Nast Publications Inc.

OPPOSITE: 21 Rendering of Bathroom designed by Kem Weber for the 1928 Macy's Exposition. Courtesy of Architecture and Design Collection, University Art Museum, University of California, Santa Barbara.

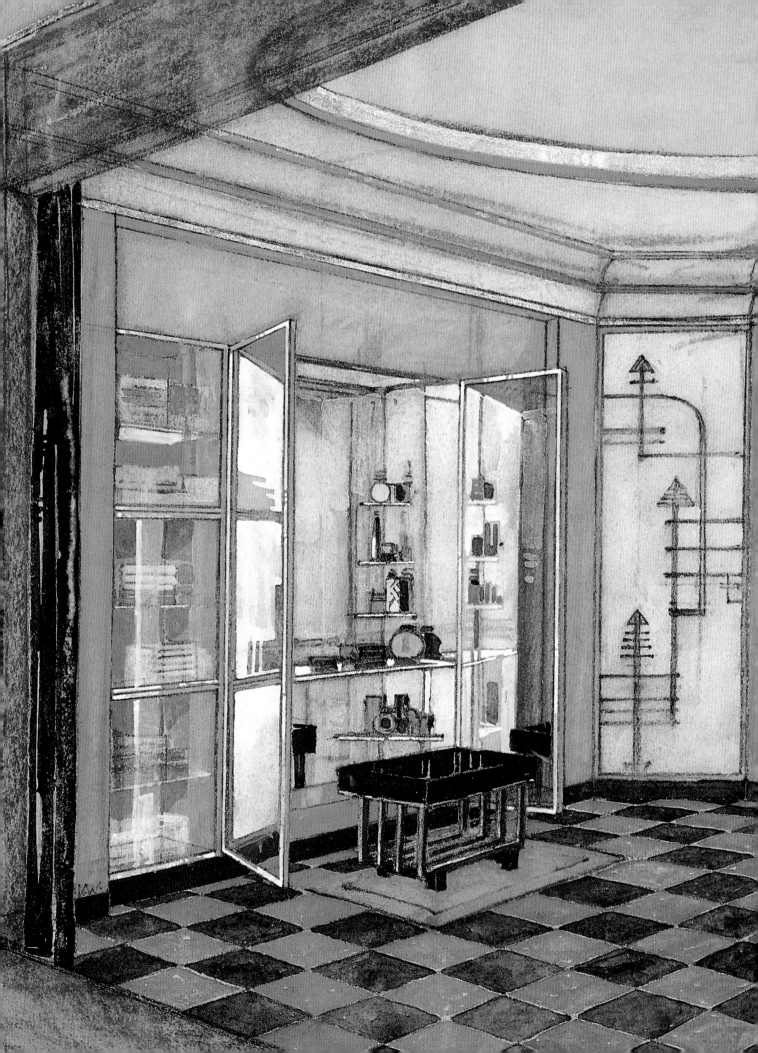

Modern
in feeling...
Modern
in effect...

Modern, too, these floors, in convenience and utility

An Armstrong's Linoleum Floor, permanently cemented over builders' deadening felt. It is Handmade Marble Inlaid No. 79 with double border of tan and black. This floor has the new Accolac finish.

MODERN, yes . . . but intensely practical, say many leading architects in discussing the new linoleum floors. Naturally, *all* decorative features, whether modern or not, must be practical as well as effective in design. But Armstrong's Linoleum Floors combine both these qualities in an ideal manner—they are not only modern in effect, but modern in feeling, too. Thus they contribute to even the more daringly modern interiors a binding influence which ties together the entire decorative ensemble.

For example, consider Armstrong's Handmade Marble Inlaid designs. They express in their geometric patterns the very spirit of the modern vogue, yet bring to rooms the impressiveness of age-old marble. In many differently sized squares, in varied color-effects, this type of linoleum floor offers surprising decorative possibilities.

And the modern virtues of quiet and comfort, too, these floors bring to rooms! For the resilient cork in Armstrong's Linoleum absorbs sound and cushions footsteps. In addition, consider the

facts that these floors are cleaned with just the sweep of a dust-mop or a damp cloth. The Accolac process, used on Armstrong's Inlaid Linoleum prevents dirt and grit from grinding

into the floor itself and protects its lustrous appearance. Armstrong Cork Company, Linoleum Division, Lancaster, Penna.

*This is No. 3 of a series of color-plates illustrating "Modern Floors in Modern Architecture." The complete set of six will be sent to any architect upon request.

Look for the CIRCLE A trade-mark on the burlap back

Armstrong's Linoleum Floors
for every room in the house

PLAIN · INLAID · EMBOSSED · JASPÉ · ARABESQ · PRINTED

No. 995 (upper left)— Sterling Silver Vase; height, 6¼ inches; $25.

No. 990 (lower left)— Sterling Silver Vase; height, 9 inches; $40.

No. 985—Small Sterling Silver Vase; height, 4½ inches; $18.

No. 1000—Sterling Silver After Dinner Coffee Set. Coffee Pot, $75; Sugar Bowl, Gold Lined, $16.50; Creamer, Gold Lined, $13.50. D1000 — Waiter, 13 inches, $45. Four-piece set, $150.

No. 50—Sterling Silver Cups, height, 5 inches. Per half dozen, $50. No. 855 — Serving Tray, 8 x 20½ inches, $140.

No. 990—Sterling Silver Candlesticks; height, 10 inches; each, $30.

TRADE MARK
STERLING

SENSIBLY INTERPRETING THE SPIRIT OF MODERNISM

FAITHFULLY interpreting the spirit of the day, silver in modern design by Reed & Barton takes note of utility, as well as beauty. Here are pieces one likes to live with, to enjoy, to *use*. Here the influences of modern decoration are applied, *sensibly*, to necessary silver. See the new designs in Reed & Barton Silvercraft at your jeweler's today, or if he is not yet showing these modern pieces, he will be glad to secure them for you upon short notice.

TAUNTON, MASS. REED & BARTON NEW YORK, N.Y.

REED & BARTON

STERLING TAUNTON, MASSACHUSETTS ESTABLISHED OVER 100 YEARS SILVER PLATE

6.6 Advertisement, *House & Garden* (June 1928), 23.

of the patterns are shown in plates 12, 13 and 14.

From France, Christofle et Cie sent a large selection of silver and pewter. Among the offerings was a green and silver vase, attributed to Luc Lanel (plate 15). The vase, named "Ecailles," had first been produced in 1926, when it appeared in the Christofle catalog at a price of 250FF or $9.50.[28] A vase identical to the one shown at Macy's appeared as item 1 in the 1931 *Dinanderies* catalog, and a similar vase graced the cover of the catalog (plate 16). Among the other French offerings was a *dinanderie* vase by Jean Dunand, shown in figure 6.7, which was one of a series of vases that Dunand had produced from 1913 on.[29]

Italy was also well represented in the display cases, with dozens of offerings of glass from Murano and ceramics from Milan and Livorno among the objects exhibited. Richard Ginori of Milan sent numerous ceramics pieces designed by Gio Ponti, including a tea service, a coffee service, and representative pieces in various patterns. Plate 17 illustrates the "Nautica" pattern exhibited at the exposition. The "Nautica" vase is representative of the

color palette that characterized the Italian exhibits.

Sweden presented nearly one hundred decorative objects, including textiles, glass, ceramics, silver, and pewter (fig. 6.8). *The Ceramic Age* reported great interest in the glass made by Orrefors Bruks Aktiebolag, designed by Simon Gate and Edward Hald, and the glass made by Kosta Bruks Aktiebolag, designed by E. Dahlskog.

From the "Court of Honor" the visitor could catch glimpses of the room settings, arranged by country. These settings embodied the common denominators of modern design. Many critics commented on the extensive use of color, including Marion McCarroll of the *New York Evening Post*, who also noted the pervasive luxury and a "restful restraint."[30] The *New York Times* noted the "smooth unbroken surfaces" with little decoration that consisted in the main of "color and other flat treatment," which permitted mass production of good design.[31] Elisabeth Cary of the *Times* perceived an emphasis on furniture low to the ground, remarking on the tendency "to lie low, to sit low, to stoop low."[32] She also commented on the attempt to conserve space with

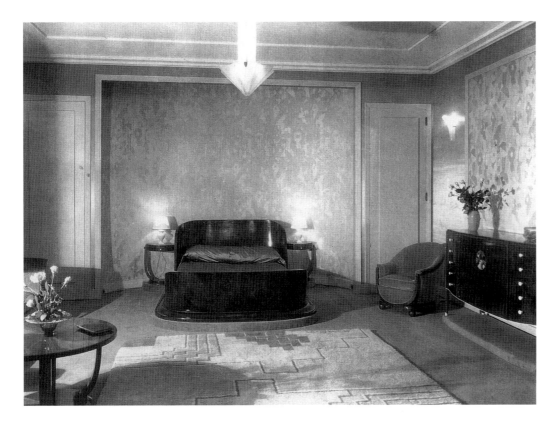

furniture that served several purposes.

Beyond these common characteristics, there were variations among the exhibits that lent support to Virginia Hamill's assessment of the national characteristics of the participant nations. The French rooms, for example, buttressed Hamill's characterization of the French offerings as luxurious.

In the bedroom by Jules Leleu, the furniture was predominantly made of rosewood, with inlaid ivory on the dresser (fig. 6.9). The color scheme incorporated chairs covered in rose velour, as well as wall hangings in blue, violet, and silver fabric. The curved bed was set into a shallow alcove.[33]

The furniture in the Leleu bedroom at Macy's was based on designs that Leleu had implemented in 1927 for M. Winburn, the founder and president of the French company Cadum.[34] Leleu continued to use this furniture throughout 1928 and beyond. In the spring of 1928, the Macy's armchair appeared at the eighteenth *Salon des Artistes Décorateurs*.[35] In the fall of 1928 Leleu presented the bed, pedestal table, and a similar dresser at the twenty-fifth Salon d'Automne in Paris.[36] Thus, with respect to Leleu, New Yorkers were seeing current European "modern" design.

Like the Leleu bedroom, the French dining room, designed by Maurice Dufrêne and executed by La Maitrise at Galeries Lafayette in Paris, had an air of luxury (figs. 6.10 and 6.11). The furniture in the dining room consisted of a table designed by Raymond Subes, a set of eight chairs, and a rosewood buffet with marble top and base, above which sat a large mirror framed in palisander wood. Opposite the buffet, wrought-iron gates designed by Edgar Brandt connected the dining room to the living room. A large silvered bronze lighting fixture hung over the table, and a leaded glass window decorated one wall. The window, encased in a heavily carved molding, was described as a "futuristic conception of a Gothic ecclesiastical design."[37]

Both the silk wallcovering and the long, narrow carpets on the floor varied in shades from tan to brown. These neutral colors were offset by Aubusson tapestry panels flanking the mirror and

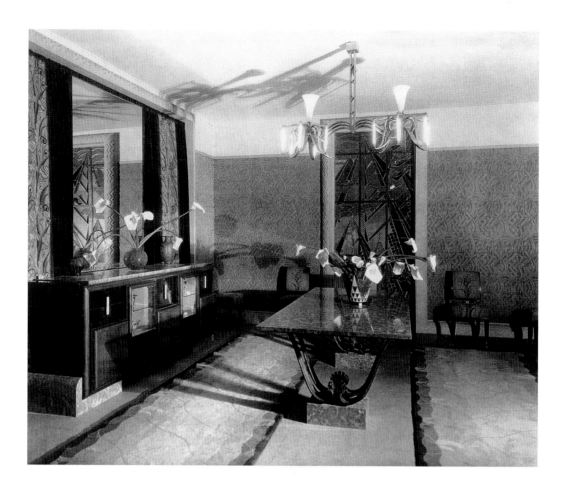

6.10 View of the dining room designed by Maurice Dufrêne for the 1928 Macy's Exposition. Courtesy of Macy's East, Inc.

Aubusson upholstery on the chairs, all of which incorporated flowers in "garden colors."[38] Most of the critics liked this room a great deal. Augusta Owen Patterson of Town & Country found the room to be "wisely unrhetorical and vastly encouraging," particularly in its colors and contours,[39] and Nellie Sanford could not imagine a "more elegant and lovely dining room."[40] The praise was not, however, universal. Marion McCarroll considered the room to be "heavy in appearance, and exceedingly formal,"[41] while C. Adolph Glassgold declared that the room was stylistically inconsistent and would injure Dufrêne's reputation.[42]

To a degree, the room reflects the somewhat schizophrenic state of modern design in Europe in 1928. The curvilinear Brandt wrought-iron gates harmonized well with the table, but both of these were somewhat inconsistent with the buffet. The Subes table at the Macy's Exposition was similar to

one that had been shown in the dining room designed by Dufrêne for the Ambassade Francaise at the 1925 Paris Exposition, but in 1925 it was accompanied by chairs that complemented its curvilinear base (pl. 18).[43] The buffet, chairs, and carpets had been exhibited at the 1927 *Salon d'Automne* in Paris, where they had been accompanied by a table and lighting fixtures that echoed their rectilinear designs.[44]

Given the short lead time for the Macy's Exposition, Dufrêne may have simply put together furniture and furnishings available to him, the result being that the dining room did lack the coherence of his designs for other exhibitions. At the time of the 1928 Macy's Exposition, Dufrêne was engaging in design that was far more adventuresome than that of the Macy's dining room. In the "Coin de L'Escalier" he designed for the *Salon des Artistes Décorateurs* in Paris in the spring of 1928, geometric patterns replaced curves, and metal

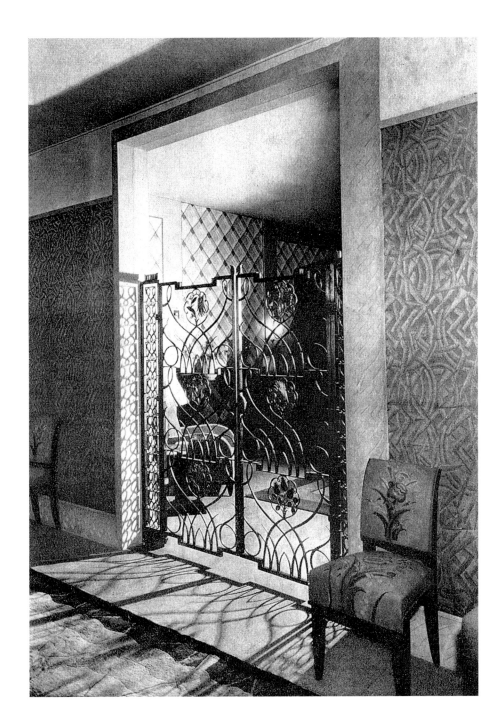

6.11 View of dining room designed by Maurice Dufrêne for the 1928 Macy's Exposition. Photograph by Gillies. *American Architect* (20 June 1928), 823.

replaced wood (fig. 6.12). See also pl. 19.

The *New York Times'* Walter Rendell Storey thought that the French living room shown in figure 6.13, designed by Philippe Petit and Rene Joubert and executed by their firm D.I.M. (Decoration Interieure Moderne), better reflected "the popular notion of French modernistic art" than the Dufrêne dining room. Storey singled out for comment the rose-colored "criss-cross" fabric covering the walls, the wall lights made of metal with alternating disks of frosted and clear glass, the "téte-à-téte chair" upholstered in copper velvet that incorporated "a wooden shelf at each end for books or ash tray," and the easy chair, with concealed mechanisms that enabled the occupant to adjust the chair.[45] He seems to have concluded that geometric patterns, angular forms, furniture that combined several functions, and new materials, or old materials treated in an unusual manner, all reflected what the public considered to be modern French design.

The cabinet in the room must have been considered one of D.I.M.'s finest designs, as it had been shown at the 1926 *Salon des Artistes Décorateurs*, and at *L'Exposition d'Art Francais Contemporain a Bucarest*.[46] It was representative of much of French modern design of the period-it had no applied ornament, but derived its interest from the inlay of various kinds of wood. Perhaps the most striking element of the room, however, was the screen by Jean Dunand, denoted in the catalog as "Screen in red lacquer, decoration 'Tigre.'"[47]

M. George Brunel, in his essay for the French section of the *Macy's 1928 Catalog*, emphasized the importance of presenting modern design in "such favorable conditions that every contributing element is given its proper valuation."[48] Some critics considered the French rooms to have successfully reflected this emphasis on harmony.[49] Others saw internal inconsistencies. Some critics focused on the artistic elements of the furniture, others on the practical aspects. There was disagreement among the critics on the quality of many of the room settings, probably reflecting their own prejudices.

These reactions were just what Percy Straus and the other organizers of the exposition sought. They believed that if Americans experienced a wide variety of modern design, ultimately an American version would emerge.

In his review of the exposition, Henry McBride of the *New York Sun* noted that the public, "recruited from all walks of life," demonstrated "a frantic desire to get at the truth of this modern art business instantly," accepting it as inevitable. After watching the "housewives, designers and manufacturers of furniture" jostling each other and making notes of the exhibits, McBride concluded that "Americanism is the thing we need to crystallize" in design, because much of the European exhibits express "what the Europeans consider to be the American idea."[50]

The critical reaction to the German rooms, designed by Bruno Paul and arranged by Tillie Prill-Schloemann, with products of eighty German firms, indicated that the Germans had a pretty good idea of what Americans would approve in modern design. Storey considered the German dining room shown in figure 6.14 to be "one of the most significant rooms in the Exposition."[51] Margaret Bruening of the *New York Evening Post* found "nothing bizarre or disturbing even to conservative onlookers, yet with every detail novel and original."[52] Royal Cortissoz, while critical of the furniture, did acknowledge a harmony of color that denoted "artistic taste."[53]

The colors in the dining room were its most striking elements. Lemon yellow silk covered the walls, one wall being embellished with hand-painted modernistic flowers in shades of soft greens and yellows.[54] A "satiny material, two-toned in tan and green," covered the chairs and draped the windows.[55] A woven carpet rested on a green painted floor, and the green woodwork closely matched the floor color.

The ceiling was slightly darker than the walls. Hidden lights filtered through the upper portions of the silk wallcovering. The light-green dining table and chairs harmonized with a light-green serving table, and with the sideboard, which featured alternating light-green and silver horizontal bands. The candelabra and the long mirror between the two windows echoed the silver of the sideboard and the chairs. White marble topped the sideboard, and an embroidered white transparent tablecloth covered the dining table. Yellow and white calla lilies completed the color scheme. It would seem

Opposite: 6.12 "Coin de L'Escalier" designed by Maurice Dufrêne. *Interieurs au Salon des Artistes Décorateurs Paris 1928 presentes par René Prou* (Paris: Charles Moreau, n.d.), plate 35. Helio Faucheux et Fils, Chelles.

Overleaf: 6.13 View of the living room designed by Joubert et Petit for the 1928 Macy's Exposition. Photograph by Sigurd Fischer. Library of Congress 267-N1.

that the whole room gleamed, due to the silk on the walls, the silver wicker on the chairs, the silver candelabra, the long mirror between the two windows, and the surface of the furniture, which some critics described as lacquered, others as enameled. Waxing poetic, one critic described stepping into the room as "more refreshing than having a cool breeze blow unexpectedly on a boiling day."[56]

With the exception of the sideboard, the dining room furniture was not as exciting as the color scheme. The chairs, which seem to have descended from eighteenth-century English hoop-backed dining chairs, were a variant on some that Paul had used in other 1928 designs, with the addition of an odd flowerlike shape between the arm and the seat.[57] The serving table, unseen in the period photographs, had a "modernistic, geometric shape" and unfolded "to make a refectory table of no mean length."[58] This table was Paul's only contribution to the combination furniture that was so prevalent at the time.

The piece that received the most attention in the dining room was the sideboard, which pleased none of the critics. Glassgold may have captured the thoughts of many viewers when he expressed his view that the "gruesome" sideboard "looked too much like a coffin to be entirely pleasant."[59] Cortissoz, decrying the "contours of the chair backs" and the "long, bulbous layers of wood in the sideboard," used this room to buttress his argument that while modern designers excelled in the use of color, they failed in their efforts to derive new forms of furniture.[60] Notwithstanding the critical reaction, it would seem that the "coffin" form was a favorite of Paul and his clients in Germany, as it appears in his designs from 1925 through the mid-1930s.[61]

Paul's other room for the show, the "Man's Study" (fig. 6.15), was a replica of one he had designed in 1925 for the director general of the German State Railways.[62] This room was more conservative than the dining room, both in its color scheme and in the furniture shapes. The bookcase, desk, round table, and desk chair featured a deep-

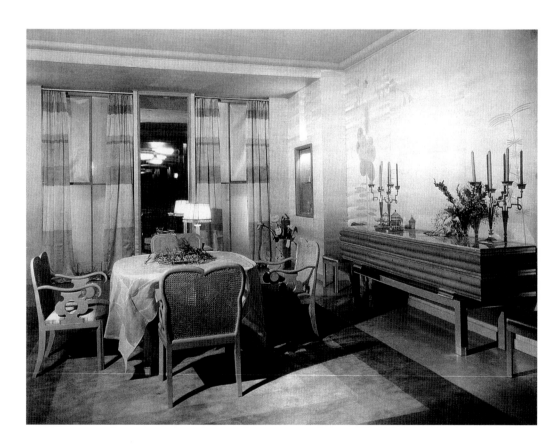

6.14 View of the dining room designed by Bruno Paul for the 1928 Macy's Exposition. *Upolsterer and Interior Decorator* (15 August 1928), 97.

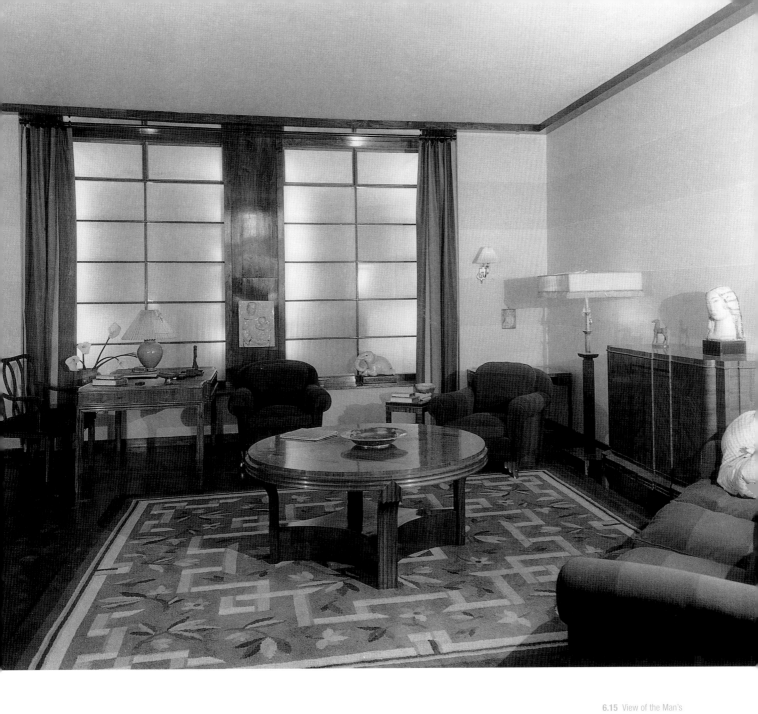

6.16 View of the Italian country living room designed by Gio Ponti for the 1928 Macy's Exposition. Herbert Photos. Collection of Tucson Museum of Art.

brown wood veneer, which complemented the dark green upholstery of the sofa and the two armchairs.[63] Light walls and transparent curtains in green and yellowish tan moderated the effect of the dark furniture and upholstery, while a rug in green and tan completed the color scheme.[64]

This was a room that was bound to appeal to those seeing modern design for the first time. The furniture was not "bizarre," but it had the elements of modern design-emphasis on geometric patterns, focus on comfort, no applied ornamentation. The colors were not garish, but they were strong and varied. The wide horizontal stripes on the walls, echoing the stripes on the easy chairs and draperies and the horizontal panels on the windows, pulled the whole room together.[65] Neither Paul's dining room nor the den represented the cutting edge of European modernism, which was reflected in the work of Paul's countrymen at the Bauhaus in Germany, but both rooms were a departure from the period settings that had characterized American design.

Paul, whom *Women's Wear Daily* referred to as

"Germany's leading architect and designer,"[66] envisioned the future of modern design as "the style of the modern man who masters the distances between countries and continents with the airplane; of the man of today whose clear voice resounds all over the globe, and whose feeling and thinking transcend the confines of countries and continents."[67] Paul's rooms for the Macy's Exposition probably exhibited fewer "nationalistic" traits than many of the other rooms, which may account in part for the critical acceptance they received in New York.

By contrast, the Italian country living room designed by Gio Ponti and executed by La Rinascente of Milan, seemed to many critics to be suffused with Italian classical history. Though Nellie Sanford considered the room, shown in figures 6.16 and 6.17, to be modern, she saw ancient Rome in the "garland-wreathed columns, and the use of painted cords and draperies."[68] To Storey, the curtained doorway on the short wall and the windows on the two long walls synthesized "the gayety of the Italian wall decorations of the eigh-

6.17 View of the Italian country living room designed by Gio Ponti for the 1928 Macy's Exposition. Photograph by Sigurd Fischer. Library of Congress 267-N5.

teenth century." [69]

The furniture reinforced the sense of new design based on classical imagery that was characteristic of the *novecento* style fashionable in Italy at the time. Spare, rectilinear, and surmounted with geometric elements resembling broken pediments, the tall cabinets along one long wall evoked a sense of Renaissance cabinets, stripped down, like the draperies and columns in the wall paintings, to their structural essence. In the ladder-back chairs with rush seats, Ponti re-created the peasant furniture that had been found in the Italian and French countryside for centuries, but, again, with a spareness and rectilinearity that brought them into the twentieth century. One can see in these chairs both the past and the future; the "superleggera" chair designed by Ponti in 1957 would seem to have originated in this room. [70] The long, narrow wooden pedestal table recalled the classical version made of marble, and the shape of the table was echoed in the three narrow runners on the floor. Both Storey and Cortissoz saw this room as proof that modern designers could take old forms, but

vary them and present them in a new manner to create a modern look.

Ceramics, manufactured by Richard Ginori in a classical mode, completed the harmonious scheme. For Cortissoz, the "structural unity" of the room differentiated it from the others in the show; the "brown tones in the furniture, those in a lighter key on the walls, and a certain refinement pervading everything," marked the room "as one in which a person of fastidious taste might live." [71]

No one would live in the other Italian room, which was a modern "First Class Meat Market" designed by Felice Casorati of Turin (fig. 6.18). One of Italy's foremost architects, Casorati designed the shop for the Monza Biennale in 1927, in order to demonstrate that "art may pervade every field of activity in the truly modern spirit." [72]

The shop, which the *New York World* thought would precipitate "a mild riot on Amsterdam Avenue," was eighteen feet square and done completely in white. [73] It featured as decorative objects sculptured heads of oxen and hogs, executed in white chalk with a pure white glaze, along with

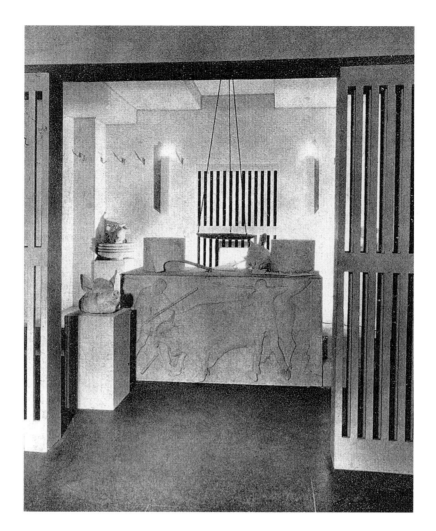

6.18 View of the butcher shop designed by Felice Casorati for the 1928 Macy's Exposition. Photograph by Herbert. "Le Esposizioni," *Domus* (October 1928), 18.

plates, knives, and cleavers. The counter featured a bas-relief entitled *Killing of the Bull*, in which two men poised to kill a bull represented the business of the shop.

Like the Ponti dining room, this shop was reminiscent of the past-it hearkened back to the days before refrigeration, when shops carried only what they could keep fresh in the wooden drums that sat on top of the counter. Yet, it was modern, both in its starkness and in the geometric forms of the pedestal, counter, and doors. While the design elements were totally impractical, the shop itself represented an attempt by business to combine "appearance and utility" in an effort "to produce a lastingly pleasing effect upon the buying public."[74]

In an essay for the *Macy's 1928 Catalog*, Guido Marangoni, the director general of the 1927

Monza Biennale, exhorted Italian "artists, artisans and manufacturers" to focus on "typical, normal and average products-samples of mass production, objects for everyday use that are noble and dignified withal."[75] Marangoni's goals were quite similar to those of Robert de Forest, who, in his foreword to the catalog, bemoaned American manufactured products as "in form or color, an affront to man and God."[76] Complimenting Macy's on its efforts to improve the standards of design, de Forest expressed his hope that efforts like the exposition would cause manufacturers to "anticipate the trend towards design which will catch the spirit and rhythm of modern life."[77] In the statements of Marangoni and de Forest, and in the efforts they described, were the seeds of modern industrial design.

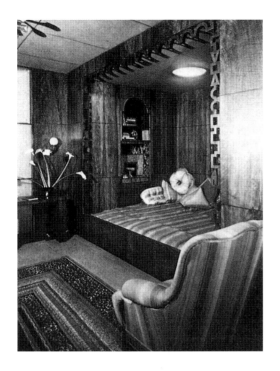

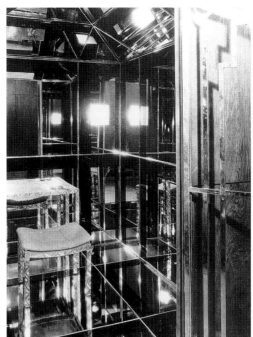

Unlike Marangoni and de Forest, Josef Hoffmann was not concerned about design for the masses; his boudoir and powder room for the 1928 Macy's Exposition were luxuriously appointed with broad expanses of panels of dark walnut and large mirrors, respectively (figs. 6.19 and 6.20).

In the powder room, angled mirrors lined the floor, walls, and ceiling to provide multiple images of the occupant. Both the mirrored surfaces and the brass dressing table and stool reflected the concealed lighting.

The powder room was the anteroom to the boudoir, which *The Gift and Art Shop* found "at once restful and oddly stimulating."[78] The restful elements were the panels of dark walnut set off by black wood inlay, in a pattern that was repeated in a lighter ceiling. The furniture consisted only of a long table beneath the window, finished in the same pattern of walnut squares, and two easy chairs, upholstered in a "striped fabric of dull tones of color" that was also used as the bedcover.[79] The bed was completely set into a deep alcove, which provided the stimulation. On the back wall, panels of colored inlaid woods depicted "amusing scenes from the daily round of events in the life of the modern woman of fashion."[80]

Recessed shelves held books, and drawers and cabinets held personal objects. While most critics applauded the sophistication and versatility of the alcove bed, some questioned its practicality in America. Henry McBride, who had also been critical of the Leleu bed, conceived of "difficulties for the valet-de-chambre who must make up the bed," noting that "all know how ill-fitted the American valet-de-chambre is to cope with difficulties."[81]

The bedroom had been designed many years earlier. Hoffmann first showed the room in 1923 at an exhibition at the Austrian Museum, and subsequently included it as part of the Austrian exhibition at the 1925 Paris Exposition.[82] Hoffmann, like some other exhibitors, may well have wanted to bring to America a tested design, to assure acceptance of the concept of modernism. As noted above, this acceptance was important to Austria, for diplomatic reasons as well as financial ones, so it exhibited hundreds of objects in addition to those in the boudoir. The Austrian objects were shown in a special case designed by Hoffmann that ran along the arcade.

In a catalog statement, Hoffmann expressed an unwillingness to tolerate "used-up, out-of-place copies of old styles on our buildings, furniture, and

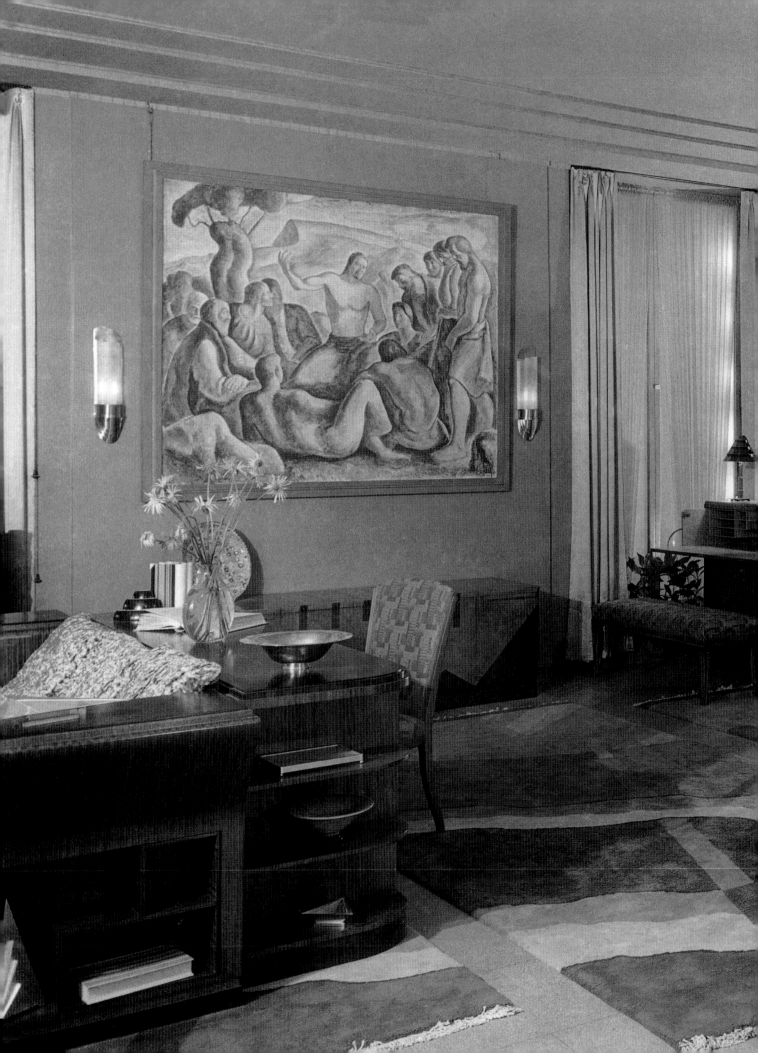

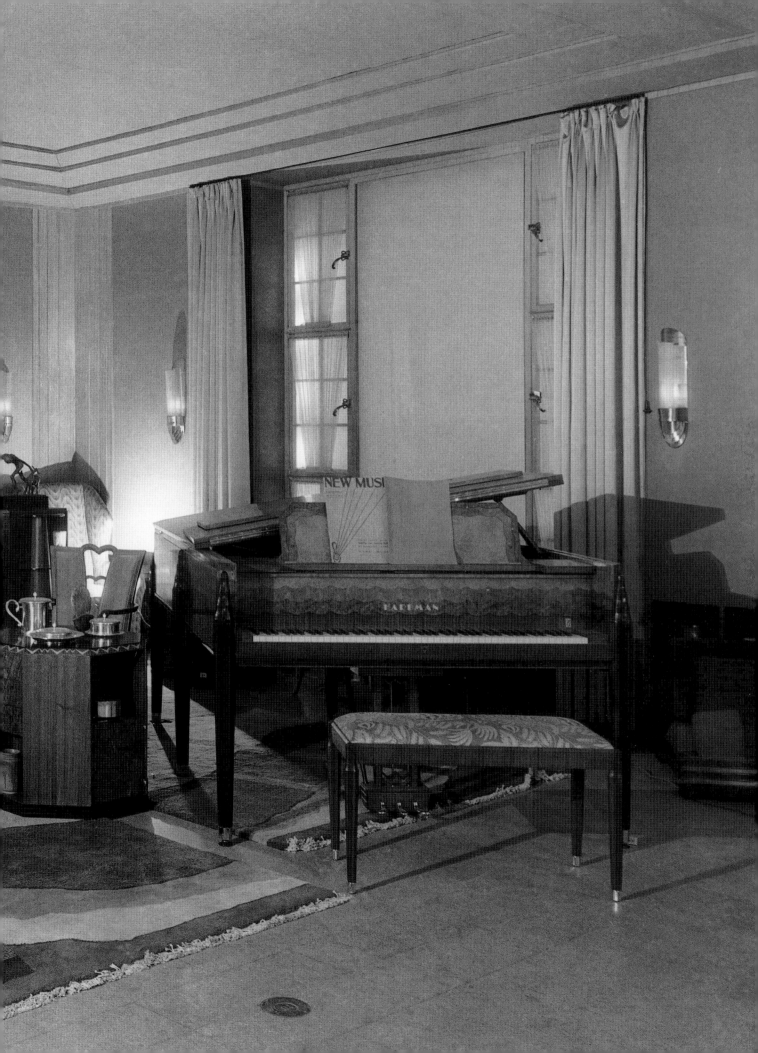

6.22 View of the living room designed by Eugene Schoen for the 1928 Macy's Exposition. Courtesy of Macy's East, Inc.

all the little things we use."[83] While the European rooms at the exposition did present a new aesthetic to many Americans, they represented only the conservative iteration of modern design, with muted colors, furniture made of wood rather than metal, and curvilinear elements softening geometric shapes. The American rooms covered a broader spectrum of modernity, from Eugene Schoen's "singularly livable living room," through Kem Weber's "epitome of city life . . . with small space, and every smart little convenience which is available," to William Lescaze's "dazzling" penthouse that was "easily the most extreme interior in the Macy exhibit."[84]

The living room designed by Eugene Schoen was a multipurpose room with multifunction furniture (figs. 6.21, 6.22 and 6.23). In one area of the room, a fireplace with a metal surround created the focal point for a cozy seating area that consisted of a sofa, two armchairs, and a small occasional table. The sofa, however, was no ordinary piece of furniture; in an article written for *Creative Art*, Schoen described a similar sofa and explained the

purpose behind its design:

Modernist interior architecture . . . has been dictated not only by a desire for novelty, but by the congested way in which people must live in large cities, the general democratisation and absence of servants and the few rooms, with their conveniences, in which they must live. . . . In the sitting room . . . may be found an interesting combination of sofa and library table in front of a simple fire-place. The sofa is roomy—in fact large enough to act as a comfortable bed, as the springs in this piece of furniture extend from the floor to the cushions. The side arms of the sofa have nooks in them to store away books, smoking articles, radio apparatus, even, making it unnecessary for the occupant to rise to have these conveniences at hand. The ends of the sofa are removable and can be easily attached to one another and form an excellent table to be used either for cards or dining for a small group. The library table behind the sofa has shelves on it for art objects and books, cupboards in which to stow away writing things, knee hole space to make a most comfortable desk out of it, all of which is distinctly American in feeling and foreign to European ideas.[85]

Across the room from the seating area sat a

Modernique piano that was distinguished from more traditional models by long, tapering legs hipped to the body of the piano in the style of Ruhlmann. The piano, veneered in burl walnut and maple patterns that suggested soundwaves, may have been the inspiration for the use of a three-part carpet. While the three pieces comprised one pattern, consisting of a setting sun, the center piece could be removed for dancing, leaving the other two pieces in place. For more serious endeavors, Schoen included a secretary, which appears to have been *en suite* with a long, low chest and a folding screen, all featuring inlaid geometric patterning.

In her thesis on Schoen, Karen J. Rigdon argues that Schoen's living room may have drawn negative reaction because it had not been designed specifically for the show but instead had been pulled together from room settings designed for his gallery.[86] As an example of the negative response to the room, Rigdon cites Glassgold's vitriolic review, in which he found "no central

motive, no feeling for arrangement, no reserve and no restraint."[87] Notwithstanding the disparate origins of the pieces, the criticism seems to have been a mite harsh. Each grouping of furniture appears internally consistent, and the room was large enough to create an aura of spaciousness despite all of the furniture.

Some of the aspects of the room were very clever. Atop the secretary sat a gunmetal lamp, designed by Schoen and executed by Nessen Studio, with a shade that was tilted to give better reading light. The octagonal side table next to the piano provided both extensive surfaces for display and drawers for storage. The low bookcases inset into the wall around the room utilized otherwise dead space. They were lined in vermilion, which, like the carpet, added color to the otherwise neutral palette.[88] The large painting of *The Pilgrim Fathers*, by Thomas Hart Benton, created a dramatic focus for the room. The lighting, the fireplace, and the many silver pieces by Peter Müeller-Monk must have created a play of light and color.

Some critics applauded Schoen's work.

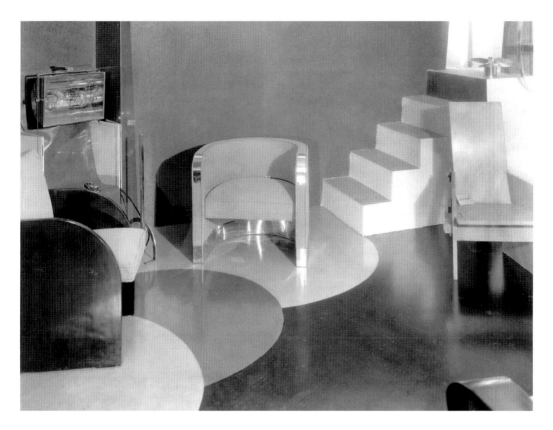

Opposite: 6.24 View of
the penthouse designed
by William Lescaze for the
1928 Macy's Exposition.
Courtesy of Ilonka P.
Sigmund.

6.25 View of the pent-
house designed by William
Lescaze for the 1928
Macy's Exposition.
Courtesy of Ilonka P.
Sigmund.

Sanford, who found Schoen's living room to be
"singularly livable," reported that "many visitors
thought that he came nearer than any to approach-
ing the needs of America of today in the modern
movement."[89] Storey appreciated Schoen's emphasis
on practicality.[90]

Practicality does not appear to have been the
driving force behind the second American room,
designed by William Lescaze (figs. 6.24 and 6.25).
According to Lorraine Welling Lanmon, Lescaze
and his collaborator Ilonka Karasz designed this
penthouse studio so as to exhibit "as many objects
and ideas as reasonably possible within the space
available."[91] Storey, however, saw no internal incon-
sistency in the room; to him, it reflected Lescaze's
view that the interior architecture of a room
should be the formative decorative element, with
fabrics and decorative accessories playing a minor
role. Storey commented that Karasz's furniture,

which included the sideboard, the low table, and
the chaise, enhanced the "architectural simplicity of
the interior."[92]

Perhaps the most provocative feature of the
room was its color scheme. Two walls were paint-
ed: one in cream yellow, and the other in eggshell
white. A third wall was covered in a deep blue syn-
thetic fabric called Fabrikoid. Circles and half cir-
cles in "scarlet, vivid green, orange, and purple"
embellished the black lacquer floor, and four silver
steps led to a black landing that opened onto an
imaginary balcony.[93] The chairs were "scarlet lac-
quer," "kingfisher blue leather and black wood, "and
"silver shiny material like leather." [94] Electric lights
enhanced the effect of the color. The lights, con-
cealed behind the windows and recesses in the
walls, shined on three different metals running
from floor to ceiling in the corners of the room.
An ultraviolet ray in one corner simulated sunlight.

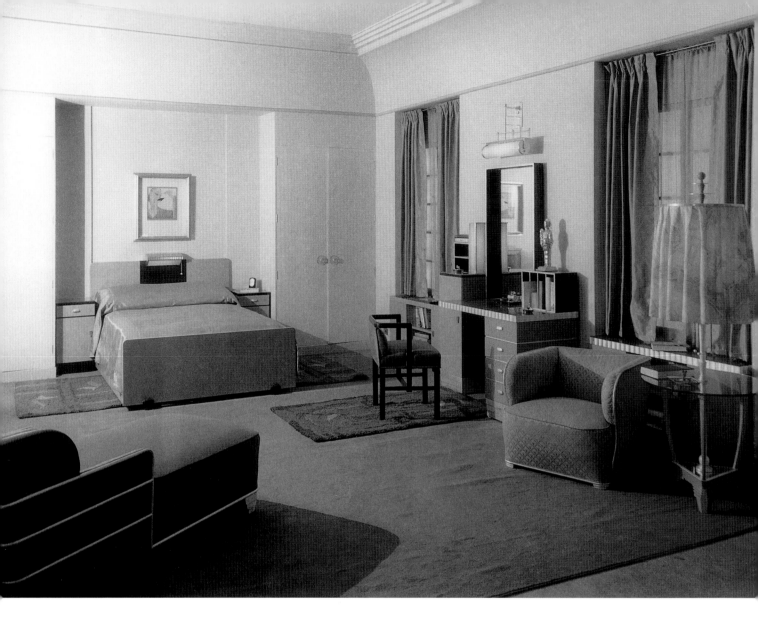

Lescaze's eclecticism may have been exactly what Macy's management was seeking in its effort to determine what elements of modern design would appeal to New Yorkers.

Karl Emanuel Martin ("Kem") Weber presented a third iteration of modernism, which most critics, and the public, found to be the perfect combination of practicality and style (figs. 6.26, 6.27, 6.28, 6.29, and 6.30). Weber's three-room apartment, which encompassed a living room/bedroom, a dining alcove/kitchenette, and a bathroom/dressing room, "was the epitome of city life, lived as it must be by city folk, with small space, and every smart little convenience which is available."[95]

In the living room/bedroom (fig. 6.26), two nightstands flanked a bed set into a shallow alcove.

As in the Schoen living room, bookshelves, built low and into the walls, conserved space. The dressing table doubled as a desk, and a table lamp provided both surface space and illumination for a reader in the comfortable chair. The deeply coved ceiling added architectural interest, while the yellow walls and red lacquered chair supplied color. The chaise, upholstered in what appears to have been a satiny fabric, lent a note of luxury to the interior. Both the chaise and the table lamp apparently sparked the interest of visitors from *House & Garden*, as they appeared on the cover of the magazine in September, 1928 (pl. 20).

In the dining alcove/kitchenette (figs. 6.27 and 6.28), Weber adopted several space-saving concepts. A small red table was surrounded by only

6.26 View of the living room/bedroom designed by Kem Weber for the 1928 Macy's Exposition. Photograph by Sigurd Fischer. Library of Congress 267-N3.

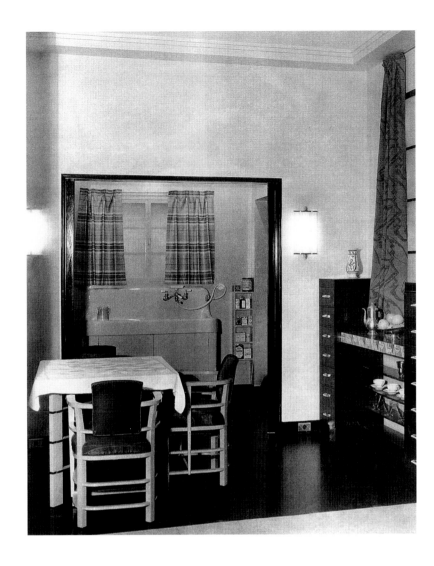

6.27 View of the dining alcove/kitchenette designed by Kem Weber for the 1928 Macy's Exposition. Courtesy of Macy's East, Inc.

three red chairs, upholstered in a shiny dark brown fabric.[96] Instead of a fourth chair, an armless sofa, covered with the same fabric, was wedged between two tall cabinets in dark wood. Opposite the sofa and cabinets, a serving table and several low shelves were placed between another pair of cabinets. The walls, painted the same soft yellow as the bedroom/living room, provided a neutral background for the furniture.[97] Sliding doors opened into the kitchenette, which had a sink in jade green enamel located on the long wall facing the dinette. A low refrigerator and an electric range, also green, faced each other on the short walls perpendicular to the sink. *House Furnishing Review* commented that the arrangement, in addition to being esthetically pleasing, was very practical, as the heat

from the stove would not adversely affect the food in the refrigerator. Simple green shelving provided handy storage. Curtains in brown and red linked the kitchenette to the dining alcove.[98]

The bathroom/dressing room (figs. 6.29 and 6.30 and pl. 21) garnered the most comment-all favorable. Weber chose jade green for the sink, bathtub, and various accessories. In this room, the walls were also green, up to the moldings, which, like the ceiling, were yellow. Green and black tiles covered the floor. A Crane Company "Tarnia" bathtub was set into an alcove, at the rear of which a mirror was built into the wall. To the right of the bathtub, set into a corner, stood a built-in shower, tiled in black and white, enclosed by a door of frosted glass with an etched geometric design. To

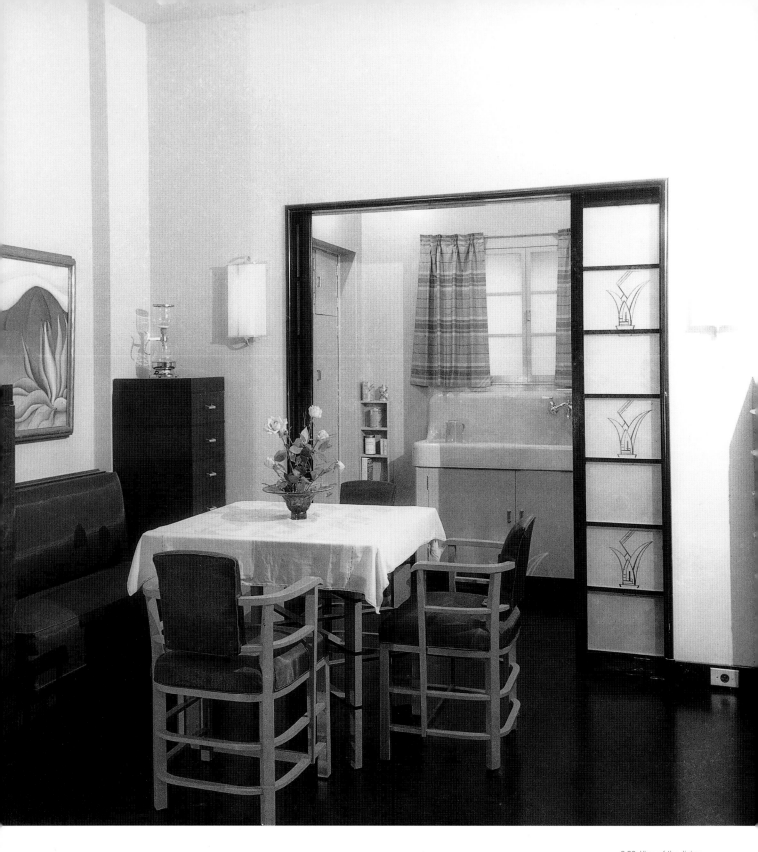

6.28 View of the dining alcove/kitchenette designed by Kem Weber for the 1928 Macy's Exposition. Photograph by Sigurd Fischer. Library of Congress 267-N2.

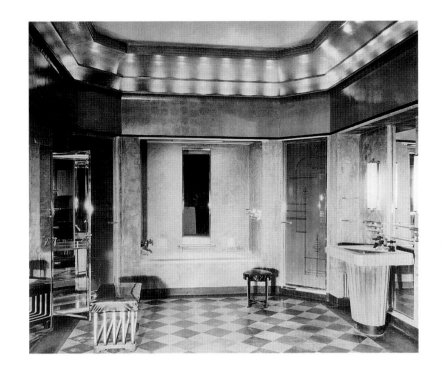

6.29 View of the bath-
room/dressing room
designed by Kem Weber
for the 1928 Macy's
Exposition. Courtesy of
Architecture and Design
Collection, University Art
Museum, University of
California, Santa Barbara.

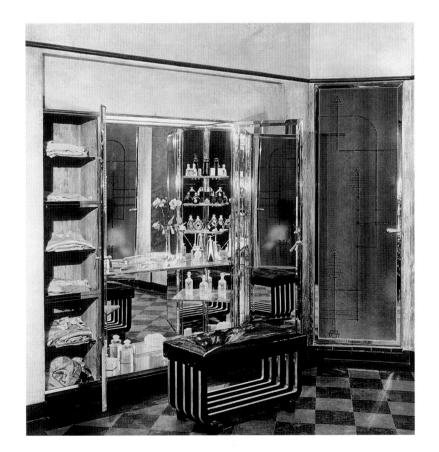

6.30 View of the bath-
room/dressing room
designed by Kem Weber
for the 1928 Macy's
Exposition. Courtesy of
Architecture and Design
Collection, University Art
Museum, University of
California, Santa Barbara.

the right of the shower, a green Crane "Corwith" sink with a specially designed base was also placed in an alcove, with a mirror, triangular glass shelves for storage of necessities, and two metal wastebaskets.

To the left of the tub another etched glass door, also set into a corner of the room, probably enclosed the toilet, which was not mentioned in the press. Facing the sink was a wall of tall glass cabinets that enclosed storage shelves and a glass dressing table. The low bench, set on chrome tubing that echoed the lines of the chaise in the bedroom, completed the ensemble.

A number of critics commented that Weber's rooms attracted more attention and favorable comment than any other rooms in the exposition. Bruening wrote: "There is novelty of form and line, but there is a practical character to all of the furnishings with no obvious striving to be bizarre and out of the ordinary that usually marks [America's] efforts in such work . . . The simplicity and good taste of the whole arrangement made a strong appeal, while the utilitarian end was well served." [99]

Of all the exhibits, Weber's rooms should have given Robert de Forest the most pleasure, as they proved his thesis that art could be brought into everyday life without enormous cost. Weber, believing that it was his responsibility as a designer to work with manufacturers, designed his furniture for mass production and used standard appliances. Minor changes in a piece of furniture could create a completely different look. The bedroom chaise was produced in other versions that retained the structural elements, but varied in the details.

Weber also appears to have been the individual who best fulfilled the hope of the organizers that American designers would take the modern European design and modify it to fit American needs. He was particularly suited to accomplish this goal, as he had studied with Bruno Paul in Europe before World War I, but then immersed himself in the design community of California. By accentuating horizontal lines, Weber created a sense of forward movement that would characterize American streamline modern design in the 1930s.

The *Macy's 1928 Catalog* termed the items exhibited "samples," and explained that some samples were for sale and that duplicates of many of the items could be ordered. Macy's constructed a

separate "Sales Information Bureau" for the purpose of advising customers of prices, delivery, and any other matters relating to purchase. Ralph T. Walker, who had been selected to design the World's Fair planned for 1930 in Chicago, created the Bureau as a modern business office, with furniture specifically created by the Hale Desk Company to complement the modern interior (fig. 6.31).

The office walls consisted of strips of asbestos in ten shades of gray, from pale gray to black. On the tented ceiling, long strips of fabric alternated with fabric arranged in a large basketweave pattern. The central portion of the gray floor was covered by a brightly colored carpet that echoed the floral pattern of two wall hangings. Gray-and-black-striped fabric covered the sofas and chairs. [100] A large mural by J. Franklin Whitman Jr., which covered the wall behind the desk, was taken to be "indicative of the close cooperation of artist and the architect today." [101]

In his writings, Walker set forth his view that the skyscraper should determine the shape of interior space. [102] The vertical stripes on the walls and furniture of the sales bureau, as well as the soaring ceiling, exemplify Walker's views.

Like Simonson, Walker chose asbestos for the office because he was interested in new materials that would "eliminate by machine as much handwork as possible, taking advantage of the lower machine costs in making possible a new fineness of technique." [103] It is difficult to imagine today the excitement that asbestos must have generated in 1928. Like tubular steel, it was not only an incredibly versatile material, but also one that symbolized a new age of limitless possibilities created by the machine.

Integral to the exposition were the lectures that both added cachet to the show and ensured continuing press coverage. The *New York Times* reported that during the first week, "the auditorium was filled morning and afternoon daily for addresses by authorities on the arts." [104]

Richard Bach explained the importance of exhibitions like the one at Macy's (and, by extension, those held at the Metropolitan Museum of Art) in educating the public about good taste. Lee Simonson also saw educational value in the exposition, as it gave people examples of surroundings in

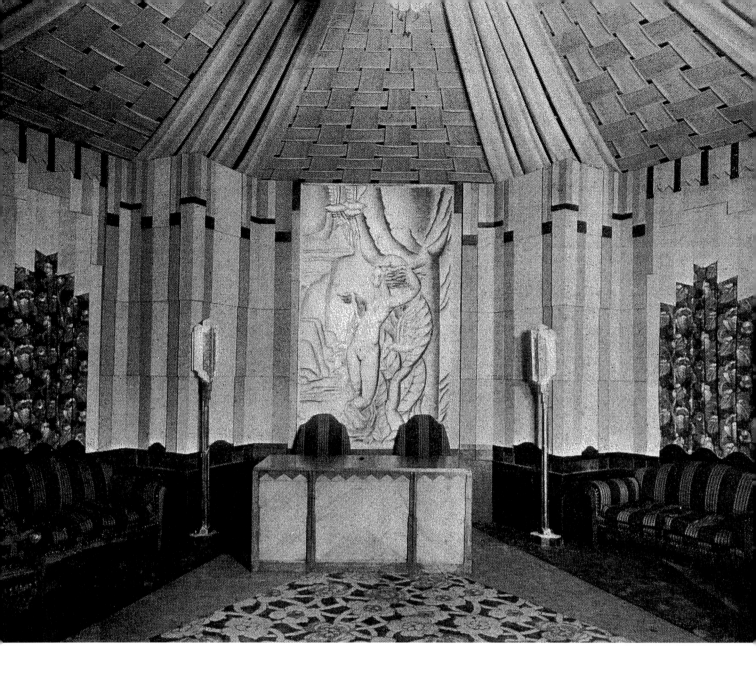

6.31 Office designed by
Ralph T. Walker for the
1928 Macy's Exposition.
The American Architect
(20 June 1928), 825.

R. H. MACY & CO., Inc.

Acknowledges with gratitude its indebtedness to all those who by their assistance and advice have made the International Exposition of Art in Industry possible

"Viewed by over 250,000 people, this Exposition, we hope, has greatly increased American interest in Modern Design"

The ADVISORY COMMITTEE

ROBERT W. DeFOREST, *Chairman*
President, The Metropolitan Museum of Art

AUSTRIA

PROFESSOR JOSEF HOFFMANN
Director, Kunstgewerbeschule

HOFRAT DR. AUGUST SCHESTAG
Director, Oesterreichisches Museum fuer Kunst und Industrie

KAMILLO PFERSMANN
Ministerialrat, Handelsministerium

FRANCE

JEAN DAL PIAZ
President, Compagnie Generale Transatlantique, Paris

CHARLES HAIRON
Vice-President, Societe des Artistes Decorateurs

MAURICE DUFRENE
Societe des Artistes Decorateurs

GERMANY

PROFESSOR BRUNO PAUL
Director, Staatschule fuer Freie und Angewandte Kunst

DR. OTTO BAUR
Director, Deutscher Werkbund

GEHEIMRAT DR. SIEVERS
Auswaertiges Amt

ITALY

DR. ARDUINO COLASANTI
Direttore Generale per le Antichita e Belle Arti, Ministero Pubblico d'Istruzione

GUIDO JUNG
President, Istituto Nazionale per l'Esportazione

DR. R. PILOTTI
Director General, Istituto Nazionale per l'Esportazione

SWEDEN

GREGOR HILMER LUNDBECK
Pres. Swedish Chamber of Commerce

JAMES CREESE, JR.
Sec'y., American-Scandinavian Foundation

UNITED STATES

JOHN G. AGAR
President, The Arts Council of New York

RICHARD F. BACH
Associate in Industrial Arts, The Metropolitan Museum of Art

ALON BEMENT, *Director, The Art Center*

STEWART CULIN
Curator of Ethnology, The Brooklyn Museum

DR. JOHN H. FINLEY
Associate Editor, The New York Times

FREDERICK P. KEPPEL
President, The Carnegie Corporation of New York

PIERRE DE MALGLAIVE
President, The French Chamber of Commerce, New York

KENNETH M. MURCHISON
President, The Architectural League of New York

CONDÉ NAST, *Publisher*

FRANK ALVAH PARSONS
President, New York School of Fine and Applied Arts

CHARLES R. RICHARDS
Director of Industrial Art, The General Education Board

HENRY SELL, *Editor, Butterick Publications*

CHARLES HANSON TOWNE
Editor Harper's Bazar

ALEXANDER B. TROWBRIDGE
Director, American Federation of Arts

RICHARDSON WRIGHT
Editor, House and Garden

• EXHIBITORS •

AUSTRIA

Prof. Josef Hoffmann
August Ungethum — Haus und Garten
Wiener Kunstgewerbeschule
Oesterreichischer Werkbund
Wiener Werkstaette — J. and L. Lobmeyr
Eugen Mayer — Max Welz
Troost — Friedrich
Reinhard — Rothe
Hagenauer — Schachner
Wimmer — Frederich Mayer
Lusk — Nechansky
Duschka — Zimpel
Schaechl — Petrovich
Ubellacker — Doll
Schwamberger — Katzer
Frau Otten-Friedman
Ramsauer — Gompers
Willfort — Kratzik
Meissinger — Palzer
Singer — Rix
Floegel — Baudisch
Kopriva — Vally Wieselthier
Ehmann — Knorlein

FRANCE

Leleu
Maurice Dufrene — Joubert et Petit
Gabriel Englinger — Jean Dunand
La Maitrise — D I M
Adran — Rouard
Hebrard — Christofle et Cie
Paul Daum — Baccarat
Jean Luce — Jacques Gruber
Manufacture Nationale de Sevres
Jean Besnard — Jan and Joel Martel
Union Centrale des Arts Decoratifs
Societe des Tissus et Tapis
Cornille et Cie — Aubusson
Raymond Subes — Reimlingen
Jorgensen — Chevalier
P. Genet and L. Michon
Edgar Brandt — Charles Poisson
Manufacture de Savigny
Claudius Linossier — Jean Serriere
Maurice Daurat — Guilliere
Fjerdingstad — Groult
Luc Lanel — Chassaing
Chana Orloff — Bugatti
Dejean — Pavie
Mme. de Bayser-Gratry
Decorchement — Henri Navarre
Marcel Goupy — Marinot
Decoeur — Lenoble
C. D. Germain — Rene Kieffer
G. Crette — Pierre Mauboussin

GERMANY

Professor Bruno Paul
Vereinigte Werkstaetten fuer Kunst im Handwerk, Munich
Smyrna Teppich Fabrik, Kottbus
Hablik Lindemann, Itzehoe
Richmodishaus fuer Kunst und Handwerk G. m. b. H., Cologne
Handelsgesellschaft fuer Handwerk und Volkskunst, Hamelna Weser
Handelsgesellschaft m. b. H. fuer Handwerk und Volkskunst, Hannover
Lette-Verein, Abt. Textilkunst, Berlin
Werkstaetten der Stadt Halle
Deutsche Werkstaetten A. G. Munich
Emmy Roth, Berlin
Atelier Wendlandt, Berlin
Staatliche Porzellan Manufaktur, Berlin
Staatliche Majolika — Manufaktur Karlsruhe A. G., Karlsruhe i. Baden
Staatliche Porzellan Manufaktur, Meissen
Toepferei Grootenburg Paul Drasler G. m. b. H. Krefeld-Bochum
Keramische Werkstaetten, Douglas Hill, Berlin
Kammerburger Werkstaetten, Dusseldorf
Steingutfabriken Velten-Vordamm, G. m. b. H.
Hael-Werkstaetten, Marwitz
Kurt Zeschmar & Bettina Krumbholz, Leipzig
Martin Buchner, Berlin
K. L. Rosenstock, Leipzig
Glashutte "Brehmenstall", Ernsthal am Renusteg
Puhl und Wagner, Berlin Treptow
Richard Sussmuth, Penzig in Schlesien
Staatliche Fachschule fuer Glasindustrie und Holzschnitzerei in Zwiesel
Professor Ludwig Gies
Martin Seitz — Ruth Schaumann
Professor Waldemar Raemisch
Professor Schumacher — Douglas Hill
Elisabeth Michahelles — Alen Mueller
Kurt Hermann Rosenberg
Professor Hillerbrandt
Professor Ernst Boehm

Professor M. Laeuger — Professor Karl Wach
Professor Scharff — Gertrude Schutz

ITALY

Gio Pugl? — Felice Casorati
Professor Balsamo Stella
Professor Giulio Rosso
Maria Marino
La Rinascente, Domus Nova, Milan
Silvio Raimondi — Hilda Senetura
Vetri Soffiati Muranesi Venini and Co., Murano
Scuola Artistica Industriale, Padua
Maestri Vetrai Muranesi, Cappelin, Murano
M. Jesurum and Co., Venice
Argenterio Christofle, Milan
Riccardo Ginori — Thayaht, Florence
Societa Ceramica Italiana, Laveno

SWEDEN

Simon Gate — Edvard Hald
E. Dahlskog — Jacob Angman
Wiwen Nilsson — Edvin Ollers
Anna Petrus — Astrid M. Aasgesen
Orrefors Bruks Aktiebolag
Kosta Bruks Aktiebolag
Guldsmeds Aktiebolaget, Stockholm
P D. Norstedt & Soner, Stockholm
Swedish Arts and Crafts Co., Chicago, Illinois
A J. Van Dugteren & Sons, New York
J. H. Venon, Inc., New York
K P Lockitt & Co., New York

UNITED STATES

Kem Weber — Lescaze
Ilonka Karasz — Eugene Schoen
Ralph T Walker — Johns-Manville, Inc.
Asbestos Limited, Inc.
Albert Voight Manufacturing Co.
McLeod, Ward & Co. — Karpen Brothers
David E. Kennedy, Inc.
Edison Electric Appliance Co.
General Electric Co. — The Crane Co.
Cotton Textile Institute
Amory, Browne & Co. — McCampbell & Co.
The Willich-Franke Studios
Decorative Rubber Flooring Co.
Shaw Studio — Monmouth Rug Mills
Clarence Whitman & Sons
Celanese Corporation of America
Parker, Wiley, Inc. — Hardman, Peck & Co.
Overbrook Carpet Mills, Inc.
Extra-Violet Ray Laboratories
Washington Square Book Shop
Schmieg, Hungate and Kotzian
Kleurfax Linen Looms
W. C. Chapman Co.
Onondaga Silk Co. — F. Schumacher & Co.
Henrich Reflector Co.
Nessen Studio — Frederick L. Keppler
Paul Lobel — H. S. Dan
Wilhelmina Schmidt — Peter Mueller-Munk
Jeno Juszko — Boardman Robinson
Thomas H Benton — Alexander Couard
J. Franklin Whitman, Jr.
Walter Von Nessen — Greta Von Nessen
Juanita Gonzalez — Marie Thster
Helen Turquand — Robert Wood
Mary Lewis — Anita Atkinson
Elsa Horne Voss — Carl Walters
C. P. Freigang — Henry Varnum Poor
R. Guy Cowan — Ernest Fiene
International Silver Company
Lesher Whitman Company
Sterling Bronze Company
New York Telephone Company
Reed and Barton — Halo Desk Company
Dudenaing Galleries — Greenwich House
The Potters' Shop — Montross Galleries
Downtown Galleries — Alfred Knopf & Co.
Cheney Brothers — Stehli Silks Corporation
Ferargil Galleries — Milch Galleries
Grand Central Art Galleries
Reuss Pottery — Cowan Pottery Studio
Corning Glass Works, Steuben Division
Henriette Shore — Peter Krasnov
Edward Weston — Robert Leonard
Ralph Steiner — Alexander Archipenko
Peter Elling — P. Ott
Hans Skolle — A. Drexler Jacobson
Walter Sinz — A. E. Baggs
Elizabeth Anderson — Hunt Doderich
Erika Lohmann — Winold Reiss
George Biddle — Aaron Douglas
L. Massari — Seymour Fox
Estelle Manville — C. Applegate
Oranzio Maldarelli — Heinz Warneke
Paul Manship — Duncan Ferguson
Annette Rosenshine — William Zorach
Ivan Mestrovic — Marion Stroll
Flower Service, Inc. — W. and E. Tiebout
Dupont De Nemours & Co. Inc.
Whitehead Metal Products, Inc.

Executive Director of the Exposition

Virginia Hamill

Exposition Architect

Lee Simonson

Organizations, Societies and Individuals

AUSTRIA

Wolfgang Hoffman, New York
Ed Kanitz & Co., Vienna

FRANCE

The French Line
French Chamber of Commerce, New York
Association Francaise d'Exposition et d'Echanges Artistiques, Paris
Societe des Artistes Decorateurs, Paris
George Brunel, Paris

GERMANY

Frau Tilly Prill-Schloemann, Cologne
The Hamburg American Line

ITALY

Navigazione-Generale Italiana
Lloyd Sabaudo
Guido Marangoni

SWEDEN

O. G. Marell
Swedish-American Line, New York
Swedish-American Chamber of Commerce, New York
American-Scandinavian Foundation, New York

UNITED STATES

The Metropolitan Museum of Art
The Brooklyn Museum
The Art Center
The Times Square Travel Bureau

SPEAKERS AT THE EXPOSITION

Robert W. DeForest
Frank Crowninshield
Richard F. Bach
Lee Simonson
Virginia Hamill
Harvey Wiley Corbett
Helen Appleton Read
Kem Weber
Adolf Glassgold
Dr. Curt L. Heymann
Edward Hald
Mrs. George Palen Snow
Edward Steichen
Emily Price Post
Prof. William Lyon Phelps
Eugene Schoen
Marian C. Taylor
Prof. Edwin Avery Park
Prof. Bruno Paul

6.32 Advertisement. *New York Times*, 28 May 1928, sec. 1, p. 19.

which they could express themselves. Simonson predicted that modern design, being well suited to the needs of the modern family, would not be a passing fad.[105] He praised the smaller modern pieces, which were appropriate for the cramped quarters occupied by many New Yorkers in the 1920s, and the metal furniture, which, cheaply made through mass production, could be moved easily, would not warp or break, and would require little care.[106]

Kem Weber urged American designers to express the spirit of "the age of skyscrapers, subways and telephones."[107] Virginia Hamill attributed the beauty of European objects to the fact that manufacturers did not design in-house, but retained the best artists for particular projects. In Hamill's view, this methodology benefited both the artist, who was able to do projects for several manufacturers at the same time, and the manufacturer, who obtained designs based on an artist's broad experience and knowledge. She believed that a close relationship between manufacturer and artist would also yield an improvement of the quality of the products, as the manufacturing processes would be adapted to the needs of the artists.[108] Given her focus on the relationship between art and industry, it is particularly odd that she ignored the work of the Bauhaus designers.

The most spirited colloquy of the lecture series took place between Edward Steichen and Emily Price Post, the noted authority on etiquette. Steichen pressed the audience to "rid their homes of antique furniture which 'does not function as it should' and consign other useless bric-a-brac to their attics." Post expressed her belief that the home should reflect the tastes of its occupants, and she urged the audience hold on to their antiques, if that was their preference.[109]

Addressing visitors who may have been concerned about what to wear in their modernist dwellings, Mrs. George Palen Snow of *Vogue* noted that fashion was already modern, decoration having been discarded in favor of a focus "on line and geometrical cutting to reveal structure." She advised her audience that they might wear "anything presented . . . in the mode of today, provided it is in good taste."[110]

Eugene Schoen expressed two themes: First, he thanked his "fellow men" for freeing architects and decorators from the tyranny of past styles.[111] Second, he praised the emphasis in modern design on utility and simplicity, which he believed to be mandated by both the economic conditions and cramped living conditions of the 1920s. Because women had to make do with less household help than in previous eras, the "carved panels, sideboards and ornate furniture, which required a half dozen servants with oil rags," would have to go.[112] Given the smaller living spaces, rooms had to perform more than one function, and furniture like the four-part sofa Schoen designed could meet that need.

The multipurpose furniture and rooms designed by Schoen reflected the close relationship between social conditions and design. Just as the wealth and leisure time of the upper classes in earlier days gave rise to styles that emphasized workmanship and detail, so did the hurried lives of the middle class in twentieth-century America engender the simple, easily cared for, and easily reproducible lines of modern design. Professor Edwin Avery Park of the Yale University School of Fine Arts discussed this relationship and described the evolution of the modern movement.[113]

In the final lecture given at Macy's, Bruno Paul praised the "joy of experimentation" that pervaded American architecture, but expressed surprise at the period styles of the interiors. He contrasted the American design experience with that of Germany, where architecture had not been very progressive, but modern designs in furniture, fabrics, and objects accounted for 80 percent of total production in 1928.[114]

In its closing advertisement in the *New York Times*, Macy's claimed that more than 250,000 people had seen the exposition (fig. 6.32). While there is no independent verification of the numbers, anecdotal reports confirm that it was a very popular show. On Sunday, May 20, the *New York World* reported that Macy's was so packed on the "half holiday" the previous day "as to require the services of special uniformed attendants to keep visitors moving in one direction."[115]

Guides and attendants kept the crowds moving, and special evening inspection tours were arranged so that groups could view the exhibits in a more

leisurely manner. Nevertheless, *The Decorative Furnisher* reported that "it was never possible to make an inspection of the exposition in a leisurely manner, the oncoming crowds forced one around and around so that a fleeting glance at many of the items was all that was possible." The magazine concluded that within a short period of time, modern design would be featured not as a novelty, but because the public would want to incorporate it into their homes.[116]

While the public expressed its interest in modern design by attending in droves, the press demonstrated its fascination with the new movement in the dozens of articles written about the exposition, both during the show and for months afterwards. Whatever individual critics might have thought of the offerings, the press was united in its praise of the exposition itself and of Macy's decision to mount such a comprehensive display of modern design.[117]

The exposition may have converted some of the influential critics. Marion Clyde McCarroll acknowledged that she had been opposed to modern design, particularly its "queerly shaped furniture, its devotion to strange color harmonies and its general determination to be 'different' at any cost." After seeing the exposition, however, she had to acknowledge that she was fascinated by the new approach.[118]

Whether they liked what they saw or not, most commentators agreed that the exposition demonstrated the arrival and staying power of the modern style.[119] As the public read over and over that modernism was the wave of the future, they must have felt that they had to acquire and display some elements of it. This was just the result that Macy's executives had desired.

The critics also agreed, however, that modernism was an evolving concept. Much of the press discussion centered on how the American rooms differed from the European ones and how America would develop its own rendition of modernism. Nellie Sanford considered the American rooms to be the "eccentric and conservative exhibits" of the exposition, the Americans not having found the "middle ground" that she saw in the French offerings and many of those from Germany.[120]

The *New York Sun* agreed with Sanford, terming the American exhibits "dashing and bizarre," with forms and colors carrying modernism to "jazzy extremes."[121] To Helen Appleton Read of the *Brooklyn Daily Eagle*, Kem Weber's rooms exemplified the "distinctive American expression" that would emerge from "creative selection" of the ideas of other countries.[122] It is ironic that the imported ideas did not encompass the work of the more avant-garde European designers, like Charlotte Perriand, Le Corbusier, Robert Mallet-Stevens, and Marcel Breuer, whose work was closest to the ideals of utility and simplicity that would come to characterize later twentieth-century American design.[123]

Echoing the remarks made by Virginia Hamill, a number of commentators expressed a hope that artists would play a large role in the development of an American modern style. Adolph Glassgold approved of Macy's decision to label the objects on display with the names of both the manufacturers and the designers, as it would incentivize both to do their best work.[124]

The exposition was clearly popular with both the public and the press. Whether it was a commercial success for Macy's is more difficult to gauge in the absence of hard sales data. On June 5, Macy's announced a plan to open an "Atelier of Design" in September, to develop existing styles, create new ones, and help manufacturers modify designs to accommodate machine production.[125]

Macy's marketed the exposition throughout the store. Its windows displayed merchandise of modern design from the countries represented in the exposition, with descriptive captions noting that the items displayed were available for sale. In various departments one could find modern ceramics, glassware, apparel, textiles, and linens. The furniture department had added to its stock of modern furniture and provided special displays to accommodate "informal groupings" of the furniture that incorporated paintings and accessories.[126]

In a financial report on Macy's published a month before the 1928 exposition opened, the *Wall Street Journal* reported that earnings per share had increased from $7.05 in 1920 to $16.66 in 1928. The *Journal* considered Macy's merchandising policies to be a large factor in its success, commenting that "Macy has achieved the unusual combination of

a store that emphasizes popular prices and at the same time has kept up with the most modern artistic trends in display, decoration and merchandise."[127]

Several years after the 1928 Exposition, in an extremely laudatory article about Macy's preeminence among New York department stores, Fortune cited the store's merchandising policies, including its foray into modern design, as a major reason for its success:

> Macy's has done much to form the taste of the housewives of New York. In 1927 and 1928 Macy's held "Art in Trade" exhibitions at which were assembled chairs, tables, china, linen, household furnishings designed by artists in this country and abroad. The good people of Manhattan thronged to gaze at modernistic pianos and futuristic water glasses. Among other more or less direct results of these "Art in Trade" exhibitions is the success of that corner on the furniture department in which is assembled a collection of modernistic furniture unequaled in any department store in the city. The splendid modern rugs on the sixth floor and the delicately tinted modernistic china and glass in the basement are also fruits of the "Art in Trade" days.[128]

Ralph Hower attributed Macy's success to strong management that improved the quality of the merchandise to keep pace with a public that was increasingly educated about good taste in design. Acknowledging that Macy's was not the first department store to emphasize style, Hower saw its real contribution as bringing style to the masses.

A number of articles in *Women's Wear Daily* around the time of the 1928 exposition indicate that many design professionals were trying to figure out how to merchandize modernism to a broader public. Several experts advised department stores to stock more modern items, incorporate them in room settings, and put resources into advertising and lectures that explained how to incorporate modern design into the home.[129] Paul Frankl, Eugene Schoen, Kem Weber, and William Lescaze were all recruited to tell the public how to incorporate modern design in their homes. Schoen thought that "modernistic products [could] be combined with the furniture of practically any period, provided it is done with taste and understanding." Before Weber would introduce modern design into a traditional room, he would discard everything not essential. He would then add a modern grouping in one corner, and a few modern accents throughout the room, always paying attention to "the texture, the feel and the color of the pieces being assembled.'" Lescaze preferred not to mix period and modern furnishings in one room. If a client desired such a mix, Lescaze would create a modern grouping in a corner of a room, perhaps with a low table, two chairs and a lamp, differentiating the area from the rest of the room by using a different wall color.[130]

All of this advice was undoubtedly helpful to average New Yorkers, but without the visual imagery of the 1927 and 1928 expositions, they would have had difficulty comprehending the ways in which modern design could fit into their lives. Other retailers, undoubtedly watching the positive reactions to the expositions, continued to mount exhibitions that complemented Macy's efforts.

B. Altman & Co. Presents *An Exhibition of 20th Century Taste*

Opposite: **7.1** View of
Fifth Avenue and 34th
Street, New York City, with
B. Altman & Co. in the
foreground. Detail from
photograph, c. 1930.
Museum of the City of
New York, Print Archive,
#15. Gift of Frederic Lewis.

"A New Era of Art and Ideas"[1]

After the Lord & Taylor and Macy's expositions, other New York department stores must have determined that they could not be left behind in the march to modernism. In July 1928, James McCreery & Co. presented a modern home with interiors and furniture designed by its staff. The bedroom furniture and furnishings were offered at $1,417.70, which McCreery's touted as a price "within the means of persons with even limited incomes." Two days after the opening of the display, McCreery's announced sales of some of the furniture, which was viewed by *Women's Wear Daily* as "avoiding the extreme, and demonstrating the new art in a mild and tempered form." Store management was apparently so sure of success that the modern furniture exhibited at McCreery's was not slated to be included in the August furniture sales.[2]

In September 1928, a number of stores presented modern design. Bloomingdale's filled six model rooms with modern furniture, and announced plans to add to the offerings in order to present a comprehensive view of modern design and have it available to their customers on an ongoing basis.[3] Lord & Taylor exhibited eight modern ensembles of American design and promptly sold four sets of a bedroom suite included in the offerings. The price of the suite was comparable to the bedroom suite at McCreery's. *Women's Wear Daily* reported that "young folks in particular" favored the modern designs.[4]

By far the most ambitious exhibition that fall was *An Exhibition of 20th Century Taste in the New Expression of the Arts in Home Furnishings and Personal Accessories as Achieved by European and American Designers*, which opened to the public at B. Altman & Co. on September 17, 1928 (fig. 7.1).[5] *Good Furniture Magazine* considered the Altman's show to

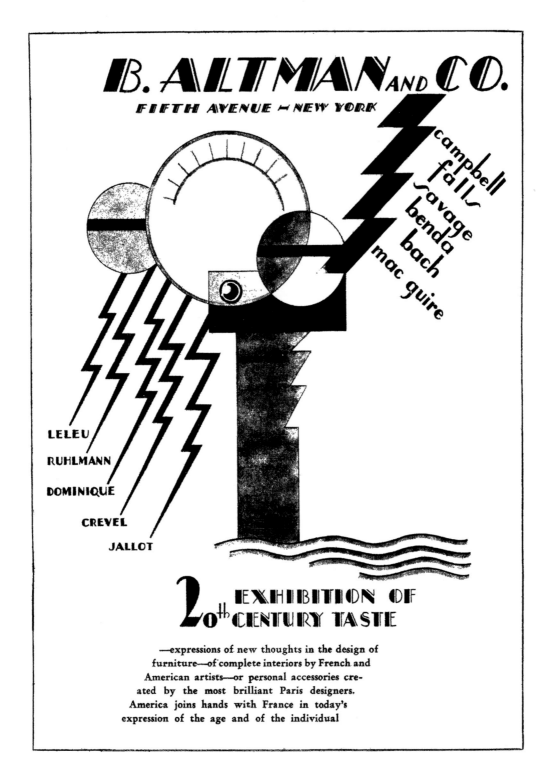

7.2 Advertisement. *New York Herald Tribune*, 16 September 1928, 10.

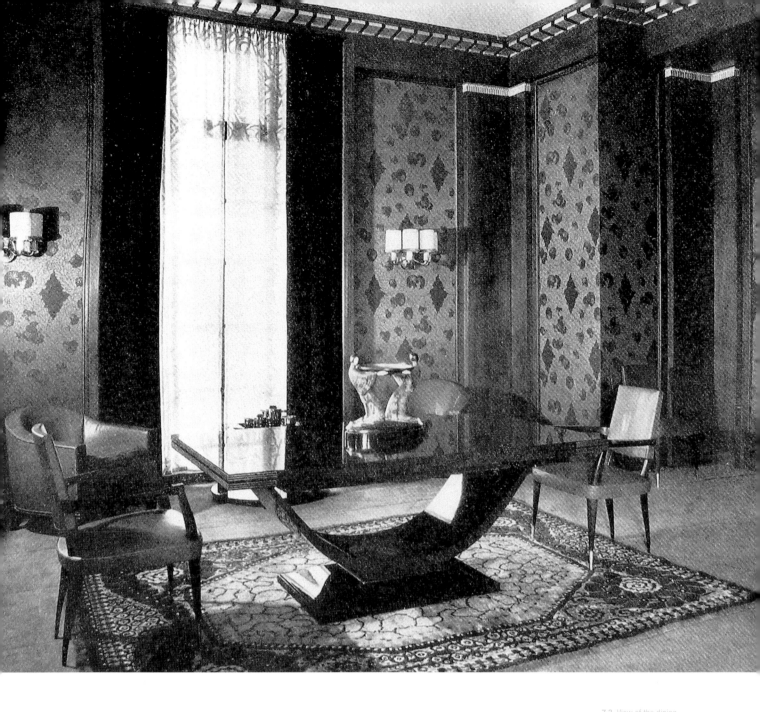

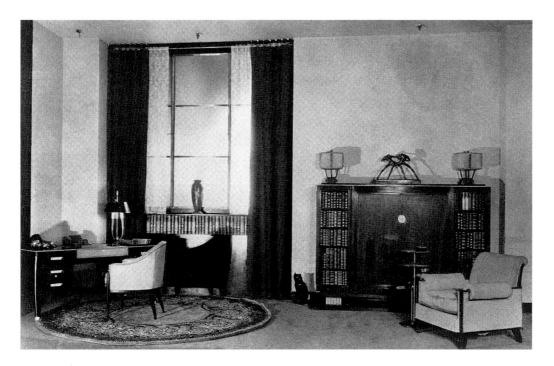

7.4 View of the library designed by Jacques-Émile Ruhlmann for the 1928 Altman's Exhibition. *Upholsterer and Interior Decorator* (15 October 1928), 121.

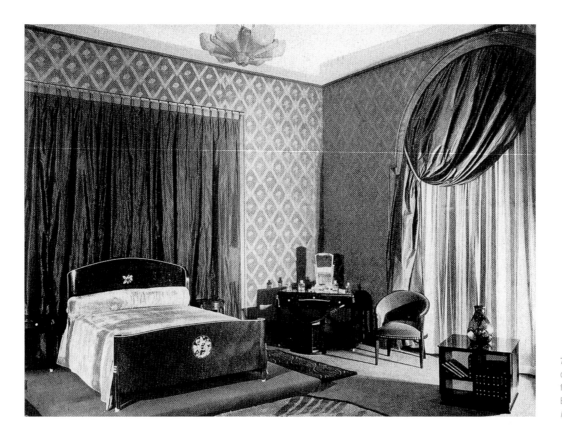

7.5 View of the bedroom designed by Jules Leleu for the 1928 Altman's Exhibition. *Decorative Furnisher* (October 1928), 82.

be "finished, polished and perfectly expressive of the ideas of some of the best designers of France and America."[6] Altman's presented several complete rooms and ensembles by three French designers, Jacques-Émile Ruhlmann, Jules Leleu, and Dominique, a partnership of André Domin and Marcel Genevriére. Also shown were eight rooms designed by six Americans, Charles Buckles Falls, Wladyslaw Theodor Benda, Oscar Bach, Ruth Campbell, Steel Savage, and Robert Reid MacGuire.

Like its counterparts, Altman's put a great deal of money into the exhibition, which covered about one-third of the eighth floor of the store. Altman's hired MacGuire to design background elements, produced a sixteen-page catalog, and advertised heavily (fig. 7.2). Altman's customers exited specially designated express elevators into a central hall with many special effects, such as columns encased in silvered wood, and crystal lights in the form of icicles. The elevator doors on the eighth floor were fitted with specially designed silver overlays in a geometric pattern.

Around the central hall were arrayed the model rooms, in which each item was tagged with the designer's name and the price. While nothing could be bought directly from the exhibition, salespeople advised customers where to find the items on the selling floor. Thus, like Macy's, Altman's banished from the exhibition itself the taint of commercialism, but encouraged and facilitated commercial transactions elsewhere in the store. Unlike Macy's, Altman's did not seek out established American designers for its American rooms. Perhaps to differentiate itself from the other stores, perhaps to convince the public that it would be seeing something new, Altman's selected accomplished American artists without previous design experience. The store enticed the artists with an arrangement whereby they would be paid a flat fee for their designs, plus a percentage of sales.[7]

The French rooms at Altman's, like those in the Macy's exposition, represented the more traditional group of French modernists. Ruhlmann offered a dining room and a library, both of which featured gently curving burled walnut furniture with his signature inlays (figs. 7.3 and 7.4). In the dining room, the dominant colors were found in the silver and red wall hangings, red leather uphol-

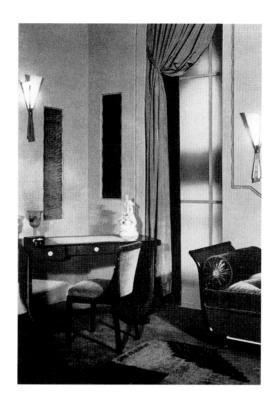

7.6 View of the boudoir corner designed by Jules Leleu for the 1928 Altman's Exhibition. *Upholsterer and Interior Decorator* (15 October 1928), 122.

stery, red velvet draperies, silvered bronze mounts, silvered wall moldings, and patterned rug.

Ruhlmann's library had a color scheme more conducive to contemplation. The chairs were upholstered in tan leather, and leather inlay formed the surface of the center of the desk. The furniture, made of Makassar ebony with ivory inlays and silvered bronze mounts, was solid and rich-looking—the perfect backdrop for the dozens of leather-bound books that filled the bookcase and the windowsill.

Leleu presented a bedroom that closely resembled the one he displayed at Macy's, incorporating "soft super-imposed shades in the draperies and rugs, an almost classic line in the very plain furniture, and an artistic use of the inevitable inlays of ivory in which the French moderns rejoice."[8] Even in a black-and-white photograph, the sumptuous textures of this room are apparent; one can see how the polished woods, the taffeta draperies, and the mohair upholstery created an atmosphere of luxury and restfulness (fig. 7.5). Leleu also presented a boudoir corner that drew upon French classicism (fig. 7.6).

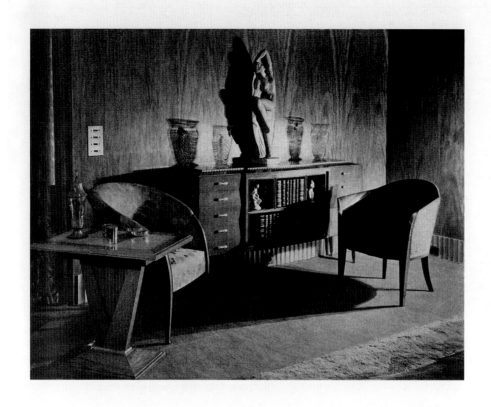

CORNER OF A ROOM BY DOMINIQUE

In the Altman Exhibition of XX Century Taste.

*The Upholsterer and
Interior Decorator*

7.7 View of the salon designed by Dominique for the 1928 Altman's Exhibition. *Upholsterer and Interior Decorator* (15 October 1928), 97.

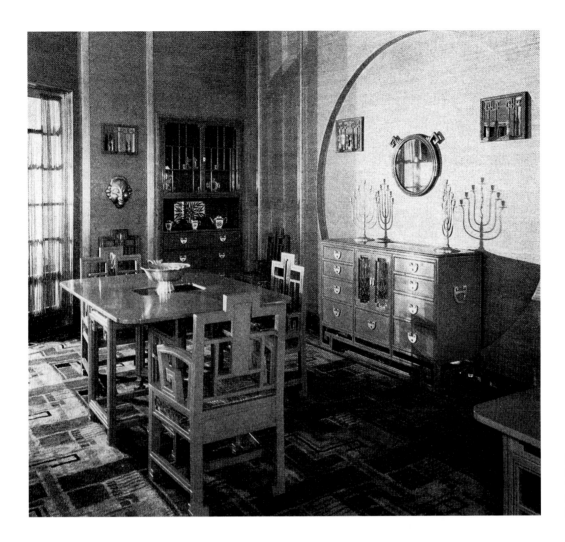

7.8 View of the breakfast room by C. B. Falls for the 1928 Altman's Exhibition. *Decorative Furnisher* (October 1928), 81.

Dominique designed a salon (fig. 7.7) with furniture that was very similar to that presented by Ruhlmann and Leleu. In this room, furniture of walnut, treated to look like ash, was placed against walls of light-colored wood panels with intense graining. The furniture was enlivened by sharkskin inlays and silvered bronze mounts, as well as a color scheme that included a hue described by some critics as magenta and others as violet.

The French rooms presented nothing new to veterans of the previous department store exhibitions, and not much that was applicable to the average New Yorker. Relying heavily on expensive materials incorporated into rooms that had but a single purpose, the French designers were obviously designing for wealthy clients with huge abodes. Lee Simonson, whose tolerance for this kind of

design was limited, commented that the "rooms with their air of Parisian luxuriousness seem essentially unrelated to the American mind that really craves new and simple surroundings in which to live." Simonson reported that the French rooms averaged $8,000, more than double the price of the American rooms at Altman's and quadruple the price of the room settings shown by some of the other department stores.[9]

The American artists at Altman's were searching for a modern style. C. B. Falls, an illustrator and poster designer, presented a breakfast room and a bedroom inspired by ancient motifs (figs. 7.8 and 7.9). The breakfast room, based on Chinese forms, was a riot of color and pattern.[10] The furniture was finished in red lacquer, and much of it was embellished with mirrored glass inlays. In the bed-

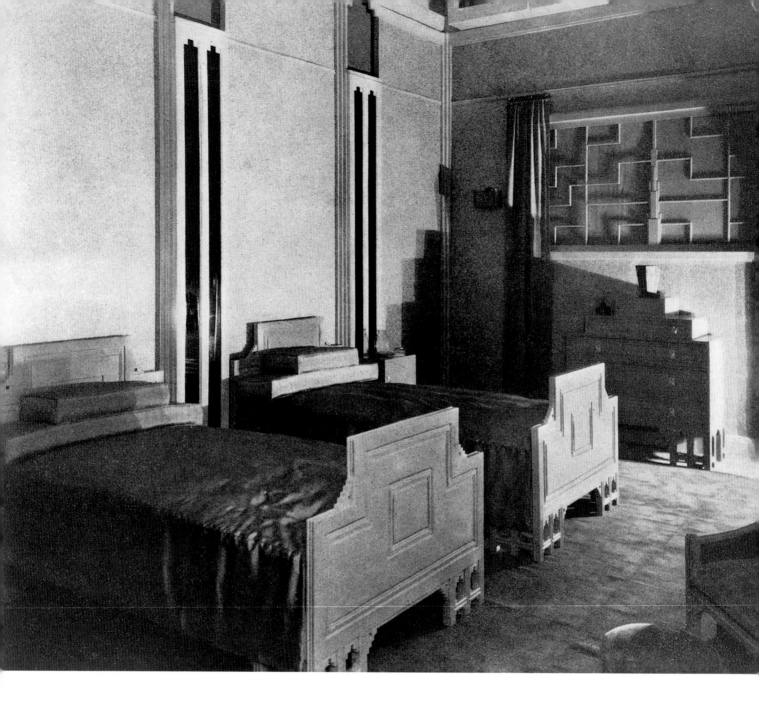

7.9 View of the bedroom
by C. B. Falls for the 1928
Altman's Exhibition.
*Upholsterer and Interior
Decorator* (15 October
1928), 107.

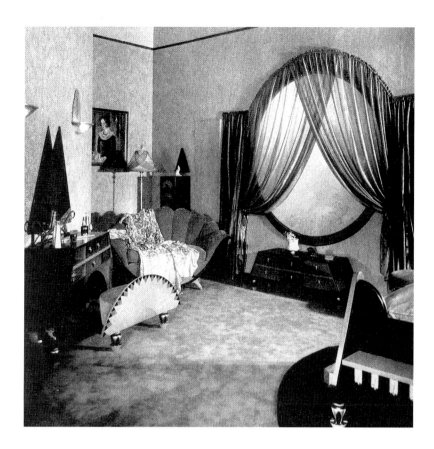

7.10 View of the bedroom designed by Ruth Campbell for the 1928 Altman's Exhbition. *Decorative Furnisher* (October 1928), 80.

room, with a design motif based on Mayan architecture, furniture finished in "brilliant" yellow lacquer competed with the "glaring" green carpet, upholstery, and curtains for the occupant's attention.[11]

Ruth Campbell, a portrait painter and designer of jewelry and ceramics, created a bedroom with the "poppy, symbolic of sleep, as the design motif, and an intriguing triangle as a basic form"[12] (figs. 7.10 and 7.11). The color scheme incorporated turquoise, black, shades of red, and salmon.[13]

The poppy appeared in the large circular etched glass window, the footboard, and the back of the dressing table stool. The sofa could be seen as a poppy in full bloom, an allusion fostered by its red color. The bedspread and another chair were also upholstered in red. The bed was perhaps the most novel element in the room, with a shelf along one side that eliminated the need for a bedside table. The storage was provided mainly by two tall, narrow chests in red and green that flanked the window.

Arts & Decoration's Helen Drew, praising the room as a woman's contribution to the new interior design, cited the small "coffer" at the foot of the bed, intended to hold the occupant's bedroom slippers, as an example of the ways in which a woman designer could meet the needs of "the woman of taste and imagination."[14] *House & Garden's* Matlack Price, picking up on this same theme, praised the design of the tall, narrow dressers designed by Campbell, with their many small drawers to keep organized the occupant's lingerie and stockings of "many shades and subtle gradations."[15] These practical attributes aside, however, one might tend to agree with Lee Simonson's assessment of this bedroom as "a complete parody of the kind of spotty and lurid stage setting which little theatres thought so epoch-making ten years ago."[16]

W. T. Benda, an artist and theatrical designer who had emigrated to the United States from Poland many years earlier, presented a dining room that *Decorative Furnisher* termed the "most reactionary" interior in the show (fig. 7.12). The walls of the dining room were gold, with masks fabricat-

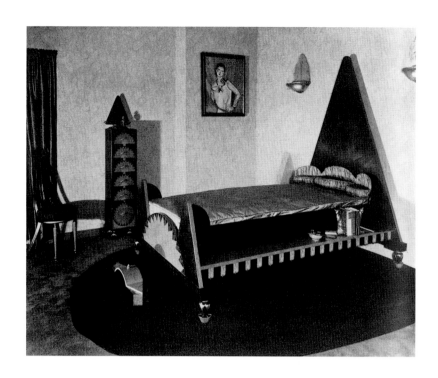

7.11 Another view of the bedroom designed by Ruth Campbell for the 1928 Altman's exhibition. *Upholsterer and Interior Decorator* (15 October 1928), 98.

7.12 View of the dining room designed by W. T. Benda for the 1928 Altman's Exhibition. *Good Furniture Magazine* (December 1928), 312.

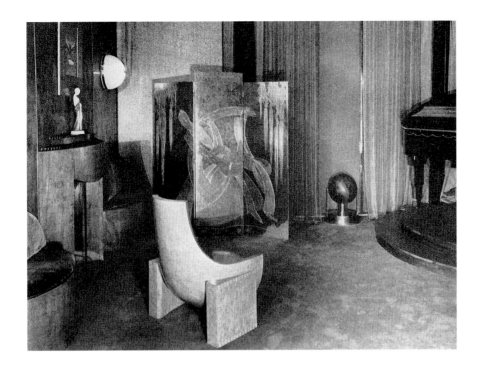

7.13 Music room designed by Robert Reid MacGuire for the 1928 Altman's Exhibition. *Good Furniture Magazine* (December 1928), 313.

ed by Benda as decoration. The walnut furniture was embellished with turquoise medallions, which complemented the blue leather upholstery.

The simple, stolid furniture could be seen to have some modern elements, but it demonstrates the confusion in American design at the time. *Good Furniture Magazine* found the room a bit "baffling" because it had "a touch of the classic here, and more than a touch of the Germanic in the rather heavy designing of sideboard and table, and in the use of heavy pillars at the windows."[17] *The New Yorker* questioned the use of "Moorish arches and general Arabian Nights detail in an Exhibition of Twentieth Century Taste."[18]

Benda's dining room contrasted sharply with the music room designed by Robert Reid MacGuire, an architect and stage designer, which contained dark blue and silver furniture, as well as a modernistic black piano, with incised designs in blue and silver (fig. 7.13).[19] A threefold screen depicted an interpretation of the dance, with silver dancers against a blue background. "Big balls of blue glass, adroitly shaded, and mounted in metal with a touch of black," provided the dramatic lighting for the room.[20] Blue upholstery harmonized with blue fabric hanging on wood wall panels

stained green. This was a room more consonant with the prevailing European modernism than most of the other American rooms at Altman's. The simple geometric shapes of the furniture, the use of platforms, the indirect lighting, the broad expanses of wood, and the lavish use of silver accents all evidenced MacGuire's familiarity with, and admiration for, the European modernists.

MacGuire's other room, "Chambre d'une jeune fille" (fig. 7.14), was a tribute to the traditional modernists, and, as such, was a target for Simonson, who termed it "a parody on almost every form of eccentricity that the best designers in Paris such as Jourdain and Jallot of the older generation, Jo Bourgeois and Lurçat in the younger, are successfully discrediting."[21] Simonson, of course, disdained the traditional modernism of Ruhlmann and Leleu, favoring the simplicity of the rationalists, which he believed to be better suited to American tastes and needs.

Steel Savage, an American commercial artist, must have looked to the French rationalists and the Wiener Werkstatte for his inspiration. Savage, who had spent three years in Vienna, designed "The Conversation Room," which Matlack Price described as "a room in which the people in it will

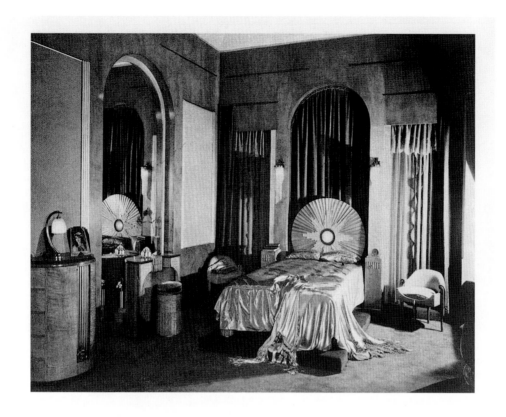

ROBERT REID MACGUIRE'S ROOM AT B. ALTMAN & CO.
In their Exhibition of XX Century Taste.

*The Upholsterer and
Interior Decorator*

7.14 "Chambre d'une
jeune fille" designed by
Robert Reid MacGuire for
the 1928 Altman's
Exhibition. *Upholsterer and
Interior Decorator*
(15 October 1928), 108.

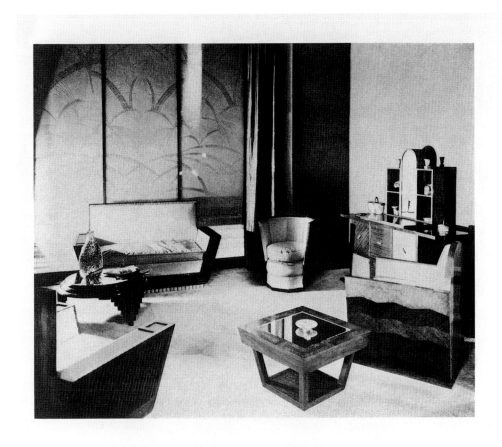

W. T. BENDA, CELEBRATED ILLUSTRATOR AND MAKER OF MASKS, DESIGNED
THIS CONVERSATION ROOM FOR B. ALTMAN & CO.

In the Exhibition of XX Century Taste.

*The Upholsterer and
Interior Decorator*

7.15 Conversation room
designed by Steel Savage
for the 1928 Altman's
Exhibition. *Upholsterer
and Interior Decorator* (15
October 1928), 117.

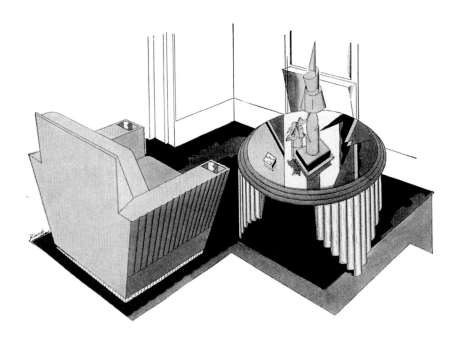

7.16 Furniture designed by Steel Savage for the 1928 Altman's Exhibition. *House & Garden* (October 1928), 109. Courtesy of Condé Nast Publications, Inc.

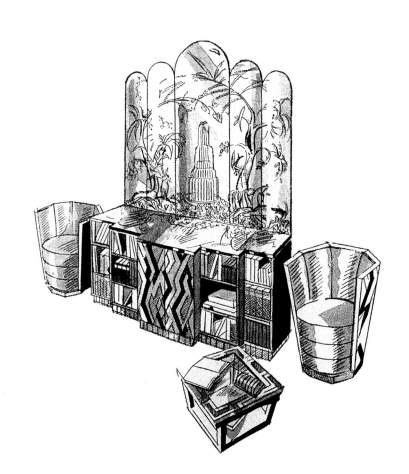

7.17 Mirror designed by Steel Savage for the 1928 Altman's Exhibition. *Arts & Decoration* (October 1928), 80.

7.18 Office designed by Oscar Bach for the 1928 Altman's Exhibition. *Decorative Furnisher* (October 1928), 80.

be a part of its decoration"[22] (figs. 7.15 and 7.16). The deep blue walls and low, comfortable seating furniture, upholstered in white, formed a backdrop for conversation. Numerous small tables and stands provided space for reading materials and food and drink. The most spectacular element in the room was a five-part mirror designed and painted by Savage (fig. 7.17).

To Helen Drew, the office designed by Oscar Bach "could not have been imagined in any age but our own" (fig. 7.18).[23] Like a number of other critics, Drew was struck by the leather and metal walls and furniture, which she considered to be the most radical in the Altman's show. The metal furniture was accented in bronze, which complemented the bronze figures of laborers in the window grille. Black leather upholstery covered the chairs and one tabletop. Gray, green, and black blocks of a synthetic material covered the floor, and green walls completed the color scheme, except for the red typewriter that sat on the small table.

All of the rooms—the curvilinear furniture and motifs of MacGuire, the angular designs of Savage, the "Germanic" interpretation of Benda, the primitive images adapted by Falls—were representative of the plethora of styles that characterized American modern design in the late 1920s. Simonson, reviewing the Altman's show and another at Lord & Taylor in September 1928, proposed

that department stores establish ateliers directed by talented designers who could supervise their adherents and train a younger generation.[24] With well-respected designers heading their ateliers, American department stores might be able to induce manufacturers to take the risks entailed in producing new lines of furniture.

Altman's was rewarded immediately for the risks it took in mounting the exhibition, in that it sold several of the interiors. Attendance at the exhibition, however, was lower than anticipated. *Women's Wear Daily* speculated that by September 1928, New Yorkers might have been sated with modern design shows and that their use as "a grand institutional gesture" was just about over. Lukewarm reviews might also have had an effect. On September 22, *Women's Wear Daily* reported that although the average visitor liked the exhibits, opinions had been "proffered in various quarters" that the American exhibits were theatrical and impractical, with color schemes "inharmoniously chosen." Whatever the reasons for the decrease in interest, it may have had an impact on the other stores; *Women's Wear Daily* reported that at least one other New York department store was contemplating the cancellation of a planned exhibition because of Altman's attendance figures.[25]

The Altman's exhibition was the last in the series of major department store exhibitions.

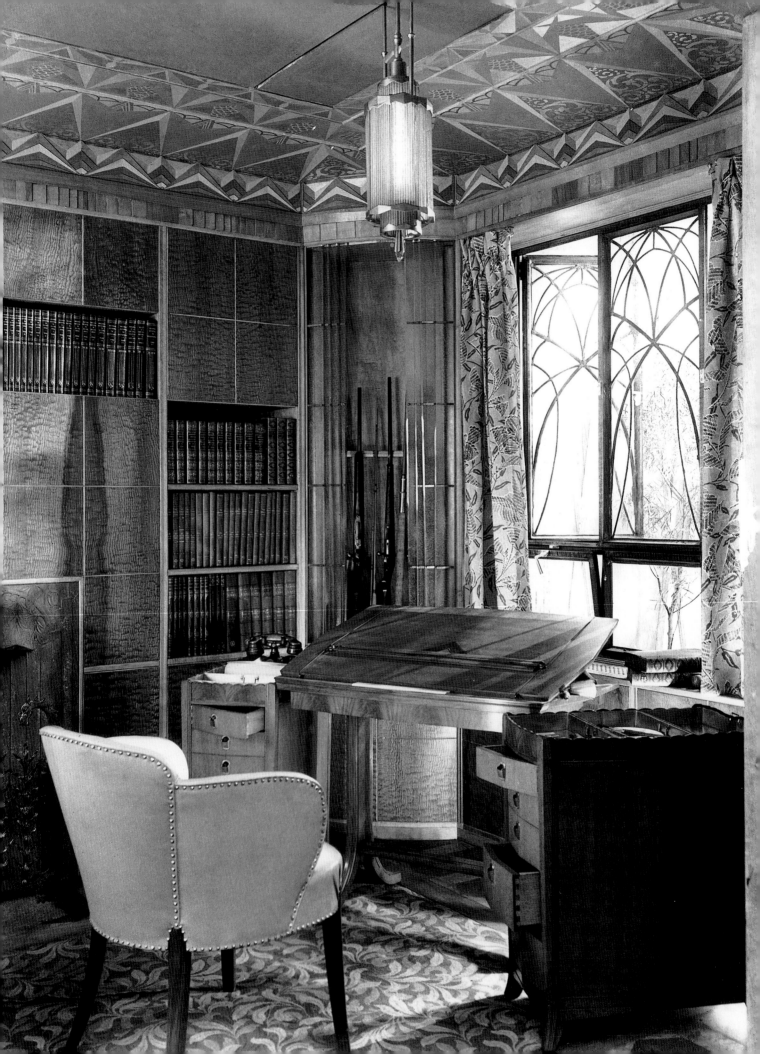

America Embraces Modern Design

*"Modernism in decoration is gaining favor slowly but
surely in the thinking of urban America."*[1]

The extensive press coverage of the department store
and museum exhibitions led to an increase in public
awareness of the new design movement. Whatever
the public might have thought of the offerings at the
department stores, newspapers and magazines told
them over and over that if they wanted to be a part
of life in the twentieth century, they had to have
modern design in their homes and offices (pl. 22).
Sales data for 1928 reflected public interest in, and
acceptance of, modern design. Bruno Paul's dining
room for Macy's was purchased by Park Avenue
Galleries in New York, which worked almost exclu-
sively in the modern manner for its Park Avenue
clientele.[2] In September 1928, Lord & Taylor
announced that modern furniture accounted for 20
per cent of its furniture sales.[3] While sales of modern
furniture and furnishings did not come close to over-
taking sales of traditional designs, the stores learned
that if the goods were reasonably priced and embod-
ied the qualities of simplicity and practicality, they

sold well. One critic concluded that while the atten-
tion given the new style was somewhat out of pro-
portion to sales, it was the "seed from which much of
the future business of the home furnishings depart-
ments would spring."[4] Buttressing this claim, a study
done for *International Studio* found that although there
were only twelve modern apartments in New York
City in June 1928, one year later there were approxi-
mately sixty.[5]

Interest in modern design was spreading across
America. The course designed by Paul Frankl for *Arts
& Decoration* quickly drew more than two hundred
applicants, including department store employees
from as far away as Atlanta, Georgia, and Toronto,
Canada.[6] Modern design was a presence at the major
furniture markets in late 1928, evidencing the fact
that American manufacturers were beginning to
understand the need to incorporate some modern
design into their production lines. By late September,
1928, manufacturers and philanthropists had pledged
more than $400,000 to create an Industrial Art
School as part of the Art Institute of Chicago, to
teach modern art and design for industrial use.[7] In

November 1928 a group of American architects and designers, who had formed the American Union of Decorative Artists and Craftsmen, opened the American Designers Gallery in Manhattan, to demonstrate the development of the modern movement in America. Their inaugural exhibition was kept open for six weeks in New York, and then toured department stores in ten American cities. In 1928 major exhibitions of modern design were mounted by department stores all over the country, including Jordan Marsh Company in Boston, Marshall Field & Company in Chicago, and major stores in Cincinnati, Atlanta, Seattle, and Los Angeles.

There were glaring omissions from the department store shows; from our vantage point, a group of "modern design" expositions without Le Corbusier, Marcel Breuer, Mies van der Rohe, and their compatriots would not seem worthy of the title. Nevertheless, Macy's, Lord & Taylor, Abraham & Straus, Frederick Loeser & Co., Wanamaker's, and B. Altman and Co. created an excitement and a sense of inevitability of the ascension of modern design that became, over time, a self-fulfilling prophecy. While the asbestos chosen by Lee Simonson for the Macy's backgrounds might not, in hindsight, have been a particularly propitious choice, his concept of using manufactured products in substitution of natural ones was to become intrinsic to American modern design. The luxurious furnishings of the French traditionalists at Lord & Taylor, later to be termed art deco, never found their way into the mainstream of American design, but underlying elements of their work, including the lack of applied and carved ornament, and the adoption of geometrically based forms, became the basis of twentieth century design in America.

By the end of 1928, critics agreed that modern design had arrived, and the debate shifted to how long it would last and what shape it would take in America. Practicality was an important feature of the new style, which was epitomized by comfortable chairs and sofas that were built deep and low, cabinets that had maximum storage capacity, efficient lighting that was often concealed behind translucent materials, and multipurpose furniture, all sized for a small house or apartment. In general, case furniture was characterized by pedestal bases and a lack of applied or carved ornament, with expanses of veneer

enlivened by incised geometric patterns or inlays of ivory, metal, or exotic woods. The simple lines of the modern furniture created a backdrop for color, pattern and texture in walls, floors, and windows.

Designers used color as a design element in two distinct ways. Some rooms, apparently inspired by the concrete and steel skyscrapers abounding in New York, were done in shades of brown and beige, with mirrored surfaces and touches of silver. Others, showing the influence of modern art, emphasized intense colors. Texture also played a large role in modern design; leather, velour, silk, satin, and wool turned rooms into tactile experiences. Pattern most often appeared in carpets, wall hangings, and draperies, with geometric designs predominating.

The exhibits at the department stores accustomed American eyes to simple lines, vibrant colors, and exciting patterns, in effect setting the stage for the versions of modern design that would evolve during the remainder of the twentieth century. During the 1930s designers like Donald Deskey, Gilbert Rohde, and Kem Weber would build on the foundation established at these exhibitions and extrapolate from the European iterations of modern design an American idiom.

The future of modern design was given a boost by the Metropolitan Museum of Art's eleventh exhibition of industrial art, which featured room arrangements of contemporary design by modern American architects. The architects for the museum exhibition, which opened in February 1929, included Ely Jacques Kahn, who had designed the Lord & Taylor exposition, and Eugene Schoen and Ralph T. Walker, both of whom had participated in the 1928 Macy's exposition. For the museum exhibition Walker designed a Man's Study for a Country House (figs. 8.1 and 8.2).

The room incorporated many of the elements seen at the department store exhibitions. The color scheme in shades of brown was enlivened by the geometrically patterned silver stenciling on the ceiling. Leather covered the comfortable chairs and the ottoman. A grid system of plain wood formed the backgrounds. The furniture, basically devoid of applied ornament, was practical, as was the overhead lighting, which consisted of fixtures that moved along a track, ostensibly to be placed where they would be most convenient at any given time.

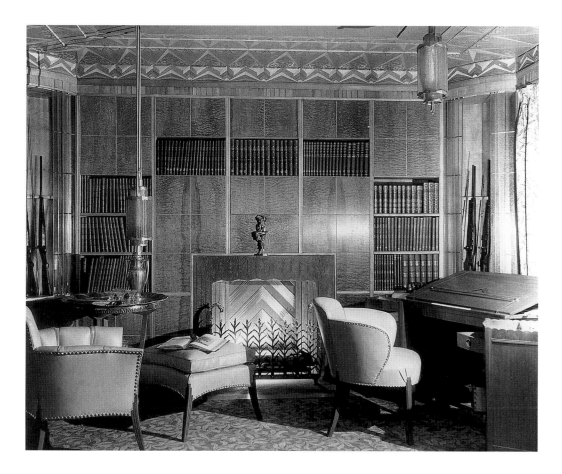

8.2 View of Man's Study for a Country House at The Metropolitan Museum of Art. Photograph by Sigurd Fischer. Library of Congress 308-N6.

The museum exhibition also reflected the broad spectrum of modernism manifested at the department store exhibitions. In the bedroom designed by John Wellborn Root, shown in figure I.6, the gray velvet walls, rose colored velour and silk upholstery, thick carpet, and large mirrors all appear to have been inspired by the work of Ruhlmann, Leleu, and Süe et Mare, without any modifications to reflect an American spirit. For the Business Executive's Office shown in figure I.5, however, Raymond Hood seems to have looked to Chareau and Jourdain, but moved beyond them in his use of metal furniture by Oscar Bach. Like the exhibits in the department store expositions, the varied museum exhibits, which also included efforts by Eliel Saarinen, Joseph Urban, George C. Booth, and Leon V. Solon, demonstrated that American modern design was very much a work in progress. The public was apparently interested in good modern design; attendance was high and the exhibition was extended to run more than six months.[8]

Arthur Pulos credits American museums with giving "cultural respectability" to the modern movement.[9] The New York department stores, with the imprimatur of the museum, gave the movement commercial credibility.[10] By mounting exhibits worthy of a world's fair, Macy's and the other department stores assured that attention would be paid to modern design. The critics and the public did pay attention, and the modern design movement, which just four years earlier had been limited to a small cadre of patrons and designers, secured a foothold in American design.

Demonstrating the power of cooperation between commerce and culture, the New York department stores and the Metropolitan Museum of Art contributed to a dramatic upsurge in modernism at the end of the decade, and provided guidance to the manufacturers and designers who would shape modern design thereafter.

Chapter Notes

Introduction

[1] Advertisement, *Arts & Decoration* (July 1928), 91.

[2] Advertisement, *House & Garden* (September 1928), 196.

[3] Pamphlet entitled "International Exhibition of Modern Decorative and Industrial Arts" issued by the Office of the General Commissioner, Grand Palais, Paris, VIII, attached to letter from M. Jusserand to Hon. Charles Evans Hughes, 21 May 1923, inviting the United States to participate in the 1925 Paris Exposition. National Archives, State Department Files, 851.607 W/3; Internal State Department Memorandum, 28 April 1924. National Archives, State Department Files, 851.607 W/43; Charles Evans Hughes to M. Jusserand, 22 May 1924. National Archives, State Department Files, 851.607 W/3.

[4] Alastair Duncan lists modern design exhibitions held in New York City that were presented by museums, designers' groups, and department stores. *American Art Deco* (New York: Harry N. Abrams, 1986), Appendix, unpaginated. See also, Robert A. M. Stern, Gregory Gilmartin, and Thomas Mellins, *New York 1930* (New York: Rizzoli International Publications, Inc., 1987), 329-338, and Karen Davies, *At Home in Manhattan* (exh. cat., New Haven, Conn.: Yale University Art Gallery, 1983). Some of these shows featured American designers, and most adopted the Paris Exposition framework of showing objects in context in order to demonstrate "how they could function in daily life." Yvonne Brunhammer and Suzanne Tise, *French Decorative Art: The Société des Artistes Décorateurs 1900-1942* (Paris: Flammarion, 1990), 94.

[5] John Heskett, *Industrial Design* (London: Thames and Hudson, 1980), 95.

[6] A number of writers have examined the sociological and artistic basis of modern design. See, e.g. Jeffrey L. Meikle, "Domesticating Modernity: Ambivalence and Appropriation, 1920-40," in *Designing Modernity; The Arts of Reform and Persuasion 1885-1945*, Wendy Kaplan, ed. (exh. cat., Miami Beach: The Wolfsonian, 1995), 143–168; Arthur J. Pulos, *American Design Ethic: A History of Industrial Design to 1940* (Cambridge, Massachusetts and London: MIT Press, 1983).

[7] Duncan, *American Art Deco*, 25. Penelope Hunter writes that "the motivating force in the Museum's 1929 exhibition was the attempt to create a decorative art adapted to modern life." Penelope Hunter, "Art Deco and The Metropolitan Museum of Art," *Connoisseur* (April 1972), 279.

Chapter 1

[1] J. W. Robinson to Henry Kent, n.d., attaching card of Donald Porteus, dated 17 October 1913 (The Metropolitan Museum of Art Archives).

[2] The museum's efforts in this regard were in keeping with its mission to "encourage and develop…the application of the arts to manufacture and practical life." Huger Elliot, "The Educational Work of the Museum," *Bulletin of the Metropolitan Museum of Art* (hereafter "*Bulletin*") 21, no. 9 (September 1926), 202.

[3] "A Lecture For Salespeople," *Bulletin* 9, no. l (January 1914), 27.

[4] *Bulletin* 11, No. 4 (April 1916), 94.

[5] "Seminars for Salespeople and Buyers," *Bulletin* 12, no. 3 (March 1917), 72, 73; also mentioned in "Seminars for Salespeople," *Bulletin* 12, no. 4 (April 1917), 98.

[6] Elliot, "The Educational Work of the Museum," 212, 213.

[7] "The Museum in Use," *Bulletin* 17, no. 12 (December 1922), 265. The department stores paid the Museum for the lectures. One receipt in the archives of the museum reflects a payment by Macy's of $500 in 1921; another records a payment by Lord & Taylor for $300 to cover a lecture series given by Cornell. (The Metropolitan Museum of Art Archives.)

[8] Ralph M. Hower, *History of Macy's of New York 1858–1919*, (Cambridge, Mass.: Harvard University Press, 1946); Ralph M. Hower, *History of Macy's New York 1919–1942* (unpublished chapters), 8. Transcript, Archives of Macy's East, Inc. (Hereafter, "Macy's Archives")

[9] The Metropolitan Museum of Art, *Forty-ninth Annual Report 1918* (New York: 1919), 29.

[10] Christine Wallace Laidlaw, "The Metropolitan Museum of Art and Modern Design: 1917-1929," *Journal of Decorative & Propaganda Arts* 8 (Spring 1988), 88.

[11] Robert W. de Forest, "Art in Everyday Life; A Radio Talk," *American Magazine of Art* (March 1926), 128.

[12] "The Designer and the Museum: An Exhibition in Class Room B," *Bulletin* 12, no. 4 (April 1917), 93.

[13] R. Craig Miller, *Modern Design In The Metropolitan Museum of Art 1890-1990* (New York: Harry N. Abrams, 1990), l0.

[14] "Notes," *Bulletin* 13, no. 12 (December 1918), 290.

[15] Miller, *Modern Design*, 11.

[16] *American Industrial Art; An Exhibition of Current Manufactures Designed and Made in the United States* (exh. cat., New York: The Metropolitan Museum of Art, 1924), n.p., in The Metropolitan Museum of Art, *American Industrial Art: Annual Exhibitions of Current Manufacturers, Designed and Made in the United States…1917-1940* (New York, 1917–1940) (hereafter "*Museum Exhibitions*").

[17] *American Industrial Art*, n.p., in *Museum Exhibitions*. Bach viewed quantity design as "a democratic expedient for meeting the requirements of the mass." Richard F. Bach, "American Industrial Art," *Bulletin* 19, no. 1 (January 1924), 3.

[18] *American Industrial Art: Ninth Annual Exhibition of Current Manufactures Designed and Made in the United States* (exh. cat., New York: The Metropolitan Museum of Art), n.p., in *Museum Exhibitions*.

[19] Richard F. Bach "American Industrial Art: Tenth Annual Exhibition," *Bulletin* 21, no. 12 (December 1926), 275.

[20] Joseph Breck, "Modern Decorative Arts: A Loan Exhibition," *Bulletin* 21, no. 2 (February 1926), 36; see also Joseph Breck, "The Current Exhibition of Modern Decorative Arts," *Bulletin* 21, no. 3, part I (March 1926), 66–68. These objects, mostly French, represented the more traditional modern designers. Still, Breck anticipated a certain level of resistance in New York. In the *Bulletin,* he supposed that the objects, which would be unfamiliar to a majority of the museum's visitors, would be met "at first with indifference, even with hostility," but he hoped that it would give "food for thought." Joseph Breck, "Modern Decorative Arts: A Loan Exhibition," 37.

[21] Joseph Breck, "Modern Decorative Arts: Some Recent Purchases," *Bulletin* 21, no. 2 (February 1926), 37. While these objects did represent modern design, they were not the kind of items that could be manufactured in quantity, which were the focus of Richard Bach's efforts.

[22] Richard F. Bach, "On the Road to Better Design: Notes on Realizable Aims in Our Industrial Arts," *Bulletin* 22, no. 7 (July 1927), 196.

[23] "Art-In-Trade Exhibition," unsigned memorandum referred to in a letter from Henry Watson Kent to Edwin R. Dibrell, 10 March 1927 (The Metropolitan Museum of Art Archives).

[24] R.H. Macy & Co., *Minutes of the Advisory Council 1927,* 3 March 1927, 12 (Macy's Archives). The Advisory Council consisted of the three partners of the firm, Jesse, Percy, and Herbert Straus, as well as the general manager, the controller, the advertising manager, and five managers of merchandise departments. Hower, *History of Macy's of New York 1858–1919,* 367.

[25] Henry Watson Kent, New York, to Edwin R. Dibrell, New York, 10 March 1927 (The Metropolitan Museum of Art Archives).

[26] Robert W. de Forest, New York, to Edwin R. Dibrell, New York, 31 March 1927 (The Metropolitan Museum of Art Archives).

[27] Herbert Straus, New York, to Henry Watson Kent, New York, 20 April 1927 (The Metropolitan Museum of Art Archives).

[28] *Tucson Daily Citizen,* n.p. (Tucson Museum of Art Archives).

[29] "Macy Art in Trade Show is Approved," *World* (New York), 1 May 1927, 23.

[30] See, e.g., "Art-in-Trade Show Opens Tomorrow at Macy & Co.," *Brooklyn Daily Eagle,* 1 May 1927, E6; "Macy Store Holds Art in Trade Show," *New York Evening Post,* 28 April 1927, 7; "Ultra-Modern Note in Art Craftsmanship on View Next Week; Metropolitan Museum Style and Design Experts Join in Display Starting Monday at Macy's; Radio to Aid," *New York Herald Tribune,* 28 April 1927, 21.

[31] "Macy Exhibit Will Show Influence of Art on Life," *Women's Wear Daily,* 27 April 1927, sec. 1, p. 1.

[32] "Art-in-Trade Show Opens Tomorrow at Macy & Co.," 1 May 1927, E6.

[33] "The exhibit could be held just as well in a museum as in the store, it was said." "Macy Exhibit Will Show Influence of Art on Life," 27 April 1927, sec. 1, p. 1.

Chapter 2

[1] "Art in Trade is Shown by Macy; Exhibition at Store Modern and American," *New York Sun,* 2 May 1927, 18; "Art in Trade Exhibit Opens at R.H. Macy's: Percy S. Straus Notes Growing Artistic Taste," *Women's Wear Daily,* 2 May 1927, sec. 1, p. 1, 2.

[2] "Art in Manufacture and Trade," *Bulletin* 22, no. 6 (June 1927), l80. In later writings, de Forest expounded upon the role of department stores in promoting design. He acknowledged that the interest of the average museum visitor is "dulled, consciously or unconsciously, by the knowledge that what he sees is not his," and that "art is too personal a matter to be greatly stimulated" by the "attenuated possession" of a museum visit. He believed that shoppers, on the other hand, would be stimulated to acquire the objects they saw, and would therefore be "sensitive to suggestion and responsive to progress." Robert W. de Forest, "Getting in Step with Beauty," *American Review of Reviews* (January 1928), 64, 65.

[3] "Macy's Exhibit Will Show Influence of Art on Life," *Women's Wear Daily,* 27 April 1927, sec. 1, p. 2.

[4] Lee Simonson, "Angles of An Exposition Plan," *Journal of The American Institute of Architects* 15, no. 7 (July 1927), 232.

[5] Helen Appleton Read, "Art-in-Trade Exposition Stresses the Modern Note," *Brooklyn Daily Eagle,* 8 May 1927, E5.

[6] "'Art in Trade' Exhibit Suggests Novel Shop Interiors," *Retail Ledger* (first June issue 1927).

[7] A number of these textiles may be seen in color in J. Stewart Johnson, *American Modern* (exh. cat. New York: The Metropolitan Museum of Art, 1990).

[8] "Art in Trade Exhibit Opens at R.H. Macy's," 2 May 1927, sec 1, p. 1.

[9] "Macy Exhibit Will Show Influence of Art on Life," 27 April 1927, sec. 1, p. 4.

[10] See Charles R. Richards, Henry Creange and Frank Graham Holmes, *Report of Commission Appointed by the Secretary of Commerce to Visit and Report upon the International Exposition of Modern Decorative and Industrial Art in Paris 1925* (Washington, D.C: 1926).

[11] "New Art Show at Macy's," *Upholsterer and Interior Decorator* (15 May 1928), 116.

[12] "Macy Exhibit Will Show Influence of Art on Life," 27 April 1927, sec. 1, p. 4.

[13] "Decorated Interiors in Retail Stores," *Good Furniture Magazine* (June 1927), 326.

[14] M.D.C. Crawford, "Macy Exhibit Seen as Sign of Far-Reaching Effect of Movement for Art in Industry," *Women's Wear Daily,* 3 May 1927, sec. 1, p. 1; "30,000 Attend Macy Exhibit," *Women's Wear Daily,* 6 May 1927, sec. 1, p. 1.

[15] "Throng Sees Macy Useful-Art Show," *New York World,* 3 May 1927, 5. It would appear that Macy's fulfilled its promise to the museum not to commercialize the exposition.

[16] "Art-in-Trade Show Visited by 50,000," *New York World,* 8 May 1927, 12.

[17] "A Reaction In Our Art," *New York Times,* 3 May 1927, 24.

[18] "The Art Galleries," *The New Yorker* (14 May 1927), 77. See also, "6,000 at Macy's View Exposition of Art in Trade," *New York Herald Tribune,* 3 May 1927, 10.

[19] *New York Herald* (Paris), 15 May 1927, n.p. (Macy's Archives).

[20] "Says Industry Changes Art, Art Center Director Addresses Art in Trade Exposition," *New York Herald*

Tribune, 7 May 1927, 11. Picking up on Alon Bement's "Renaissance" theme, the *New Yorker's* Repard Leirum praised the cooperation of Macy's and the museum, which, he believed, "demonstrated that the Lorenzo de Medici attitude is now adopted as a commercial asset by manufacturers and retailers, and is no longer the privileged function of one single individual." Repard Leirum, "About the House," *The New Yorker* (14 May 1927), 75.

[21] *Retail Ledger,* n.p., n.d. (Macy's Archives).

[22] Leirum 1927, 75.

[23] "Simplified Furnishing," *The Furnishing Trades' Organizer* (August 1927), vi. (Macy's Archives).

[24] "Art-in-Trade Show Visited by 50,000," 12.

[25] Read, "Art-in Trade Exposition Stresses the Modern Note," E5.

[26] Henry McBride, "Art-in-Trade Exposition Indicates Great Advance in Public Taste," *New York Sun*, 7 May 1927, 26.

[27] Margaret Bruening, "Small Exhibitions Feature the Closing Weeks of the Art Galleries," *New York Evening Post*, 7 May 1927, sec. 5, p. 11.

[28] "Art in Trade Exhibit Opens at R. H. Macy's," 1.

[29] "Art-in-Trade Show Opens Tomorrow at Macy & Co.," *Brooklyn Daily Eagle*, 1 May 1927, E6.

[30] Paul Hyde Donner, New York, to Herbert N. Straus, New York, 1 June 1927 (Macy's Archives).

[31] Ralph Abercrombie, New York, to Edwin R. Dibrell, New York, 31 May 1927 (Macy's Archives).

[32] Edwin R. Dibrell, New York, to Henry Watson Kent, New York, 14 May 1927. (The Metropolitan Museum of Art Archives); see also "'Art in Trade' Exhibit Suggests Novel Shop Interiors," *Women's Wear Magazine* (20 June 1927), 40.

Chapter 3

[1] Walter Rendell Storey, "A Setting for our Modern Furniture," *New York Times Magazine*, 25 December 1927, 12.

[2] "Modern Art Makes its Bow in a Commercial Manner," *Decorative Furnisher* (December 1927), 101; Storey, "A Setting For Our Modern Furniture," 12; "Modern Art in a Department Store," *Good Furniture Magazine* (January 1928), 34.

[3] "Modern Art in a Department Store," 34.

[4] "Modern Art in a Department Store," 33.

[5] Storey, "A Setting For Our Modern Furniture," 13.

[6] "What of Modernism?" *Crockery and Glass Journal* (March 1928), 103.

[7] "Home Furnishings = Modern Art," *Women's Wear Daily*, 22 December 1928, sec. 1, p. 17.

[8] "Modernistic Apartment Demonstrates Practicality of New Art," *Women's Wear Daily*, 10 December 1928, sec. 1, p. 11.

[9] Ibid.

[10] The commentators differed on the exact nature of the pink color in the room. Most commentators referred to "apricot" tones; some termed them "rose." See, e.g. "Commercializing Art Moderne Furniture," *Good Furniture Magazine* (January 1928), 31; "Modernistic Furnishings for the Apartment," *New York Evening World*, 24 December 1927, 18.

[11] "Modern Furniture Reflects the Trend of Changing Habits in Daily Living," *Woman's Home Companion* (April 1928), 134.

[12] "Modernistic Apartment Demonstrates Practicality of New Art," sec.1, p.11; "Three Rooms Furnished in Modern Style," *House Beautiful* (April 1928), 426; "Commercializing Art Moderne Furniture," 30.

Chapter 4

[1] Nellie C. Sanford, "The Livable House Transformed," *Good Furniture Magazine* (April 1928), 174.

[2] Paul T. Frankl, "Just What is This Modernistic Movement?" *Arts & Decoration* (May 1928), 108.

[3] Paul T. Frankl, "Why We Accept Modernistic Furniture," *Arts & Decoration* (June 1928), 58.

[4] The easy chairs flanking the fireplace bear an strong resemblance to a chair designed by Jacques Émile Ruhlmann for the Petit Salon in the Hôtel du Collectionneur at the 1925 Paris Exposition, providing an early example of the influence of European modern design in America. See Brunhammer and Tise 1990, 112.

[5] Sanford, "The Livable House Transformed," 175.

[6] For an analysis of Frankl's early work in New York, see Christopher Long, "The New American Interior: Paul T. Frankl in New York, 1914-1717, *Studies in the Decorative Arts* (Spring-Summer 2002), 2-32.

[7] Sanford, "The Livable House Transformed," 176.

[8] Walter Rendell Storey, "Modernism Enters the Small House," *New York Times Magazine*, 26 February 1928, 12.

[9] Storey, 12; Margaret Breuning, "Chief Feature of the Week in Art," *New York Evening Post*, 11 February 1928, 14; Helen Appleton Read, "Modern Note is Interpreted in the Livable House, Now on View at Abraham and Straus'," *Brooklyn Daily Eagle*, 5 February 1928, 6E.

[10] Hazel Clair Swain, "Evolution of Modernistic Furniture," *Women's Wear Daily*, 31 March 1928, sec. 1, p. 1.

[11] "A. & S. Dismantle Modern Rooms and Reprice Goods for Prompt Sale." *Women's Wear Daily*, 4 August 1928, sec. 1, p. 12.

[12] Adolph Glassgold, "Frederick Loeser Exhibition," *Arts* (May 1928), 299.

[13] Lorraine Welling Lanmon, *William Lescaze, Architect* (Philadelphia: Art Alliance Press, 1987), 33-37. See also, Yvonne Brunhammer, *Arts Decoratifs des Annees 20* (Paris: Editions du Seuil), 194 for an image of one of the exhibits at the Exposition at Weissenhof in Stuttgart in 1927.

[14] Lanmon 1987, 37.

[15] Lindsay Stamm Shapiro, "The Early Work 1923-1928," in Christian Hubert and Lindsay Stamm Shapiro, eds., *William Lescaze* (New York: Rizzoli International Publications, Inc., 1982), 8.

Chapter 5

[1] *An Exposition of Modern French Decorative Art.* (exh. cat., New York: Lord & Taylor, 1928), n.p.

[2] Ibid.

[3] Ibid.

[4] "Exposition of Modern French Decorative Art," *American Architect* (5 March 1928), 317. While the catalog and the press ascribed the contents of this room to Jourdain, much of the furniture resembles pieces designed by Pierre Chareau and should probably be attributed to him. Sylvie Gonzalez, St. Denis, to the author, 29 January 2003. See also, Brian Brace Taylor,

Pierre Chareau: designer and architect (Köln and New York: Taschen, 1998), 54 (reclining chair), 55 (low table with wings), and 82 (sliding table).

[5] *An Exposition of Modern French Decorative Art*, n.p.

[6] Maxine McBride, "Many Thrills in Modernistic Furniture," *New York Sun*, 8 March 1928, 16.

[7] Walter Rendell Storey, "France Sends Us Her Decorative Art," *New York Times Magazine*, 19 February 1928, 14.

[8] "Lord & Taylor Exposition of Modern French Decorative Art," *Women's Wear Daily*, 3 March 1928, sec. 1, p. 3.

[9] Ibid.

[10] *An Exposition of Modern French Decorative Art*, n.p.

[11] "Exposition of Modern French Decorative Art," (5 March 1928), 320.

[12] The console and reading stand, both in varnished maple and palisander, were shown by D.I.M at the 1926 Salon des Artistes Décorateurs in Paris, as part of a "Petit Salon" that also incorporated a dressing table of the same design. See *Les Intérieurs Français au Salon des Artistes Décorateurs* (Paris: Charles Moreau, n.d.), plate 23.

[13] *An Exposition of Modern French Decorative Art*, n.p.

[14] "'Yes,' Says the Public to Lord and Taylor's Modernist Exposition," *Crockery and Glass Journal* (April 1928), 84, 85.

[15] N. C. Sanford, "American-Made Furniture in the Modern Trend," *Good Furniture Magazine* (June 1928), 287.

[16] "A Little Portfolio of Modernist Rooms," *House & Garden* (May 1928), 98.

[17] Sanford, "American-Made Furniture in the Modern Trend," 289.

[18] See, e.g., piano by Ruhlmann illustrated in Roberto Papini, *Le Arti di Oggi* (Milan: Casa Editrice d'Art Bestetti e Tumminelli, 1930), Fig. 255, 158. Helen Appleton Read commented that despite the elegance and richness of the work of the French traditionalists, they exhibited a "thriftiness" in form that enabled manufacturers to copy them in cheaper materials. Helen Appleton Read, "An Exposition of Modern French Decorative Art" (pamphlet, 1928, Shaver Papers). The dining room furniture bore a strong resemblance to furniture designed by Paul T. Frankl for the residence of Mrs. Whitney Miller. See "The Dining Room Done in White," *House & Garden* (November 1927), 108, 109.

[19] Sanford, "American-Made Furniture in the Modern Trend," 288.

[20] Count Maxence de Polignac and Jacques Rapin to Société des Artistes Décorateurs, 9 May 1928; copy sent to the director of Manufacture National de Sèvres by Maurice Fresson. Manufacture Nationale de Sèvres, carton T 40. My thanks to Tamara Préaud, archivist, Manufacture National de Sèvres.

[21] "Two Suggestive Mantel Treatments," *House Beautiful* (June 1928), 767.

[22] "Lord & Taylor Exhibit Sells $50,000 American-Made Modern Furniture," *Women's Wear Daily*, 17 March 1928, sec. 2, p. 2.

[23] M. D. C. Crawford, "Resume of Details in Modern Art Exhibit Opening at Lord & Taylor" (Shaver Papers).

[24] "Art Exhibit Closes," *New York Times*, 8 April 1928, sec. 1, p. 2.

[25] "What about This Modern French Decorative Art?" *Decorative Furnisher* (March 1928), 94.

[26] Peter Small, "The Modern French Decorative Art Exposition," *Creative Art* 2 (March 1928): xlv.

[27] "Art Exhibit Closes," sec. 2, p. 2.

[28] *Paris Herald*, n.d., n.p. (Shaver Papers).

Chapter 6

[1] N. C. Sanford, "An International Exhibit of Modern Art," *Good Furniture Magazine* (July 1928), 15.

[2] Jesse Isidor Straus, New York, to Henry W. Kent, Robert de Forest, and Richard Bach, all New York, 16 December 1927 (The Metropolitan Museum of Art Archives).

[3] Jesse I. Straus to Stewart Culin, Brooklyn, New York, December 28, 1927 (Brooklyn Museum of Art Archives; Culin Archival Collection, General Correspondence [1.4.150]); Jesse I. Straus to Kent et al., 16 December 1927.

[4] Jesse I. Straus to Kent et al., 16 December 1927.

[5] "5,000 Exhibits Macy Plan for Art Exhibit," *Women's Wear Daily*, 7 May 1928, sec. 1, p. 10. Extant documents do not explain the switch from "Trade" to "Industry" in the title of the 1928 exposition. Karen Lucic explains that industrial art in the 1920s was defined by its usefulness: Karen Lucic, "Seeing Through Surfaces: American Craft as Material Culture," in *Craft in the Machine Age*, ed. Janet Kardon. (New York: American Craft Museum, 1996). See also Davies 1983, 87–88. Macy's may have wanted to convey that sense of usefulness.

[6] "Macy's to Exhibit Art in Industry," *New York Times*, 7 May 1928, 43.

[7] "Modern Art Exhibition in Macy Store," *New York American*, 7 May 1928, sec. 2, p. 13.

[8] Macy's had already made a commitment to the future of modern design; on December 5, 1927, it opened a modern furniture department. *Dry Goods Economist* (17 December 1927), 49.

[9] "Art in Industry to Be Exhibited," *New York Sun*, May 7, 1928, 33; see also "Macy's Capitalizes Interest in Modernistic Art," *American Exporter* (September 1928), 16.

[10] "Macy's Capitalizes Interest in Modernistic Art," (September 1928), 16.

[11] Brunhammer and Tise 1990, 150.

[12] Dianne H. Pilgrim lends credence to the hypothesis that the organizers of the 1928 Macy's Exposition were wise to have chosen more conservative modern design in order to attract a wider audience. She argues that the *Machine Age Exposition*, held in New York in 1927, was ahead of its time, and that the public was not yet ready to embrace the cultural transformation arising from the machine. Dianne H. Pilgrim, "Design for the Machine," in *The Machine Age*, ed. Richard Guy Wilson (exh. cat., Brooklyn, N.Y.: Brooklyn Museum, 1986), 279.

[13] Percy Straus to Mr. Dibrell, 28 April 1928, in R.H. Macy & Co., Executive Memoranda from Percy S. Straus, 1916–29 (#1471) (Macy's Archives).

[14] The space occupied by the auditorium built in 1927 was devoted to room display in 1928, so a portion of Macy's middle building, to the east of the exposition space, was appropriated as an auditorium.

[15] "America Demanding Art in Industry," *The Glass Industry* (June 1928), 131.

[16] Ibid. 132, 133.

[17] "Modern Home Exhibit Opens," *New York Sun*, 14 May

1928, 28.

[18] "Foreign Diplomats at Opening of Industry Exposition," *New York Herald Tribune*, 15 May 1928, 28.

[19] "World Art Exhibit Opened by Macy's," *New York Times*, 15 May 1928, 8.

[20] A number of commentators analogized the exposition to a World's Fair and suggested that the planners of the Chicago World's Fair, then scheduled to take place in 1930, would have a difficult time outdoing Macy's. See, e.g., Henry McBride, "Exposition of Decorative Art Arouses Much Popular Interest," *New York Sun*, 19 May 1928, 6.

[21] "World Art Exhibit Opened by Macy's," 8.

[22] Margaret Bruening, "International Exhibition of Arts and Industry," *New York Evening Post*, 19 May 1928, 10.

[23] "Modernistic and International Is Macy's Second Art in Industry Exposition," *Dry Goods Economist* (2 June 1928), 75.

[24] "New Design to Express a New Age." *Exhibitors Herald* and *Moving Picture World* (27 October 1928), 13 (Macy's Archives).

[25] "Ablest Craftsmen of Six Nations Contribute 6,000 Exhibits to Demonstration of Utility of Modern Art in Everyday Life," *New York World*, 20 May 1928, 6N.

[26] "15 Furnished Rooms to House Macy Exhibit," *Women's Wear Daily*, May 11, 1928, 14.

[27] Susan Kindberg, at Reed & Barton, interview by telephone, March 2001.

[28] Anne Gros, Responsible du Musée, Musée Bouilhet-Christofle, Paris, to author, 21 April 2001.

[29] See, e.g., Felix Marcilhac, *Jean Dunand: His Life and Works* (New York: Harry N. Abrams, 1991), 30.

[30] Marion Clyde McCarroll, "Room Decoration, Crafts and All Kinds of Art Objects of Modern Design are Displayed at Exposition of Art," *New York Evening Post*, 21 May 1928, 8. In this article, McCarroll acknowledges that she has been opposed to modern design, and her praise for the show may be an indication of the relatively conservative nature of the exhibits. She is impressed by the "pleasing curves and graceful forms" that have evolved from the "harsh, sudden lines and angles" of the early modern design, and by the absence of the "bizarre."

[31] "Industrial Art," *New York Times*, 15 May 1928, 26.

[32] Elisabeth L. Cary, "International Exposition of Art in Industry," *New York Times*, 13 May 1928, 18. Cary quotes Virginia Hamill as explaining that the low furniture derived from oriental influences.

[33] Walter Rendell Storey, "The Latest Art-in-Industry Exhibit," *New York Times Magazine*, 27 May 1928, 18.

[34] Viviane Jutheau, *Jules et André Leleu* (Paris: Éditions Albia, 1996), 53.

[35] "Le XVIII Salon des Artistes Décorateurs," *Art et Décoration* 53 (January–June 1928), 193.

[36] "Le Salon d'Automne," *Mobilier & Décoration*, 8 (July–December 1928), 297. See also "XXV Salon d'Automne," *Art et Décoration*, 54 (July–December 1928), 187; Marcel Valotaire, "The Trend of Decorative Art: The Salon d'Automne," *Creative Art* 3 (November 1928), 86.

[37] "A Background for Dining—Shall It Be Modernique or Possessed of Old-Time Charm and Elegance," *New York Sun*, 23 May 1928, 20.

[38] Ibid., 20.

[39] Augusta Owen Patterson, "The Decorative Arts," *Town and Country* (1 June 1928), 89.

[40] N.C. Sanford, "An International Exhibit of Modern Art," *Good Furniture Magazine* (July 1928), 16.

[41] McCarroll, "Room Decoration, Crafts, and All Kinds of Art Objects of Modern Design," 8.

[42] C. Adolph Glassgold, "Art in Industry," *Arts* 13, no. 6 (June 1928), 377.

[43] See also image of Projet de la salle à manger du pavillon de La Maîtrise des Galeries Lafayette, Évelyne Possémé, *Le Mobilier Français 1910–1930 Les Années 25* (Paris, 1999), 140.

[44] "Le Salon d'Automne," 9.

[45] Storey "The Latest Art-in-Industry Exhibit," 18; see also McCarroll, "Room Decoration, Crafts, and All Kinds of Art Objects of Modern Design," 8.

[46] *Les Interieurs Français au Salon des Artistes Décorateurs présentés par Maurice Dufrêne* (Paris: Charles Moreau, n.d.), plate 22; "L'Exposition d'art Francais Contemporain a Bucarest," *Mobilier & Decoration* 8, (July–December 1928), 86.

[47] *Macy's 1928 Catalog*, 23.

[48] George Brunel, "The Progress of Modern Art," *Macy's 1928 Catalog*, 19.

[49] See, e.g., Bruening, "International Exhibition of Arts and Industry," 10.

[50] McBride, "Exposition of Decorative Art Arouses Much Popular Interest," 6.

[51] Storey, "The Latest Art-in-Industry Exhibit," 18.

[52] Bruening, "International Exhibition of Arts and Industry," 10.

[53] Royal Cortissoz, "Modernism in Crafts Exhibition at Macy's," *New York Herald Tribune*, 20 May 1928, 10.

[54] Storey, "The Latest Art-in-Industry Exhibit," 18; see also, Julia Blanshard, "Modernists Reclaim the Dining Room," *Eagle* (Berkshire, Mass.), 26 May 1928, n.p. (Macy's Archives).

[55] McCarroll, "Room Decoration, Crafts, and All Kinds of Art Objects of Modern Design," 8.

[56] Blanshard, "Modernists Reclaim the Dining Room."

[57] See image of Speisezimmer, 1928, with vier stühle and zwei armlehnstühle, designed by Bruno Paul, Alfred Ziffer, *Bruno Paul,* (exh. cat., Munich: Munchner Stadmuseum: Klinkhardt & Biermann, 1992), 247.

[58] Blanshard, "Modernists Reclaim the Dining Room."

[59] Glassgold, "Art in Industry," 379. Nellie Sanford also alluded to the "necrological suggestion in the long, plain buffet, mounted on a sturdy stand." Sanford, "An International Exhibit of Modern Art," 17.

[60] Cortissoz "Modernism in Crafts Exhibition at Macy's," 10.

[61] See, e.g., Ziffer, *Bruno Paul,* 239, 240, 259.

[62] "Art in Industry Show Will Open Here Next Week," *Evening World*, 7 May 1928, 20; see also Ziffer, *Bruno Paul,* 239, 240.

[63] Storey, "The Latest Art-in-Industry Exhibit," 18; Frances Strauss, "But Is It Art? International Modernism at Macy's," *Brooklyn Citizen*, 27 May 1928, 15.

[64] Storey, "The Latest Art-in-Industry Exhibit," 18. The rug actually dated at least as far back as 1922, when it appeared in a room Paul designed in Munich. Ziffer, *Bruno Paul*, 234.

[65] Ella Burns Meyers noted that horizontal stripes had replaced vertical ones in many new fabrics and wallpapers. Ella Burns Meyers, "Trends in Decoration," *Good Furniture Magazine* (September 1928), 129.

66 "Modern Furniture in the Modern Home—Its Appeal to the Present Generation," *Women's Wear Daily*, 26 May 1928, sec. 1, p. 1.

67 *Macy's 1928 Catalog*, 36.

68 Sanford, "An International Exhibit of Modern Art," 18.

69 Storey, "The Latest Art-in-Industry Exhibit," 18. Arturo Songa created the wall treatment on canvas.

70 See "Superleggera" chair, 1957, designed by Gio Ponti, in Kathryn B. Hiesinger and George H. Marcus, *Landmarks of Twentieth-Century Design* (New York: Abbeville Press, 1993), 208.

71 Cortissoz, "Modernism in Crafts Exhibition at Macy's," 10.

72 Bruening, "International Exhibition of Arts and Industry," 10.

73 "Ablest Craftsmen of Six Nations," 6N.

74 "An 'Art in Industry' Meat Market," *Butchers' Advocate* (23 May 1928), 10.

75 Guido Marangoni, "The Promising Future of Italian Art," in *Macy's 1928 Catalog*, 52, quoting from the program at Monza in 1927.

76 Robert W. de Forest, "Foreword," in *Macy's 1928 Catalog*, 3, excerpted from the Metropolitan Museum of Art, *Industrial Arts Monograph No. 4* (New York, 1928).

77 Ibid., 6.

78 Albert MacPhail, "Another Modern Art Display Draws Thousands to Macy's," *Gift and Art Shop* (28 June 1928), 21.

79 Storey, "The Latest Art-in-Industry Exhibit," 18.

80 "Boudoir Powder Room and Butcher Shop Features of Macy Exhibit, Opening Monday," *Women's Wear Daily*, 10 May 1928, sec. 1, p. 6. See also Storey, "The Latest Art-in-Industry Exhibit," 18. According to Eduard Sekler, the "inlaid" scenes were actually paintings by Maria Strauss-Likarz to imitate intarsia. Eduard F. Sekler, *Josef Hoffmann: The Architectural Work* (Princeton, N.J.: Princeton University Press, 1985), 389.

81 McBride, "Exposition of Decorative Art Arouses Much Popular Interest," 6.

82 Sekler, *Josef Hoffmann*, 180; *Encyclopedie des arts decoratifs et industriels modernes au XXeme siecle*, vol. 4 (New York: Garland, 1977), pl. lxxvi.

83 Josef Hoffmann, "Austrian Contribution to Modern Art," in *Macy's 1928 Catalog*, 8.

84 Sanford, "An International Exhibit of Modern Art," 18, 19, 20.

85 Eugene Schoen, "The Design of Modern Interiors," *Creative Art* 2, no. 5 (May 1928), xli, xlii.

86 Karen J. Rigdon, *Eugene Schoen: Designs for Furniture, 1927–1936* (master's diss., Cooper-Hewitt, National Design Museum, 1986), 36.

87 Ibid., 36, citing Glassgold, "Art in Industry," 1928, 379.

88 *Art in Trade* described the walls as "putty colored," while McBride termed them "dull pink." "Macy's Exposition a Forerunner of Many Art in Trade Shows," *Art in Trade* (July 1928), 15; McBride, "Exposition of Decorative Art Arouses Much Popular Interest," 6. The curtains were pale blue. Ralph Flint, "More Modernistic Interiors," *Christian Science Monitor*, 7 May 1928 (Macy's Archives).

89 Sanford, "An International Exhibit of Modern Art," 20.

90 Storey, "The Latest Art-in-Industry Exhibit," 18.

91x Lorraine Welling Lanmon, *William Lescaze* (Philadelphia: Art Alliance Press, 1987), 38.

92 Storey, "The Latest Art-in-Industry Exhibit," 18. I want to express my appreciation to Ashley Callahan, curator of the Henry D. Green Center for the Study of the Decorative Arts at the Georgia Museum of Art, who provided information concerning the furniture designed by Karasz and secured the photographs of the room.

93 Julia Blanshard, "With Minimum of Space, Modernism Brings Refreshing Novelty, Comfort, and Convenience to the Home," *Courier* (Orange, N.J.), 24 May 1928 (Macy's Archives). Storey reported only blue and vermilion semicircles. Storey, "The Latest Art-in-Industry Exhibit," 18.

94 "Fantastic Furniture Gets Good," *NEA Sunday Magazine* (5 August 1928), 7 (Macy's Archives).

95 Bruening, "International Exhibition of Arts and Industry," 10.

96 "Art in Industry Exposition at R.H. Macy & Co." *House Furnishing Review* (June 1928), 14 (Macy's Archives).

97 Bruening, "International Exhibition of Arts and Industry," 10; "Views of European and American Interiors at Macy's Modern Art Exhibit," *Women's Wear Daily*, 19 May 1928, sec. 1, p. 3.

98 "Art in Industry Exposition at R.H. Macy & Co.," 14.

99 Bruening, "International Exhibition of Arts and Industry," 10.

100 "Fantastic Furniture Gets Good," *NEA Sunday Magazine* (5 August 1928), 7 (Macy's Archives).

101 "And Now—the Modern Office!" *Geyer's Stationer* (June 1928), 39 (Macy's Archives).

102 Ralph T. Walker, *Ralph Walker Architect* (New York: Henahan House, 1957), 21.

103 Ibid.

104 "Design Exposition Visited by 100,000," *New York Times*, 20 May 1928, 25.

105 "Says Home Planning Is Half of Comfort," *New York Times*, 16 May 1928, 41.

106 "Metal to Replace Wooden Furniture," *New York World*, 16 May 1928, 11.

107 "Designers Are Urged to Express America," *New York Times*, 17 May 1928, 42.

108 Essentially, Hamill was predicting her future. During the 1930s, she designed for International Silver Company, Congoleum Nairn, Owens Illinois Glass, Libbey Owens Ford, Bates Bedspreads, and Cannon Mills, among others. She convinced Cannon to manufacture the first colored bath towels in the United States. Pat Harris, undated article; *Tucson Daily Citizen* Biographical File for Virginia Hamill Johnson (Archives of the Tucson Museum of Art).

109 "Value of Antiques Debated at Macy's," *New York Times*, 18 May 1928, 39.

110 "Modern Clothes for Modern Interiors Discussed at Macy's," *Women's Wear Daily*, 18 May 1928, sec. 1, p. 5.

111 "Sees Literature Aid in Modern Freedom," *New York Times*, 19 May 1928, 26.

112 "Modern Clothes for Modern Interiors Discussed at Macy's," sec. 1, p. 5.

113 "Art Exposition Packs Macy Exhibit Space to Limit," *New York World*, 20 May 1928, 3.

114 "100,000 Visitors Attend Art-in-Industry Show," *New York Herald Tribune*, 20 May 1928, 21.

115 "Art Exposition Packs Macy Exhibit Space to Limit," 3.

116 "R.H. Macy & Co. Hold an Exposition of Modern Art," *Decorative Furnisher* (June 1928), 95; see also

George S. Chappell, "Modern Art at Macy's," *The Architect* (July 1928), 445, in which the author concluded that if public interest was a criterion of appreciation "the exposition was a *succés fou.*"

[117] See, e.g., Storey, "The Latest Art-in-Industry Exhibit," 18.

[118] McCarroll, "Room Decoration, Crafts, and All Kinds of Art Objects of Modern Design," 8.

[119] See, e.g., "Second Macy Art in Industry Exposition Reveals International Progress," *Women's Wear Daily*, 19 May 1928, sec. 1, p. 1; Chappell, "Modern Art at Macy's," 445; Richard F. Bach, "Styles A-Borning: Musings on Contemporary Industrial Art and Decoration," *Creative Art* 2 (June 1928), xxxvii; Helen Appleton Read, "Twentieth-Century Decoration: A Significant Meeting of Various Modernists," *Vogue* (15 July 1928), 74.

[120] Sanford, "An International Exhibit of Modern Art," 18. Sanford's comment made sense only because Virginia Hamill had excluded the work of the French rationalists.

[121] "Modern Home Exhibit Opens," 28.

[122] Read, "Twentieth-Century Decoration," 100.

[123] Storey, "The Latest Art-in-Industry Exhibit," 18.

[124] Glassgold, "Art in Industry," 376.

[125] "Macy to Have Atelier," *New York Times*, 5 June 1928, 50.

[126] "How Macy's Tied up Their Modern Art Exposition with Selling in Other Departments," *Women's Wear Daily*, 18 May 1928, sec. 1, p. 5.

[127] "Macy Is Foremost among Big Stores," *Wall Street Journal*, 13 April 1928, 3.

[128] "Cheap and Smart," *Fortune* (May 1930), 86.

[129] See, e.g., Hazel Clair Swain, "Modern Art Called Only New Merchandising Idea on Retail Horizon," *Women's Wear Daily*, 19 May 1928, 5; Clayton E. Gibbs, "Modern Furniture in the Modern Home—Its Appeal to the Present Generation—How It Should Be Sold," *Women's Wear Daily*, 26 May 1928, sec. 1, p.13.

[130] "How to Blend Modernistic and Period Furniture," *Women's Wear Daily*, 26 May 1928, sec. 1, p. 14.

Chapter 7

[1] *An Exhibition of 20ᵗʰ Century Taste in the New Expression of the Arts in HOME FURNISHINGS and Personal Accessories as Achieved by European and American Designers*, exh. cat. (New York: B. Altman & Co., 1928), cover page (Hagley Museum and Library) (hereafter "*Altman's Catalog*").

[2] "Modern Bedroom Exhibit Proves Immediate Sales Stimulant," *Woman's Wear Daily*, 28 July 1928, sec. 1, p. 15.

[3] "American and 18th Century English Styles Led in Favor during August Furniture Sales, Survey Shows," *Women's Wear Daily*, 15 September 1928, sec. 1, p. 14.

[4] "Lord & Taylor Furniture Sales 20% Modernistic," *Women's Wear Daily*, 22 September 1928, sec. 1, p. 1.

[5] *Altman's Catalog*, n.p.

[6] "Modern Rooms in New York and Chicago," *Good Furniture Magazine* (December 1928), 311.

[7] "Altman Modern Art Exhibit Opens Monday," *Women's Wear Daily*, 15 September 1928, sec. 1, p. 14.

[8] "Modern Rooms in New York and Chicago," 312.

[9] Lee Simonson, "Modern Furniture in the Department Store," *Creative Art* (November 1928), xviii.

[10] "An Exposition of XX Century Taste," *Upholsterer and Interior Decorator* (15 October 1928), 94.

[11] Walter Rendell Storey, "New Decorative Art Season under Way," *New York Times Magazine*, 30 September 1928, 15; "About the House," *The New Yorker* (6 October 1928), 78.

[12] Helen J. Drew, "Furniture for the Ultra-Modern Room," *Arts & Decoration* (October 1928), 82.

[13] Matlack Price, "New Art and the Designer," *House & Garden* (October 1928), 146.

[14] Drew, "Furniture for the Ultra-Modern Room," 82.

[15] Price, "New Art and the Designer," 146. It should be noted that Price was also a spokeperson for Bartlett-Orr Press, Inc., which handled the publicity for the Altman's exhibition.

[16] Simonson, "Modern Furniture in the Department Store," xvi.

[17] "New Art Show 'On Parade' at Altman's," *Decorative Furnisher* (October 1928), 82; "Modern Rooms in New York and Chicago," 313.

[18] B. B., "About the House," *The New Yorker* (6 October 1928), 78.

[19] "Modern Rooms in New York and Chicago," 313; Drew, "Furniture for the Ultra-Modern Room," 82

[20] "Modern Rooms in New York and Chicago," 313.

[21] Simonson, "Modern Furniture in the Department Store," xviii.

[22] Price, "New Art and the Designer," 146.

[23] Drew, "Furniture for the Ultra-Modern Room," 82.

[24] Simonson, "Modern Furniture in the Department Store," xx. Simonson was, of course, promoting a model that had been adopted by all of the major department stores in Paris.

[25] "Angles on the Altman Art Show," *Women's Wear Daily*, 22 September 1928, sec. 1, p. 14. It is also possible that worsening financial conditions played some part in these decisions.

Chapter 8

[1] N. C. Sanford, "Decorating in Art Moderne," *Good Furniture Magazine* (November 1928), 241.

[2] Ibid, 242.

[3] "Lord & Taylor Furniture Sales 20% Modernistic," *Women's Wear Daily*, 22 September 1928, 1.

[4] Ella Burns Myers, "Trends in Decoration," *Good Furniture Magazine* (December 1928), 294.

[5] Curtis Patterson, "A Source Book on Modern Interiors," *International Studio* (September 1929), 72-73; cited in Lanmon 1987, 38.

[6] "Modern Art Course Finds Favor," *Women's Wear Daily*, 18 August 1928, sec. 1, p. 14.

[7] "$400,000 Subscribed for Industrial School to Foster Modern Design," *Women's Wear Daily*, 21 September 1928, 13.

[8] The Metropolitan Museum of Art, *Sixtieth Annual Report 1929* (New York, 1930), 39.

[9] Arthur J. Pulos, *American Design Ethic; A History of Industrial Design to 1940* (Cambridge, Massachusetts and London: The MIT Press, 1983), 317.

[10] Both William Leach and Susan Strasser have discussed the rise of the consumer culture and the methodologies used by manufacturers and merchants to create demand for their offerings. William Leach, *Land of Desire* (New York, 1993); Susan Strasser, *Satisfaction Guaranteed* (Washington and London, 1989).

Bibliography

"About the House." *The New Yorker* (26 May 1928), 69.

"About the House." *The New Yorker* (22 September 1928), 66-68.

"About the House." *The New Yorker* (6 October 1928), 78.

"Accessories to Modernism." *House & Garden* (June 1928), 104.

"America Demanding Art in Industry." *The Glass Industry* (June 1928), 131-133.

"American Modernist Furniture Inspired by Sky-scraper Architecture." *Good Furniture Magazine* (September 1927), 119-121.

"An 'Art in Industry' Meat Market." *The Butchers' Advocate* (23 May 1928), 10.

"And Now, 'The Glorified Bathroom.'" *The Valve World* (November 1928), n.p.

Art Deco and Its Origins. Exh. cat., Huntington, New York: Heckscher Museum, 1974.

"Art in Industry." *The Arts* 13 (May 1928), 315.

"Art in Industry." *The Magazine of Business* (July 1928), n.p.

"Art in Industry at Macy's." *Dry Goods Economist* (2 June 1928), 74.

"Art in Industry at R. H. Macy & Co." *House Furnishing Review* (June 1928), 14.

"Art in Industry; The R. H. Macy & Co., Inc., Exposition was International." *The Bulletin; National Retail Dry Goods Association* 10 (June 1928), 250-251.

"'Art in Trade' Exhibit Suggests Novel Shop Interiors." *Women's Wear Magazine* (20 June 1927), 40.

"Art in Trades Elaborately Shown in Big Macy Exhibition." *Dry Goods Economist Gifts and Jewelry Section* (7 May 1927), 113.

"Art Moderne at the Midsummer Markets." *Good Furniture Magazine* (September 1928), 118-119.

"Art Moderne For a Conservative Clientele." *Good Furniture Magazine* (September 1928), 131-133.

Arwas, Victor. *Art Deco.* New York: Abrams, 1980.

"Art Works for a Living." *The Independent* 119 (9 July 1927), 35-38.

Bach, Richard F. *Museums and the Industrial World.* New York: The Gilless Press, 1926.

———. *Museum Service to the Art Industries, An Historical Statement to 1927.* New York, 1927.

———. "Art and the Machine." *The American Magazine of Art* 19 (February 1928), 73-77.

———. "Styles A-Borning: Musings on Contemporary Industrial Art and Decoration." *Creative Art* 2 (June 1928), xxxvii-xl.

———. "The Resurgence of Quality." *Annual of American Design* (1931), 79-81.

———. "Museums and the Trades; A Statement of the Case to Date. New York, n.d., 170-177.

"A Baedeker to Modernism." *Fashionable Dress* (September 1928), 24.

Baldwin, William H. "Modern Art and the Machine Age." *The Independent* 119 (9 July 1927), 39.

B. Altman & Co. *An Exhibition of 20ᵗʰ Century Taste in the New Expression of the Arts in Home Furnishings and Personal Accessories as Achieved by European and American Designers.* Exh. cat. New York: B. Altman & Co., 1928.

Barter, Judith A. and Jennifer Downs. *Shaping the Modern: American Arts at The Art Institute of Chicago 1917–1965.* Chicago: The Art Institute of Chicago Museum Studies 27, 2001.

Bassett, Mark and Victoria Naumann. *Cowan Pottery and the Cleveland School.* Atglen, Pa.: Schiffer Publishing Ltd., 1997.

Battersby, Martin. *The Decorative Twenties.* New York: Walker and Company, 1969.

Baxter, Leonora R. "Art from Many Lands." *The Nomad* 4 (August 1928), 36.

Bayer, Herbert, Walter Gropius and Ise Gropius, eds., *Bauhaus 1919-1928.* New York: The Museum of Modern Art, 1938.

Bayer, Patricia. *Art Deco Interiors.* London: Thames & Hudson, 1990.

"Beautifying the Commonplace; Progress Made in Development of Industrial Art Seen in Exhibits of Six Nations at Exposition Staged by R. H. Macy & Co., New York." *Carpet and Upholstery Trade Review* and the *Rug Trade Review* (n.d., n.p.).

Blanshard, Julia. "With Minimum of Space, Modernism Brings Refreshing Novelty, Comfort and Convenience to the Home." *Orange (N.J.) Daily Courier,* 24 May 1928, n.p.

———. "Modernists Reclaim the Dining Room." *Berkshire (Mass.) Eagle,* 26 May 1928, n.p.

Bosserman, Joseph Norwood. *Ralph Walker Bibliography.* Charlottesville, Virginia: American Association of Architectural Bibliographers, 1960.

"Bringing Art into Trade." *The Drapers' Organizer* (August 1927), 71.

"Bringing Art Into Trade." *The Literary Digest* (28 May 1927), n.p.

"Bristol Exhibit of Modern Art Furniture." Advertisement, *Arts & Decoration* 29 (May 1928), 40.

Bruening, Margaret. "Small Exhibitions Feature the Closing Weeks of the Art Galleries." *New York Evening Post,* 11 May 1927, 11.

———. "Chief Feature of the Week in Art." *New York Evening Post,* 11 February 1928, 14.

———. "Modern French Interior Decoration Feature of the Week's Art Events." *New York Evening Post,* 3 March 1928, 14.

———. "International Exhibition of Arts and Industry." *New York Evening Post,* 19 May 1928, 10.

Brunel, Géo. "Une Exposition D'Art Moderne Appliqué Organisée a New-York par la Maison R. H. Macy et Co." *La Renaissance* (September 1928), 398-399.

Brunhammer, Yvonne. *Arts Decoratifs des Annees 20* (Paris: Editions du Seuil), 1991.

Brunhammer, Yvonne and Suzanne Tise. *French Decorative Art; The Societe des Artistes Decorateurs.* Paris: Flammarion, 1990.

"Business Streets of the Future Will Be on Three Levels." *Retail Ledger* (First June Issue 1927), 1.

Cary, Elisabeth L. "French Decorative Modes and a Long Art Perspective." *New York Times,* 4 March 1928, sec. X, p. 14.

———. "International Exposition of Art in Industry." *New York Times,* 13 May 1928, sec. X, p. 18.

Chappell, George S. "Modern Art at Macy's." *The Architect* 10 (July 1928), 445, 447, 526.

"Cheap and Smart." *Fortune* (May 1930), 82-86, 142.

Clary, E. J. "Making the Small Window Produce." *Merchants Record and Show Window* 63 (November 1928), 9-11.

"Commercializing Art Moderne Furniture." *Good Furniture Magazine* (January 1928), 30-31.

Cortissoz, Royal. "The Modernistic Motive in Contemporary French Decoration." *New York Herald Tribune,* 6 March 1928, 17.

———. "Modernism in Crafts Exhibition at Macy's." *New York Herald Tribune,* 20 May 1928, sec. VII, p. 10.

Cram, Ralph Adams. "Will This Modernism Last? No." *House Beautiful* (January 1929), 45, 88.

Crawford, M.D.C. "Lord & Taylor Exposition Devoted to French Modern Art." *Women's Wear Daily,* 25 February 1928, sec. 1, p. 12, 20.

Cresswell, Howell S. "The Autumn Salon, 1927." *Good Furniture Magazine* (January 1928), 20-26.

———. "Oriental Lacquer on Modern Furniture." *Good Furniture Magazine* (June 1928), 291-295.

Crocker, P.K. "The Growing Alliance Between Art and Merchandise." *Women's Wear Daily,* 24 December 1927, sec 1, p. 3.

———. "Bringing Metropolitan Art Museum into the Realm of Retailing." *Women's Wear Daily,* 14 January 1928, sec. 1, p. 1, 14.

Crowninshield, Frank. "The High Cost of Laughing." *House & Garden Trade Supplement,* (August 1928), 7.

Darton, Mike, ed., *Art Deco: An Illustrated Guide to the Decorative Style 1920-1940.* London: Tiger, 1990.

Davies, Karen. *At Home in Manhattan.* Exh. cat., New Haven, Conn.: Yale University Art Gallery, 1983.

De Cerval, Marguerite. *Maubaussin.* Paris: Editions du Regard, 1992.

"Decorated Interiors in Retail Stores." *Good Furniture Magazine* (June 1927), 325-327.

de Forest, Robert W. "Art in Everyday Life." *The American Magazine of Art* 17 (March 1926), 127-129.

———. "Getting in Step with Beauty." *The American Review of Reviews* (January 1928), 63-68.

Department of Overseas Trade. *Reports on the Present Position and Tendencies of the Industrial Arts as Indicated at the International Exhibition of Modern Decorative and Industrial Arts, Paris, 1925.* London, n.d.

Deshairs, Léon. *Intérieurs en Couleurs France.* Paris: A. Levy, 1926.

———. "French Furniture of the Twentieth Century." *Good Furniture Magazine* (December 1928), 295-303.

Dibrell, Edwin R. "Renaissance of Art in Merchandise Is Revolutionizing Retailing." *Women's Wear Daily,* 14 September 1927, sec. 1, p. 1, 12.

———. "Renaissance of Art in Merchandise Is Revolutionizing Retailing." *Women's Wear Daily,* 1 October 1927, sec. 1, p. 5.

Drew, Helen J. "Furniture for the Ultra-Modern Room." *Arts & Decoration* (October 1928), 80, 82.

Druesdow, Jean L., ed., *Authentic Art Deco Interiors and Furniture in Full Color.* Mineola, New York: Dover Publications, Inc., 1997.

Duane, Andrew. "And Now—the Modern Office!" *Geyer's Stationer* (June 1928), 39.

Duncan, Alastair. *American Art Deco.* New York: Harry N. Abrams, 1986.

———. *Art Deco Furniture.* London: Thames & Hudson, 1984, reprinted 1997.

———. *Modernism; modernist design 1880-1940.* Minneapolis: Antiques Collectors Club, 1998.

Encyclopedie des Arts Decoratifs et Industriels Modernes au XXeme Siecle. Paris: Impr. Nationale, Office Central d'éditions et de librairie; reprint, New York: Garland, 1977.

"Exposition of Modern French Decorative Art." *The American Architect 133* (5 March 1928), 317-322.

"An Exposition of XX Century Taste." *The Upholsterer and Interior Decorator* (15 September 1928), 93-95.

"Fact and Comment." *The Upholsterer and Interior Decorator* (15 May 1927), 91.

Fiell, Charlotte and Peter Fiell. *20s Decorative Art.* Koln: Taschen, 2000.

Frankl, Paul T. "Just What is This Modernistic Movement?" *Arts & Decoration* (May 1928), 56, 57, 108, 117, 118.

———. "Why We Accept Modernistic Furniture." *Arts & Decoration* (June 1928), 58, 59, 90, 99.

———. Logic in Modernistic Furniture." *Arts & Decoration* (July 1928), 54, 55, 82, 83.

"French Art Moderne Exposition in New York." *Good Furniture Magazine* (March 1928), 119-122.

Fry, Charles Rahn. *Art Deco Interiors in Color.* New York: Dover Publications, Inc., c1977.

Gebhard, David. *Josef Hoffmann: Design Classics.* Exh. cat., Fort Worth: Fort Worth Art Museum, c. 1982.

Gebhard, David and Harriette von Breton. *Kem Weber; The Moderne in Southern California 1920-1941.* Exh. cat., Santa Barbara, California: University of California, Santa Barbara Art Gallery, 1969.

Gilman, Roger. "Is This Modernistic Furniture More Than a Fad? Yes." *House Beautiful* (February 1929), 162, 198.

Glassgold, C. Adolph. "The Modern Note in Decorative Arts, Part One." *The Arts* 13 (March 1928), 153-167.

———."The Modern Note in Decorative Arts, Part Two." *The Arts* 13 (April 1928), 221-235.

———. "Frederick Loeser Exhibition." *The Arts* 13 (May 1928), 299.

———. "Art in Industry." *The Arts* 13 (June, 1928), 375-379.

"Glimpse of N.Y. Modernistic Apartment." *Arts & Decoration* 29 (September 1928), 64.

Goldsmith, L.E. "Art in Trade Glorified by Macy's." *The Bulletin*, National Retail Dry Goods Association 9 (May 1927), 238-241.

Gorham, I. B. "Comfort; Convenience; Colour." *Creative Art* 7 (October 1930), 249-251.

Günther, Sonja. *Bruno Paul, 1874-1968*. Berlin: Gebr. Mann, 1992.

Gura, Judith. "Modernism and the 1925 Paris Exposition." *The Magazine Antiques* (August 2000), 194-203.

Harris, Leon A. *Merchant Princes; An Intimate History of Jewish Families Who Built Great Department Stores*. New York: Harper & Row, 1979.

Heide, Robert and John Gilman. *Popular Art Deco*. New York: Abbeville Press, 1991.

Heisinger, Kathryn B. and George H. Marcus. *Landmarks of Twentieth-Century Design*. New York; Abbeville Press, 1993.

Hendrickson, Robert. *The Grand Emporiums; The Illustrated History of America's Great Department Stores*. New York: Stein & Day, 1979.

Herbst, René. *Devantures Vitrines Installations de Magasins a L'Exposition Internationale des Arts Decoratifs Paris 1925*. Paris: C. H. Moreau, n.d.

Heskett, John. *Industrial Design*. London: Thames and Hudson, 1980.

"The High Cost of Laughing." *House & Garden* (Trade Supplement, August 1928), 7.

Hillier, Bevis. *The Style of the Century 1900-1980*. New York: E.B. Dutton, Inc., 1983.

———. *The World of Art Deco*. Exh. cat., New York: E. B. Dutton for The Minneapolis Institute of Arts,1971.

Hillier, Bevis and Stephen Escritt. *Art Deco Style*. London: Phaidon, 1997.

Hitchcock, Henry Russell, Jr. "Some American Interiors in the Modern Style." *Architectural Record* 64 (September 1928), 235-243.

Holme, C. Geoffrey and Shirley B. Wainwright. *"The Studio Year-Book of Decorative Art, 1925*. London.

Hower, Ralph M. *History of Macy's of New York 1858-1919*. Cambridge, Mass.: Harvard University Press, 1946.

———. *History of Macy's of New York 1919-1942; Chapters in the Evolution of the Department Store*. Transcript. Macy's Archives.

Hubert, Christian and Lindsay Stamm Shapiro eds. *William Lescaze*. New York: Rizzoli International Publications, Inc., 1982.

Hunter, Penelope. "Art Deco and The Metropolitan Museum of Art," *The Connoisseur* 179 (April 1972), 273-281.

"The Influence of Modern Art on the Home." *McCall's Needlework* (Summer 1928), 24, 25, 63.

"International Art in Industry." *Fairchild's International Magazine* (August 1928), 65.

"International Exhibition of Art in Industry at Macy's." *The Pottery, Glass & Brass Salesman* (17 May 1928), 13, 33.

"International Exposition of Art in Industry at Macy's." *Retail Ledger* (First June Issue, June 1928), n.p.

"International Modernity," *The American Sketch* (July 1928), 38.

"Is a Museum Good for Anything" *The American Magazine of Art* 20 (October 1929), 584.

"Italiani E Stranieri in una Esposizione D'Arte Decorativa Moderna a New York." *Domus* (October 1928), 18-20.

Jean Dunand. Exh. cat., Paris: Galerie du Luxembourg, 1973.

Johnson, J. Stewart. *American Modern 1925-1940*. Exh. cat., New York: The Metropolitan Museum of Art, 2000.

Jutheau, Viviane. *Jules et André Leleu*. Paris: Éditions Albia, 1996.

Kahn, Ely J. "Exhibition of French Decorative Art." *The Architectural Record* 63 (May 1928), 462-468.

Kaplan, Wendy, *Designing Modernity; The Arts of Reform and Persuasion 1885-1945*. Exh. cat., Miami Beach: The Wolfsonian, 1995.

Kardon, Janet, ed. *Craft in the Machine Age 1920-1945*. Exh. cat., New York: American Craft Museum, 1996.

Keyes, Homer Eaton. "Is This Modernistic Furniture More Than a Fad? No." *House Beautiful* (February 1929), 163, 198.

Kjellberg, Pierre. *Art Déco: Les Maîtres du Mobilier*. Paris: Les Éditions de L'amateur, c 1981.

Klein, Dan, Nancy A. McClelland and Malcolm Haslam. *In the Deco Style*. London: Thames and Hudson, 1987.

Laidlaw, Christine Wallace. "The Metropolitan Museum of Art and Modern Design: 1917-1929." *Journal of Decorative & Propaganda Arts* 8 (spring 1988), 88-103.

Lanmon, Lorraine Welling. *William Lescaze, Architect*. Philadelphia: Art Alliance Press, 1987.

Leach, William. *Land of Desire*. New York: Vintage Books, 1993.

Leirum, Repard. "About the House." *The New Yorker* (14 May 1927), 75.

Lesieutre, Alain. *The Spirit and Splendour of Art Deco*. New York: Paddington Press, 1974, reprinted Secaucus, N.J.: Castle Books, 1978.

Les Intérieurs Français au Salon des Artistes Décorateurs. Paris: Charles Moreau, n.d.

Liljencrants, C. Johan. "The International Exposition of Art in Industry at R.H. Macy & Company, Inc." *The Swedish-American Trade Journal* (June 1928), 193-194.

The Literary Digest Building Supplement (August 1928), n.p.

"A Little Portfolio of Modernist Rooms." *House & Garden* (May 1928), 97-99.

"A Livable House Transformed in the Modern Manner." *The Decorative Furnisher* (April 1928), 88, 89.

Long, Christopher. "The New American Interior: Paul T. Frankl in New York, 1914-1717." *Studies in the Decorative Arts* 9 (Spring-Summer 2002), 2-32.

Lord & Taylor. *An Exposition of Modern French Decorative Art*. Exh. cat., New York:

Lord & Taylor, 1928.

"Lord & Taylor's Present an Exposition of Modern French Decorative Art." *Dry Goods Economist; Gift and Jewelry Section* (March 10, 1928), 84-85, 87, 97, 102.

Loring, John. "American Deco." *Connoisseur* (January 1979), 48-54.

MacPhail, Albert. "Another Modern Art Display Draws Thousands to Macy's." *The Gift and Art Shop* (June 1928), 20-21.

"The Macy Exposition of Art in Industry." *The Architectural Record* 64 (August 1928), 137-143.

"Macy's Capitalizes Interest in Modernistic Art," *American Exporter* (September 1928), 15.

"Macy's Exposition a Forerunner of Many Art in Trade Shows." *Art-In-Trade* (July, 1928), 14.

Manna, Loris. Gio Ponti: Le maioliche. Italy: Biblioteca de Senato Edizione, 2000.

"Macy's International Exposition of Art in Industry." *The Upholsterer and Interior Decorator* (15 June 1928), 119-120.

Marcilhac, Félix. *Jean Dunand: His Life and Works*. New York: Abrams, 1991.

Marcus, George. *Functionalist Design*. Munich and New York: Prestel, 1995.

Maraini, Yoi. "The Modernism of Italy." *House & Garden* (October 1928), 110.

McBride, Henry. "Display of Modern French Decorative Art Leads List." *New York Sun*, 3 March 1928, 10.

———. "Exposition of Decorative Art Arouses Much Popular Interest." *New York Sun*, 19 May 1928, 6.

McBride, Maxine. "Many Thrills in Modernistic Furniture." *New York Sun*, 8 March 1928, 16.

McCarroll, Marion Clyde. "Room Decoration, Crafts and All Kinds of Art Objects of Modern Design Are Displayed at Exposition of Art." *New York Evening Post*, 21 May 1928, 8.

McClinton, Katherine Morrison. *Art Deco; A Guide for Collectors*. New York, Clarkson N. Potter, Inc.; distributed by Crown Publishers, 1972.

Menten, Theodore. *The Art Deco Style*. New York: Dover Publications, Inc., 1972.

The Metropolitan Museum of Art. *American industrial art: annual exhibitions of current manufacturers, designed and made in the United States…1917-1940*. New York: The Metropolitan Museum of Art, 1917-1940.

Meyers, Ella Burns. "Trends in Decoration." *Good Furniture Magazine* (September 1928), 127-130.

———. "Trends in Decoration." *Good Furniture Magazine* (December 1928), 291-294..

Michail, M. Cristina Tonelli. *Il design in Italia 1925-1943*. Roma and Bari: Editori Laterza, 1987.

"The Mid-Summer Furniture Market." *The Upholsterer and Interior Decorator* (15 July 1928), 118-120.

Miller, Michael B. *The Bon Marché*. Princeton, N.J.: Princeton University Press, 1981.

Miller, R. Craig. *Modern Design In The Metropolitan Museum of Art 1890-1990*. New York: Harry N. Abrams, 1990.

Leonard, R.L. and C. A. Glassgold, eds., *Annual of American Design*. New York: I. Washburn, Inc., c1930; reprinted as *Modern American Design*, introduction by Mel Byars, New York, Acanthus Press, 1992.

"Modern Art Among Us." *The Literary Digest* (2 June 1928), 25-29.

"Modern Art Exhibit at Lord & Taylor." *Gift & Art Shop*, April 28, 1928, 18.

"Modern Art Gives New Beauty to Utility." *Nation's Business* 16 (August 1928), 30, 31.

"Modern Art in a Department Store." *Good Furniture Magazine* (January 1928), 32-35.

"Modern Art in Industry." *The Ceramic Age* 11 (May 1928), 163-172.

"Modern Art in Trade at Macy's." *Dry Goods Economist; Gifts and Jewelry Section* (4 June 1927), 117.

"Modern Art Makes Its Bow in a Commercial Manner." *The Decorative Furnisher* 55 (December 1927), 101.

"Modern Bedroom Exhibit Proves Immediate Sales Stimulant." *Woman's Wear Daily*, 28 July 1928, sec., 1, p. 15.

"Modern Furniture From Los Angeles." *Good Furniture Magazine* (November 1927), 233-236.

"Modern Furniture in the Modern Home—Its Appeal to The Present Generation." *Women's Wear Daily*, 26 May 1928, 1.

"Modern Rooms in New York and Chicago." *Good Furniture Magazine* (December 1928), 311-315.

"Modern Furniture Reflects the Trend of Changing Habits in Daily Living," *Woman's Home Companion* (April 1928), 134-135.

"Modern Interiors Shown in New York." *House & Garden* (August 1928), 67.

Modern Rooms in New York and Chicago." *Good Furniture Magazine* (December 1928), 311-314.

"Modernistic and International Is Macy's Second Art in Industry Exposition." *Dry Goods Economist; Gift and Jewelry Section* (2 June 1928), 75, 89, 94.

"A Modernistic Apartment." *Architecture* 58 (August 1928), 89-92.

"Modernistic Movement in Arts and Crafts." *Arts & Decoration* (April 1928), 60, 61, 101.

"The New Art – Its Future." *The Upholsterer and Interior Decorator* (15 March, 1928), 107-111.

"'New' Art Show at Macy's." *The Upholsterer and Interior Decorator* (15 June 1927), 115-116.

"New Design to Express a New Age." *Exhibitors Herald* and *Moving Picture World*. (27 October 1928), 12, 13.

"New York Gets Another View of 20th Century Art." *The Decorative Furnisher* (October 1928), 79-82, 86.

"News of the Industry." *The Upholsterer and Interior Decorator* (15 September 1928), 133.

Orfèvrerie Christofle. *Dinanderies*. Cat., Paris: Orfèvrerie Christofle, 1931.

Ostergard, Derek E. *Art Deco Masterpieces*. New York: Macmillan Publishing Co., 1991.

Papini, Roberto. *Le Arti di Oggi*. Milan: Casa Editrice D'Art Bestetti E Tumminelli, 1930.

Patterson, Augusta Owen. "The Decorative Arts." *Town & Country* (1 March 1928), 52-53, 106.

————. "The Decorative Arts." *Town & Country* (1 June 1928), 55.

Pilgrim, Dianne H. "Design for the Machine," in Wilson, Richard Guy, ed., *The Machine Age*. Exh. cat., Brooklyn, New York: The Brooklyn Museum, 1986.

Portoghesi, Paolo, Anty Pansera and Anna Pierpaoli. *Gio Ponti Alla Manifattura de Doccia*. Milano: Sugarco, 1982.

Possémé, Évelyne. *Le Mobilier Français 1910-1930*. Paris: Éditions Massin, 1999.

Powell, Edith W. "A Modernist Display Scheme." *Commercial Art* (October 1928), 170, 183.

Price, Matlack. "New Art and the Designer." *House & Garden* (October 1928), 109, 140, 146.

Pulos, Arthur J. *American Design Ethic; A History of Industrial Design to 1940*. Cambridge, Mass. and London: The MIT Press, 1983.

Quimby, Ian M. G. *Material Culture and the Study of American Life*, New York: W. W. Norton & Company, Inc., 1978.

R. H. Macy & Co. *Minutes of the Advisory Council 1927*. New York, 1927.

R. H. Macy & Co. *The Catalog of the Exposition of Art in Trade at Macy's May 2 to May 7, 1927*. Exh. cat., New York, 1927.

"R. H. Macy & Co. Give Demonstration of Modern Art in a Series of Three Splendidly Furnished Model Rooms." *The Decorative Furnisher* (January 1928), 106-107.

"R.H. Macy & Co. Hold an Exposition of Modern Art." *The Decorative Furnisher* (June 1928), 95-99, 114.

R. H. Macy & Co. *An International Exposition of Art in Industry*. Exh. cat., New York, 1928.

Read, Helen Appleton. "Art-in Trade Exposition Stresses the Modern Note." *Brooklyn Eagle*, 8 May 1927, E5.

————. "Contemporary Decorative Art in America." *Vogue* (August 1927), n.p.

————. "Twentieth-Century Decoration; A Significant Meeting of Various Modernists." *Vogue* (15 July 1928), 74.

————. "An Exposition of Modern French Decorative Art." Pamphlet, 1928 (Dorothy Shaver Papers, Archives Center, National Museum of American History, Smithsonian Institution).

Richards, Charles R. *Industrial Art and The Museum*. New York: The Macmillan Company, 1927.

————. "The Development of the Industrial Arts." *The American Magazine of Art* 19 (February 1928), 77-78.

Richards, Charles R., Henry Creange, and Frank Graham Holmes, *Report of Commission Appointed by the Secretary of Commerce to Visit and Report Upon the International Exposition of Modern Decorative and Industrial Art in Paris 1925*. Washington, D.C., 1926.

Ries, Estelle H. "The French Influence on American Decorative Arts." *Fashionable Dress* (November 1927), 29, 58-59.

————. "Pioneers in Modernist Furniture." *Fashionable Dress* (September 1928), 30.

————. "This Modernist Age." *Fashionable Dress* (September 1928), 25, 56.

Rigdon, Karen J. "Eugene Schoen: Designs for Furniture, 1927-1936." Masters Thesis, Cooper-Hewitt National Design Museum, 1986.

"The Rise of Modern Art in Industry." *The Pottery, Glass & Brass Salesman* (31 May 1928), 15.

Rudoe, Judy. *Decorative Arts 1850-1950*. London: British Museum Press, 1991.

Saloff, Tim and Jamie Saloff. *The Collector's Encyclopedia of Cowan Pottery: Identification and Values*. Paducah, Ky.: Collector Books, 1994.

Sanford, Nellie. C. "An Architect-Designer of Modern Furniture." *Good Furniture Magazine* (March 1928), 116-118.

————. "The Livable House Transformed." *Good Furniture Magazine* (April 1928), 174-176.

————. "American-Made Furniture in the Modern Trend." *Good Furniture Magazine* (June 1928), 287-290.

————. "An International Exhibit of Modern Art; Macy's of New York Sponsored Forward-Looking Event." *Good Furniture Magazine* (July 1928), 15-20.

————. "Decorating in Art Moderne." *Good Furniture Magazine* (November 1928), 241-245.

Schoen, Eugene. "The Design of Modern Interiors." *Creative Art* 2 (May 1928), XL-XLIII.

Sekler, Eduard F. *Josef Hoffmann; The Architectural Work*. Princeton: Princeton University Press, 1985.

Simonson, Lee. "Angles of An Exposition Plan." *Journal of The American Institute of Architects* 15 (July 1927), 234.

————. "Modern Furniture in the Department Store." *Creative Art* 3 (November 1928), xvi-xxi.

————. "New Methods; New Materials." *Annual of American Design* (1931), 65-67.

————. "Museum Showmanship." *The Architectural Forum* 56 (June 1932), 533-540.

————. "Redesigning Department Stores." *The Architectural Forum* 58 (May 1933), 372-376.

"Six Nations Represented at Macy's Second Art in Industry Exposition." *China, Glass & Lamps* (14 May 1928), 13.

"Simplified Furnishing." *The Furnishing Trades' Organizer* (August 1927), vi.

Small, Peter. "The Modern French Decorative Art Exposition." *Creative Art* 2, No. 3 (March 1928), XLII-XLV.

Snow, Grace Palen. "Vogue's Eye View of the Mode." *Vogue* (1 July 1928), 35.

Société de L'art Appliqué aux Métiers. *Le Pavillon de la Société de L'art Appliqué aux Métiers a L'Exposition Internationale Des Arts Décoratifs et Industriels Modernes*. Paris, 1925.

Sprackling, Helen. "Modern Art and the Artist." *House Beautiful* (February 1929), 151-155.

Stern, Robert A. M., Gregory Gilmartin, and Thomas Mellins. *New York 1930; Architecture and Urbanism Between the Two Wars*. New York: Rizzoli International Publications, Inc., 1987.

Storey, Walter Rendell. "A Setting for our Modern Furniture," *New York Times Magazine*, 25 December 1927, 12-13.

————. "France Sends Us Her Decorative Art." *New York Times Magazine*, 19 February 1928, 14-15.

————. "Modernism Enters the Small House." *New York Times Magazine*, 26 February 1928, 12-13.

————. "The Latest Art-in-Industry Exhibit." *New York Times Magazine*, 27 May 1928, 18.

————. "New Decorative Art Season Under Way." *New York Times Magazine*, 30 September 1928, 14-15.

Strasser, Susan. *Satisfaction Guaranteed*. Washington and London: Smithsonian Institution Press, 1989.

System (August 1928).

Swain, Hazel Clair. "A Definition of What the New Art Is, and an Explanation of Its Applications to Modern Merchandising." *Women's Wear Daily*, 3 March 1928, sec. 1, p. 1, 4.

————. "Evolution of Modernistic Furniture." *Women's Wear Daily*, 31 March 1928, sec. 1, p. 1, 3, 4.

Tallmadge, Thomas E. "Will This Modernism Last? Yes." *House Beautiful* (January 1929), 44, 88.

Taylor, Brian Brace. *Pierre Chareau: Designer and Architect*. Koln and New York: Taschen, c1998.

"Three Rooms Furnished in Modern Style," *House Beautiful* (April 1928), 426-427;

Troy, Nancy J. *Modernism and the Decorative Arts in France*. New Haven and London: Yale University Press, 1991.

"Two Suggestive Mantel Treatments." *House Beautiful* (June 1928), 767.

"Une Exposition D'Art Decoratif a New York." *L'Illustration* (20 August 1927), XI.

"Une Exposition D'Art Moderne Appliqué Organisée A New-York par la Maison R. H. Macy et Co." *La Renaissance* (September 1928), 398-399.

Valotaire, Marcel. "La Maitrise: A Creative force in Decorative Art." *Creative Art* 3 (November 1928), 324-329.

————. "The Trend of Decorative Art; The Salon d'Automne." *Creative Art* 4 (February 1929), 85-91.

"Various Countries Exhibit Modern Art," *The American Architect* 133 (20 June 1928), 823-827.

Vellay, Marc. *Pierre Chareau: Architecte-meublier, 1883-1950*. Paris: Rivages/Styles, 1986.

W., R. C. "Modern Art Gives New Beauty to Utility." *Nation's Business* 16 (August, 1928), 30, 31.

Walker, Ralph. *Ralph Walker, Architect*. New York: Henahan House, 1957.

Weaver, Sir Lawrence. "The Need For More Art in Industry." *The American Magazine of Art* 19 (June 1928), 316-218.

"What About This Modern French Decorative Art?" *The Decorative Furnisher* (March 1928), 94-99, 102.

"What I See in New York." *House Beautiful* (July 1928), 22.

"What is Modern Art?" *Merchants Record and Show Window* 63 (November 1928), 12-14.

"What of Modernism," *Crockery and Glass Journal* (March 1928), 29, 30, 103.

"When a Department Store Stages an Exhibit." *Retail Ledger*, (First June Issue 1927), n.p.

"When Art Goes to Work for Trade." *Crockery & Glass Journal* (June 1928), 28, 29, 74.

Wilcox, Uthai Vincent. "The Business Appeal of Beauty." *The Poster* (July 1928), 10.

"'Yes', Says the Public to Lord and Taylor's Modernist Exposition." *Crockery and Glass Journal* (April 1928), 84, 85.

Ziffer, Alfred. *Bruno Paul*. Munich: Klinkhardt & Biermann, 1992.

Newspapers, various issues April, 1927-December 1928

Brooklyn Citizen
Brooklyn Times
Brooklyn Eagle
Christian Science Monitor
New York Daily Mirror
New York Daily News
New York Evening World
New York American
New York Evening Journal
New York Evening Post
New York Herald (Paris)
New York Herald Tribune
New York Sun
New York Times
Paris Herald
Wall Street Journal
Women's Wear Daily
New York World

Publications of The Metropolitan Museum of Art:
Bulletin of The Metropolitan Museum of Art, 1914-1929.
Annual Reports 1918, 1919, 1927, 1928, 1929.

Index